Planting Patterns
From the Air

Kultivierte Erde
Kulturlandschaften aus der Luft fotografiert

First published 2005 under the title:
"L'Art de la terre" by Kubik éditions
© Archipel studio, 2005

This edition © Kubik/RvR 2005
RvR Verlagsgesellschaft
Schulstr. 64
D-77694 Kehl
info@kubikinternational.de
www.kubikinternational.de

Publisher : Jean-Jacques Brisebarre

Design: Thomas Brisebarre

ENGLISH EDITION
Produced by Silva Editions Ltd.
Project Manager: Sylvia Goulding
Translated by Rafael Pauley
Edited by Jacqueline Fortey

ISBN: 3-938265-21-3

DEUTSCHE VERSION
Übersetzt von Ulrike Lowis
Lektorat und Projektkoordination: Ruth Mader

ISBN: 3-938265-06-X

Printed in Spain in September 2005

Olivier Lasserre

Planting Patterns
From the Air

Kultivierte Erde
Kulturlandschaften aus der Luft fotografiert

KUBIK *RvR*
PUBLISHING

Introduction

Photographing the land is essential to my profession as a landscape architect. I use images to help read the landscape and illustrate development projects.

For almost twenty years, I have thus been able to amass thousands of photographs classified by area or theme – trees, walls, waterways, cityscapes, private gardens, public areas, agricultural landscapes... – made available to my colleagues at my agency based in Lausanne.

One day, in 1990, at the beginning of a new project, entitled *Abstract: textures and boundaries*, I became interested in the edge of a pavement, the texture of gravel, I sought to distinguish the border between a meadow of rape and a field of maize. Henceforth, I came to regard the landscape as a set of materials; my photographs reveal surfaces, planes, strips with their borders, their verges. Photography led me to consider areas as a juxtaposition of planes.

GEOMETRIC ELEMENTS

And so I began to ask myself the question of the representation of the most characteristic limit of a landscape, the separation of land and sky, the horizon. I felt that its photographic representation was overworked, too reminiscent of the postcard. In 1999, during a trip to the Sahara with a photographer – a seasoned globetrotter and the author of a dozen photographic books – I observed his direct way of approaching people, his method for framing landscapes, his meticulous organisation. In an attempt to escape banality in my desert images, I too decided to stop taking pictures of the horizon. My photos became nothing more than shots of sand, rocky banks, strips of brilliant grasses, dazzling black basalt, fabrics on skins... The horizontal is omnipresent, but the horizon has disappeared.

In 2000, while undertaking a town-planning study on part of the Rhône valley to which my contribution was above all photographic, I made use of an aircraft to visualise this vast territory, as one would fly over a model. My purpose was to demonstrate the superimposition of artificial structures on natural ones, the taking over of nature by man. Yet, since my visit to the desert, something had changed: I had become more demanding about the composition of my images.

Instead of treating the photograph as a document for professional use, I began to treat it as an entity in itself, with its own composition, its own geometry and coherence. The shape of a photograph is a square or a rectangle, rather than a circle or triangle and, to my mind, the geometry of the contents must respond to the geometry of its container. Increasingly, I took photographs of subjects frontally, the horizontals and verticals becoming parallel to the boundaries of the image.

This complete coherence of the image has become enduring and obvious for me: whether I am in the process of photographing a forest or a row of cobblestones, I arrange the shot so that its layout conforms to my 'obsession'. Am I losing my mind?

Einleitung

Ein unentbehrlicher Bestandteil meiner Arbeit als Landschaftsarchitekt ist das Fotografieren von Landschaften. Ich benutze die Fotografie als Mittel, um eine Landschaft besser zu verstehen und Raumplanungsprojekte zu illustrieren.

Im Laufe von fast 20 Jahren sind so Tausende von Fotografien entstanden, die ich entweder thematisch oder geographisch geordnet und klassifiziert habe: Bäume, Mauern, Gewässer, städtische Räume, private Gärten, öffentliche Plätze, landwirtschaftliche Flächen usw. Sie stehen den Kunden meiner Firma für Landschaftsarchitektur in Lausanne zur Verfügung.

Eines Tages, im Jahr 1990, im Rahmen der Vorbereitung auf ein neues Projekt mit dem abstrakten Titel „Texturen und Grenzen", fing ich an, mich Motiven wie einer Bordsteinkante oder der Textur von Kiesel zuzuwenden. Die zarte Grenze zwischen einer Rapskultur und einem Maisfeld wurde interessant. Nun begann ich, Landschaft als ein Zusammenspiel unterschiedlich gestalteter Materialien zu sehen. Meine Fotografien fingen an, Oberflächen, Landstreifen mit ihren Grenzen, ihren Rändern zu enthüllen und Räume als eine Aneinanderreihung von Oberflächen zu begreifen.

GEOMETRIE

In der Folge stellte ich mir die Frage, wie die Grenze einer Landschaft, die Trennung zwischen Himmel und Erde, darzustellen sei. Die Abbildung des Horizontes in der herkömmlichen fotografischen Darstellung hat oft etwas Abgenutztes, sie verkommt zum klischeehaften Postkartenmotiv.

1999 bereiste ich mit einem Fotografen die Sahara; ein Abenteurer, er hat zahlreiche Bücher zum Thema Fotografie verfasst. Ich bewunderte, wie er sich ohne Scheu den Menschen näherte, wie er die Landschaften einfing und wie peinlich genau er Ordnung hielt. Ich meinerseits versuchte, den Bildern der Wüste ihre Banalität zu nehmen, indem ich den Horizont von meinen Fotografien verbannte. Meine Fotos zeigten nichts als Sandflächen, Felsbänke, Streifen von schimmernden Gräsern, schwarzes Basaltgeröll, ausgebreitete Stoffe ... Die Horizontale war allgegenwärtig, der Horizont jedoch verschwunden.

Im Jahr 2000 beteiligte ich mich an einer Stadtplanungsstudie zu einem Teilstück der Rhône-Ebene. Mein Beitrag war in erster Linie fotografischer Natur. Ich benutzte das Flugzeug, um die Landschaft so zu zeigen, wie man sie sieht, wenn man ein Modell von oben betrachtet. Mein Ziel war es, die Überlagerung von natürlichen und künstlichen Strukturen zu zeigen, die Inbesitznahme der Natur durch den Menschen. Doch seit meiner Erfahrungen in der Wüste hatte sich etwas verändert, meine Ansprüche an die Bildkomposition waren gestiegen. Die Fotografie entwickelte immer mehr ein Eigenleben, mit ihrer eigenen Komposition, eigenen Geometrie und Kohärenz. Bald war sie weit mehr als nur ein Arbeitsmittel.

Ein Foto ist stets quadratisch oder rechteckig, niemals rund oder dreieckig, und in meinen Augen muss die Geometrie des Inhalts der Geometrie der Form entsprechen. Immer häufiger fotografierte ich meine Motive von vorn, und die Horizontalen und Vertikalen verliefen parallel zu den Bildrändern.

Die vollständige Kohärenz des Bildes wurde für mich zu einem beständigen und sinnfälligen Anliegen: Ob ich nun einen Wald oder eine Reihe Pflaster-

Part of the answer comes in spring 2001: a large Mark Rothko exhibition takes place in Basel, at the Beyeler Foundation, formed in 1997 by Renzo Piano — an exhibition with a harmony between container and contents, between building and paintings, so sublimely confined that thousands of visitors leave deeply moved. At this point, I admit, I know neither the artist nor the work and, as are so many other spectators, I am fascinated by the large rectangles of colour, the subtlety with which the limits are handled — they are true landscapes! They have the poetry of abstraction, the emotional content of original work. Yet I am also reassured to discover a great artist who, for twenty years, ceaselessly pursued the same theme, answering to the same rules to better reach the fundamentals.

An image by the German photographer Andreas Gursky brings further answers. In 1993, he photographed face-on the immense façade of an apartment complex in the Montparnasse district in Paris. The density of this picture represents the multitude; and its scale, its everyday reality, its layout, give it the obviousness I seek. The geometry of the building fits perfectly into the stretched rectangle of the image, like a technical drawing. There is no use of perspective, no diagonal, just an orthogonal network. The point of view of the photographer is neither unpredictable nor commonplace; it is unique and gives the image a pertinence and a force, that to me are unquestionable.

These encounters with the work of Rothko, Gursky, and many others — painters, photographers, designers, architects, weavers, landscapers, printers, craftsmen — encourage me, as if every time someone is saying to me: continue! Do not be afraid of following your obsession with borders and joints, textures and surfaces, horizontal lines!

LOW, SLOW FLIGHT

From then on I want to make this photographic work into something personal. It has become an independent project that I would like to develop and share. During the summer of 2001, I took many series of photographs of urban elements in New York and Washington where I was invited for an architectural competition. I also shot in northern Italy, where I travel regularly, and in Switzerland, where I live. These are mostly close-ups of constructed elements, yet they also include some aerial views of agricultural land, taken during a flight over the Orbe Plains in the Vaud canton, at the heart of which I have been working for twelve years. In the autumn, I chose a hundred images and presented them to the museum of photography of Lausanne, seeking the curator's opinion. The response was encouraging; a few images of New York are selected for an exhibition about the events of September 11, and twenty aerial views of farmed land are retained. So I decided to expand my work on this theme.

One evening in May 2002, during reconnaissance in the Orbe Plains in preparation of a future flight, I come across a plot of freshly tilled peat,

steine fotografierte, stets sorgte ich mich, ob die Bildgestaltung mit meiner „Obsession" konform gehe. War ich verrückt geworden?

Eine Teilantwort erhielt ich im Frühjahr 2001: In Basel fand in der 1997 von Renzo Piano erbauten Fondation Beyeler eine große Mark-Rothko-Ausstellung statt. In der Harmonie zwischen Form und Inhalt, zwischen Gebäude und Bildern, lag eine derartige Erhabenheit, die Tausende Besucher tief beeindruckte. Zugegebenermaßen kannte ich weder den Künstler noch sein Werk, und wie so viele andere war ich fasziniert von der Ausgeglichenheit der großen rechteckigen Farbfelder, von der Subtilität der Grenzen — die selbst wieder Landschaften sind! —, von der Poesie der Abstraktion, von der Emotionalität des originellen Werkes. Doch ebenso fühlte ich mich bestärkt durch die Begegnung mit der Arbeit eines großen Künstlers, der auf der Suche nach dem Wesentlichen über 20 Jahre hinweg immer wieder dasselbe Thema vertieft hat, der immer wieder denselben Regeln folgte.

Ein Bild des deutschen Fotografen Andreas Gursky lieferte mir eine zweite Antwort. 1993 hatte er die immense Fassade eines Wohnblocks in Montparnasse in Paris frontal fotografiert. Die Dichte des Bildes, in der die Vielzahl des Dargestellten zum Ausdruck kommt, sein Maßstab, sein Alltagsrealismus, seine Raumaufteilung verleihen seiner Fotografie die Eindeutigkeit, die ich suchte. Die Geometrie des Gebäudes fügt sich einer technischen Darstellung gleich genau in das Querformat des Bildes ein. Es gibt keine Perspektiven, keine Diagonalen, sondern nur ein Netz von rechtwinkligen Linien. Der Blickwinkel des Fotografen ist weder zufällig noch banal, sondern einzigartig.

Die Begegnungen mit Rothko, Gursky und vielen anderen — Malern, Fotografen, Grafikern, Architekten, Stoffdesignern, Landschaftsarchitekten, Druckern, Handwerkern ... — haben mich auf meinem Weg bestärkt. Es kam mir immer vor, als würde jemand sagen: Mach' weiter! Hab keine Angst, folge weiterhin deiner Besessenheit von Linien, Grenzen, Übergängen, Texturen und Oberflächen!

IM LANGSAMEN FLUG

Seither verfolge ich mit meiner fotografischen Arbeit ein persönliches Anliegen. Sie ist zu einem eigenständigen Projekt geworden, das ich weiterentwickeln und kommunizieren will.

Im Sommer 2001 schoss ich mehrere Fotoserien mit urbanen Motiven in New York und Washington, wohin man mich im Rahmen eines Architekturwettbewerbs eingeladen hatte. Ich fotografierte außerdem in Norditalien, wo ich mich häufig aufhalte, und in der Schweiz, wo ich lebe. Meine Motive bestanden in erster Linie aus baulichen Elementen, fotografiert aus nächster Nähe, doch bei einem Flug über die Orbe-Ebene im Kanton Waadt, wo ich seit zwölf Jahren lebe, fing ich auch an, Luftaufnahmen von Ackerbauflächen zu machen. Im Herbst wählte ich rund 100 Bilder aus, um sie beim Museum für Fotografie in Lausanne einzureichen, und um mir die Meinung des Konservators einzuholen. Das Urteil ist ermutigend — einige New-York-Bilder werden für eine Ausstellung über den 11. September ausgewählt. Die 20 Luftaufnahmen von den Ackerbauflächen behält das Museum. Ich beschließe, meine Arbeit zu diesem Thema zu vertiefen.

6

still moist, black. The maize shoots are barely emerging, they are still translucent, illuminated from behind by the setting sun. Perched on the bank of a railway line, I lean my camera upon a metal mast in order to capture this plunging perspective without horizon, framing only the luminous green of the aligned young shoots. Finally, with this image, I have achieved what I had been seeking for years: abstract landscapes! The photograph was exhibited, and chosen as the motif of the new glass-walled college of Prilly, in Lausanne. Yet to get to the roots of my idea, I need to fly, slowly, and at low altitudes, so that I can position my lens at right angles to the farmland and achieve the necessary precision in photographing the cultivated areas. I want to come face to face with the land!

A hot-air balloon, carrying an enormous flying advert for a local newspaper, helps me to achieve my objective, but its effectiveness is limited. I try aeroplanes, which are too fast to take clear images at low altitude, and a crane, perched thirty metres up in a cradle... Finally I discover the ideal solution: a helicopter and, better still, a small two-seater crop-spraying helicopter, cheap and simple.

I learn to make use of the helicopter, to attach myself firmly, to communicate with the pilot, to give him clear, precise directions, and to instantly choose the subject. Dangling outside the machine, I try to forget the drop and the fear, the cold and the heat, the vibrations and the wind, the noise and the tension. I must get used to all this, anticipate the technical problems of the shot, and completely relax in search of an earth texture, a rhythm of light, a design of plants, on original image. The images resulting from this first series of flights are not perfect, but they express what I am looking for: the rationality of agricultural work, the repetitive mechanical precision of parallels, on a ground of natural textures and colours. The constant composition is not monotonous; on the contrary, it favours comparison and diversity. More than the plant itself, I find myself interested in the marks left by the tools in the soil, in the preparation of the farmland, in the geometric footprint of the rollers, in the translucent covering of young seedlings. The crops evolve week by week, their lighting hour by hour.

In the autumn of 2003, I was to present my work to Alice Pauli, a well-known gallery owner in Lausanne. Since her debut, forty years ago, she had never exhibited photographs – something I was unaware of. I spread some large prints out on the floor, including one of maize stubble emerging from snow. She looks carefully at them, and asks me "What technique do you use?" I answer that they are photographs. In January 2004, she organises an exhibition of thirty of my images. At around the same time, an editor friend put me in contact with a publishing house. The decision is taken, a book will be published. I decide to start from scratch: all the images for the book were taken between March 2004 and February 2005, during a total of twenty-five flights. As far as possible, I use small two-seater helicopters, sometimes taking advantage of

An einem Abend im Mai 2002 stoße ich bei den Vorbereitungen für einen weiteren Flug über die Orbe-Ebene auf eine frisch bearbeitete Parzelle mit noch feuchtem und schwarzem Torfboden. Der Mais beginnt gerade erst zu sprießen, die Keime sind noch ganz durchsichtig und schimmern im Gegenlicht der untergehenden Sonne. An der Böschung einer Bahnstrecke hockend, stütze ich meine Kamera an einem metallenen Mast ab, um diesen weiten Blick ohne Horizont einzufangen – als Bildausschnitt wähle ich nur die langen Reihen von zartgrünen Pflänzchen. Mit diesem Bild erhalte ich schließlich das, was ich seit Jahren gesucht hatte: die Abstraktion von Landschaft! Die Aufnahme wird zunächst ausgestellt, später dient sie als Motiv für die gläserne Fassade einer neuen Schule in Prilly Lausanne.

Doch um meine Vorstellungen vollständig umzusetzen, muss ich fliegen, langsam fliegen, auf geringer Höhe, damit ich mein Objektiv senkrecht auf die Ackerflächen halten und die bestellte Erde mit aller Genauigkeit fotografieren kann. Ich will die Erde von Angesicht zu Angesicht betrachten!

Mit einem Zeppelin, der als riesiger Werbeträger für eine Lokalzeitung dient, gelingt mir das, doch sehr ergiebig ist diese Fahrt nicht. Ich versuche es mit dem Flugzeug, doch es ist zu schnell, um von dort aus scharfe Aufnahmen aus geringer Höhe zu machen, ebenso fotografiere ich von einem Kranwagen aus, wo ich in 30 Meter Höhe in eine Gondel gezwängt bin ... Dann finde ich die ideale Lösung: einen Hubschrauber, am besten eines dieser kleinen Modelle, die zum Düngen eingesetzt werden – ein Zweisitzer, günstig und sparsam.

Ich lerne, vom Hubschrauber aus zu arbeiten. Fest anschnallen. Mit dem Piloten sprechen, ihm klare und deutliche Anweisungen geben, das Motiv binnen Augenblicken auswählen. Aus dem Fluggerät gelehnt, versuche ich, die Leere und die Angst zu vergessen, die Kälte und die Hitze, das Vibrieren und den Wind, den Lärm und die Anspannung ... Das Ganze erfordert Übung: Es gilt, technische Probleme bei der Aufnahme vorauszuahnen, sich zu entspannen, damit man seine ganze Konzentration der Suche nach einer bemerkenswerten Bodentextur, einem Lichtspiel, einem grafischen Pflanzenmuster oder einem ungewöhnlichen Bild widmen kann.

Die auf diesen ersten Flügen entstandenen Bilder sind nicht perfekt, doch sie drücken das aus, was ich suche: die Rationalität der landwirtschaftlichen Arbeit, die mechanische und sich wiederholende Präzision der parallelen Linien auf einem natürlichen Untergrund mit natürlichen Farben. Die konstant gleiche Bildeinstellung wirkt nicht monoton, im Gegenteil, sie ermöglicht den Vergleich, unterstreicht Kontraste. Mehr als die Pflanzen interessieren mich die Spuren der landwirtschaftlichen Geräte im Boden, die Bestellung der Gemüsefelder, der geometrische Abdruck der Ackerwalze, die durchscheinende Decke des Saatguts. Die Ackerkulturen verändern sich von Woche zu Woche, die Lichtverhältnisse von Stunde zu Stunde.

Im Herbst 2003 stelle ich meine Arbeit Alice Pauli vor, einer renommierten Galeristen für zeitgenössische Kunst in Lausanne. In den 40 Jahren ihrer Tätigkeit hatte sie noch nie Fotografien ausgestellt, doch das wusste ich nicht. Ich breite vor ihr auf dem Boden einige große Abzüge aus, z.B. die Aufnahme mit den Maisstoppeln, die aus einer Schneedecke hervorragen. Sie betrachtet

work or travel assignments. On 10 July for example, I join an urgent convoy of two journalists flying from Valence to Mont Blanc. The weather deteriorates as we approach the mountains, but during the return journey, a ray of sunshine illuminates the walnut orchards of Saint-Marcellin, in the Isère Valley. A few short minutes to capture these characteristic crops.

For this book, I also decided to diversify the types of crops photographed. The Rhône Valley was perfect for this exercise: from rolling pastures at an altitude of over two thousand metres, I descend to the level of aromatic and medicinal plants, before reaching the vines and fruit trees. I leave the Rhône basin for a while in order to discover the black peat north of Lake Geneva, I observe the famous walnut trees of Grenoble, the orchards of the Valence plains, the seed production and experimental crops of the Drôme. I go to the carnation fields of Carpentras, fly over the cultivation plots of Avignon and the lower Durance. I cross the threshold of the Alpilles, view the vast olive groves of Baux-de-Provence, then glide to the paddyfields of the Camargue, and finally stop at the salterns and the oyster parks. Thus is the local geography, stretching from glacier to sea, endowed with an extraordinary agricultural diversity and in a state of constant change.

LYRICS OF THE LAND

Since the early stages of the preparation of this book, I proposed to accompany the images with direct accounts from those who, day by day, struggle with the reality of agriculture and production. I sought the contrast between the aerial views, abstract, distant, and the voice of the land, which is firm, engaged.

After the flights, I take the photographs, without making appointments, in search of the farmers and others able to help me better understand my images. I ask them to comment upon the photos and to explain to me the development of their activity to me. A breeder in the Swiss canton of Valais, a labourer pruning the vines in the Vaud canton or the department of Vaucluse in France, a soup manufacturer grain-drilling his field in the Drôme, a farmer transplanting his leek seedlings into the peat of Fribourg, a whole team harvesting cauliflowers in Tarascon, an olive producer near Baux-en-Provence... But also the director of the saltworks of the Midi or an agronomic research station, an advisor specialising in aromatic plants or in melon packaging.

First of all the crops that have been photographed must be precisely identified. The opinions vary: is it maize or sorghum? For certain crops, only the person who did the planting is able to explain the image! Lacking precise geographic coordinates for each photograph, I locate myself with the flight logs, yet sometimes the enigma persists.

I am received with patience and kindness. All give their opinions, agreeing to converse for a few moments or a few hours. Many air their opinions on today's agriculture or their fears for the future. These men and

die Bilder aufmerksam und fragt mich: „Mit welcher Technik arbeiten Sie?" Ich antworte ihr, dass es sich um Fotografien handelt.

Im Januar 2004 organisiert sie eine Ausstellung mit etwa 30 meiner Fotos. Zu dieser Zeit stellt eine Freundin für mich einen Kontakt mit einem Verlag her. Bald steht die Entscheidung fest: Es wird ein Buch geben. Ich beschließe, wieder bei Null anzufangen. Alle Fotos für dieses Buch entstehen zwischen März 2004 und Februar 2005 bei insgesamt 25 Flügen. So häufig wie möglich arbeite ich von zweisitzigen Hubschraubern aus, gelegentlich bin ich auch bei Arbeits- oder Transportflügen dabei. So zum Beispiel auch am 10. Juli, als ich die Gelegenheit habe, zwei Fernsehjournalisten auf einem Flug von Valence zum Montblanc zu begleiten. Beim Anflug auf die Berge verschlechtert sich das Wetter, doch auf dem Rückflug fällt ein Sonnenstrahl auf die Walnussplantagen von Saint-Marcellin im Isère-Tal. Ich habe nur wenige Minuten Zeit, diese charakteristischen Pflanzenkulturen festzuhalten.

Ich beschließe, das Spektrum der fotografierten Kulturen auszuweiten. Das Rhône-Tal eignet sich für ein solches Vorhaben ganz ausgezeichnet: Von den Weideflächen des Wallis auf mehr als 2000 Meter Höhe begebe ich mich auf die Ebene der Anbaugebiete für Aroma- und Arzneipflanzen und dann hinab in die Ebene zu den Weinbergen und Obstbäumen. Ich entferne mich ein wenig vom Rhône-Becken und wende mich den schwarzen Torfböden nördlich des Genfer Sees zu, entdecke die berühmten Walnüsse aus dem Umland von Grenoble, die Obstgärten in der Ebene von Valence, die Saatgutproduktion und die Versuchskulturen in der Drôme. Ich nähere mich den Nelkenplantagen von Carpentras, überfliege die Gemüsefelder von Avignon und in der Basse Durance, überquere die Alpillen, nehme die großen Olivenplantagen von Baux-de-Provence ins Visier, wende mich den Reisfeldern der Camargue zu und beschließe meine Reise mit einem Blick auf die Salzgärten und Austernbänke. So präsentiert sich die Landschaft zwischen Gletscher und Meer, die geprägt ist von einer sich beständig verändernden landwirtschaftlichen Vielfalt.

SPRACHE DER ERDE

Bereits bei den ersten Vorbereitungen zu diesem Buch denke ich daran, den Fotografien Äußerungen der Menschen gegenüberzustellen, die der harten Arbeit in der Landwirtschaft nachgehen. Der Kontrast zwischen dem abstrakten, losgelösten Blick aus der Luft und der konkreten, wirklichkeitsnahen Sprache der arbeitenden Menschen scheint mir reizvoll.

Nach den Flügen mache ich mich ohne Terminabsprache mit meinen Abzügen auf den Weg zu den Landwirten und all denen, die mir helfen können, meine Bilder besser zu verstehen. Ich bitte sie, die Fotos zu kommentieren und mir etwas über die Entwicklung ihrer Arbeit zu erzählen. So treffe ich auf einen Züchter im Valais, einen Arbeiter, der im Wallis oder im Vaucluse Reben beschneidet, einen Gemüsesamenproduzenten, der sein Feld in der Drôme einsät, einen Gemüsebauer, der in Freiburg maschinell seine Lauchpflanzen pikiert, eine Gruppe von Arbeitern, die in Tarascon Blumenkohl erntet, eine Olivenproduzentin aus der Nähe von Baux-de-Provence, aber auch den Direktor des Salzwerkes Salins du Midi und den Leiter einer landwirtschaftlichen

women teach me, impress me with their professionalism, changing in the process the way I look at my own images.

The identification of the photograph reproduced on page 117 required many hours of investigation on the ground. I remember taking the photo on the peaks of the Luberon range in southern France. First indications were that it was a young chestnut plantation, which some farmers had recently introduced to diversify their production. Yet the Luberon is a limestone mountain, and the chestnut tree grows poorly here. The arboriculturists, pruning their lines of fruit trees on the Durance plain, direct me towards the northern flank of the Luberon, where I finally find the square tree plantations I was looking for. They are cherry trees! Further towards Lacoste, the colour of the earth and form of the trees look increasingly like the image I hold in my hands. The owner of a holiday home directs me towards the Mallan farm, where I find the cherry producers. They give me a warm welcome. Joël Adrien invites me in, to meet his brother Georges, because "he is better for that sort of thing". Georges takes over two hours to explain his work and his perception of things to me. As he explains the mechanised harvest of the white cherries, it is as a regret, and I have the feeling this is because he can do it no other way. An efficient cherry-picker like him, does not easily hand over his work to a machine. Luckily, he appears to say, red cherries must still be picked by hand. He talks also of the enormous real-estate pressure, which he intends to resist. Sell? Do something else? No more worries? No. Life would no longer have the same meaning. The link with the parents and their ancestors on this domain would be ruptured. The two brothers are firmly anchored in their past. I leave this meeting touched.

Roland and Willy Stoll are also brothers; they are the largest market gardeners in Switzerland. Since their recent purchase of land, they own a large part of the Orbe plain in the Vaud canton. They employ one hundred and twenty people and plan the construction of giant greenhouses. Roland Stoll is one of the few farmers with whom I arranged a meeting. He takes an hour to explain the situation and comment on a few images. We are in a glazed and soundproof meeting-room, which overlooks a vegetable preparation, cleaning, wrapping and loading line. Scores of people work in impeccable hygienic conditions. The words of the boss are calm, precise, concise, focused. While remaining modest and enthusiastic, Roland Stoll has a systematic approach to the future: greenhouses to be built, efficiency to improve, machines to perfect, energy to be saved, standards to be respected, markets to seize... Farming also comprises big business.

THE HAND OF MAN

Neither my route nor the meetings undertaken for this book, explain the reason for this initiative. The landscape is dynamic, it changes in time with human activity, and the images in this book demonstrate,

Forschungsstation, eine Spezialistin für Aromapflanzen und eine Fachfrau für die Verpackung von Melonen.

Zunächst geht es darum, die fotografierten Kulturen genau zu identifizieren. Dabei herrscht nicht immer Einigkeit: Ist das Mais oder Sorghum? Bei einigen Kulturen kann tatsächlich nur derjenige, der das Land bestellt, das Bild erklären! Da ich keine genauen geographischen Koordinaten für jedes einzelne Bild habe, orientiere ich mich am zeitlichen Ablauf der Flüge, doch gelegentlich bleiben auch Fragen ungeklärt.

Man begegnet mir stets mit Geduld und Freundlichkeit. Jeder ist bereit, mir etwas von seiner Zeit zu opfern, die Neugier und das Interesse an den Bildern sind groß. Alle äußern ihre Meinung, diskutieren ein paar Minuten oder auch einige Stunden lang mit mir ... Viele erzählen mir, wie sie die Landwirtschaft heute sehen, und reden über ihre Zukunftsängste. Ich lerne von diesen Männern und Frauen, sie beeindrucken mich durch ihre Professionalität, verändern meinen Blick auf meine eigenen Bilder.

Die Bestimmung des Bildes von S. 117 machte mehrere Stunden Recherche am Boden notwendig. Ich konnte mich erinnern, die Aufnahme irgendwo über den Höhen des Luberon gemacht zu haben. Zunächst hatte man mich nach der Betrachtung des Bildes zu einer jungen Kastanienpflanzung geschickt, mit der einige Landwirte seit kurzem versuchten, ihre Produktpalette zu erweitern. Doch der Luberon ist ein Kalksteingebirge – ein Untergrund, auf dem Kastanien kaum gedeihen. Die Obstgärtner, die mit dem Beschneiden ihrer Obstbäume in der Durance-Ebene beschäftigt sind, verweisen mich nach und nach in Richtung Nordseite des Luberon, wo ich schließlich die quadratisch angelegten Baumpflanzungen finde, die ich suche. Es sind Kirschbäume! In Richtung Lacoste ähneln der Farbton der Erde und die Form der Bäume mehr und mehr meinem Bild. Ein Ferienhausbesitzer schließlich berichtet mir von der Ferme des Mallans, wo Kirschen angebaut werden. Dort werde ich sehr freundlich empfangen. Joël Adrian bittet mich herein, damit ich mit seinem Bruder Georges spreche, „der so was besser kann". Georges nimmt sich zwei Stunden Zeit, um mir seine Arbeit und seine Sicht der Dinge zu erklären. Als er mir erzählt, dass die Weißkirschen heute mit der Maschine geerntet werden, klingt ein Anflug von Bedauern mit. Ich glaube, das liegt daran, dass es einfach nicht mehr anders geht. Ein so guter Kirschenpflücker wie er überlässt seine Arbeit ungern einer Maschine. Ich habe den Eindruck, dass er froh ist, dass die Schwarzkirschen noch von Hand geerntet werden müssen. Er berichtet mir außerdem von der enormen Belastung durch die Grundsteuer, der er jedoch standzuhalten entschlossen ist. Verkaufen? Etwas anderes machen? Keine Sorgen mehr haben? Nein. Das Leben hätte dann nicht mehr den gleichen Sinn. Das Band, das ihn mit seinen Eltern und allen Vorgängern auf diesem Hof verbindet, wäre damit durchtrennt. Die beiden Brüder sind tief in ihrer Vergangenheit verwurzelt. Ich bin durch dieses Treffen sehr bewegt.

Roland und Willy Stoll sind ebenfalls Brüder und die größten Gemüseproduzenten der Schweiz. Nach einigen Landrückkäufen in jüngster Zeit gehört ihnen inzwischen ein bedeutender Teil der Orbe-Ebene im Kanton Wallis. Sie beschäftigen 100 Angestellte und planen den Bau riesiger Gemüsetreibhäuser. Roland

from a particular angle, the mark left by man's work on the earth, the natural base for his activities. The chosen activity is specific: agriculture, which is in a state of accelerated change, at once ancient and at the forefront of progress.

The artificial mark and its natural base represent, for me, the essentials of a landscape. The plots photographed are like the 'basic cells' of the landscape; nature and crop superimposed. The comments and opinions thus participate fully in the meaning of the images.

Urbanisation advances rapidly, as too does nature. In Switzerland for example, only a tiny country in Europe, urban land grows at the rate of one square metre per second, and forest at a rate of half a square metre per second! Farmland gives up its most difficult areas to nature, and its best to towns. It is these, exploited rationally, which are generally represented by my photographs.

This book – a landscape architect's look at the work of farmers – will have achieved one of its primary objectives if it made a contribution to its readers' appreciation of modern farmland as valuable in its own right, as a useful part of the countryside, and not simply as land ripe for development or 'renaturalisation'.

OLIVIER LASSERRE
Lausanne, May 2005

Stoll ist einer der wenigen Landwirte, mit dem ich einen Termin vereinbart habe. Er nimmt sich eine Stunde Zeit, um mir seine Situation zu erklären und einige Bilder zu kommentieren. Wir sind in einem verglasten und schallgedämpften Sitzungsraum. Von dort aus kann man beobachten, wie das Gemüse auf einem Fließband sortiert, gewaschen, verpackt und verladen wird. Mehrere Dutzend Menschen arbeiten in einer vollkommen hygienischen Umgebung. Ihr Chef ist in seinen Äußerungen bedächtig, knapp und genau. Roland Stoll ist gleichzeitig bescheiden und überschwänglich, von der Zukunft hat er ein klares Bild: Treibhäuser bauen, Maschinen verbessern, rationalisieren, Energie sparen, Normen beachten, Märkte erschließen ... Auch in der Landwirtschaft gibt es große Unternehmer.

MENSCH UND LANDSCHAFT

Doch weder meine Vorgeschichte noch die Treffen, die am Anfang dieses Buches standen, können meinen Ansatz vollständig erklären. Landschaft ist dynamisch, sie verändert sich im Rhythmus des menschlichen Schaffens. Die Bilder dieses Buches zeigen unter einem bestimmten Blickwinkel, wie der Mensch die Erde, die natürliche Grundlage seiner Existenz mit seiner Arbeit prägt. Für meine Betrachtungen habe ich eine besondere Tätigkeit ausgewählt – die Landwirtschaft: Sie erlebt rasante Veränderungen und ist gleichzeitig jahrtausendalt.

Landschaft ist in meinen Augen geprägt durch den Eingriff des Menschen. Die Motive meiner Fotografien sind gewissermaßen die „Basiszellen" der Landschaft, Überlagerungen von Natur und Kultur. Die Kommentare und Äußerungen begleiten die Bilder.

Die Verstädterung schreitet mit großen Schritten voran, die Natur auch. In der Schweiz, diesem winzigen Stück Europa, gewinnt der städtische Raum in der Sekunde einen Quadratmeter an Boden, und der Wald einen halben! Der landwirtschaftliche Raum verliert seine unwirtlichsten Terrains an die Natur und seine besten an die Städte. In erster Linie sind diese letztgenannten, nach rationellen Gesichtspunkten erschlossenen Gebiete Gegenstand meiner Fotos. Dieses Buch zeigt den Blick eines Landschaftsarchitekten auf die Arbeit der Landwirte. Wenn es dazu beitragen kann, dass der moderne landwirtschaftliche Raum in seiner Gesamtheit als landschaftlicher Wert begriffen wird, und nicht als möglicher Baugrund oder Fläche mit „Renaturierungspotenzial", hat es eines seiner grundlegenden Ziele erreicht.

Olivier Lasserre
Lausanne im Mai 2005

HIGH PASTURE
Network of geometric lines of slope and level.
Croix de Coeur, Verbier, Valais canton, Switzerland; late July

"This calf and cattle pasture, situated at an altitude of over 2200m, is made up of horizontal lines of pasture, diagonal access tracks and vertical drainage lines.
One can also distinguish the clear limit between the pasture grasses (light green) and the still intact pasture (dark green), due to the fence line that is moved every day up until mid-August. The land is so steep that our grandparents dug 'niches' in order to allow the cattle to rest. These rest areas are sometimes still visible."

ARMEL PERRION, farmer, Liddes, Valais canton, Switzerland

HOCHWEIDE
Geometrisches Netz aus Höhen- und Falllinien.
Croix de Cœur, Verbier, Kanton Wallis, Schweiz, Ende Juli.

„Auf dieser Alm auf mehr als 2200 m Höhe weiden Kühe mit ihren Kälbern. In der Horizontalen erkennt man die Weideabschnitte, in der Vertikalen kleine Wasserläufe. Die diagonalen Linien sind Zugangswege.
Außerdem sieht man eine deutliche Grenze zwischen den abgegrasten Weiden (hellgrün) und den noch unberührten Weideflächen (dunkelgrün), was daran liegt, dass die Einfriedungen bis Mitte August täglich versetzt werden.
Das Gelände ist so steil, dass unsere Großeltern ‚Nischen' angelegt haben, wo die Kühe sich ausruhen können. Diese Ruheplätze kann man teilweise noch erkennen."

ARMEL PERRION, Landwirt, Liddes, Kanton Wallis, Schweiz.

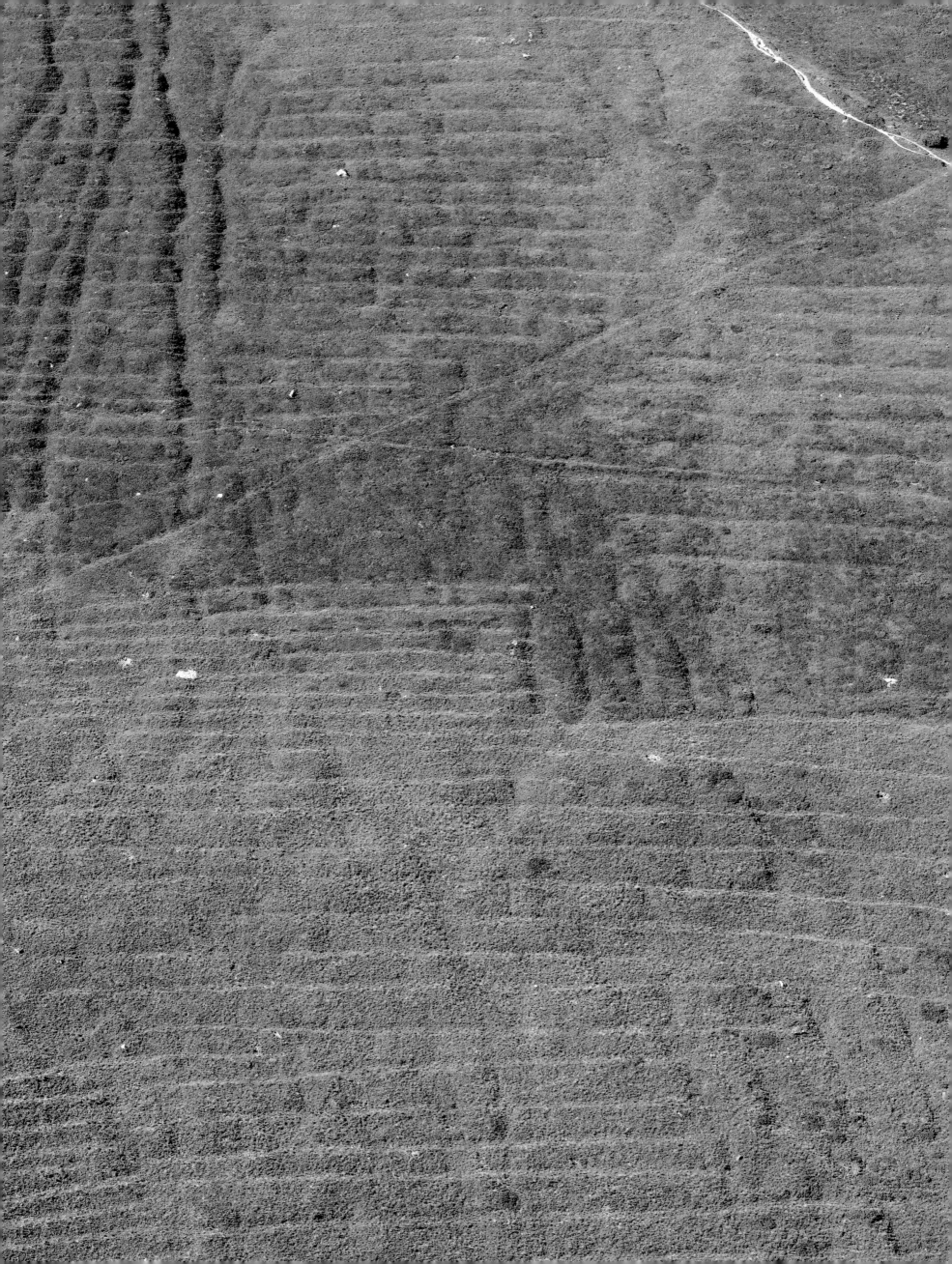

**VEGETABLE POLYTUNNELS
UNDER CONSTRUCTION**
Steel arches and their shadows,
construction under way, recently levelled
ground between the tunnels
Mallemort, Durance Valley, Bouches-du-
Rhône, France; late March

"These small, cheap polytunnels are
generally assembled by the farmer
himself..."

PIERRE VILLIN, Richel Serres de France, Eygalières,
Bouches-du-Rhône, France

**IM BAU BEFINDLICHE FOLIENTUNNEL
FÜR DEN GEMÜSEANBAU**
Stahlkonstruktion mit Schattenspiel. Im
Bau befindlich. Der Boden ist zwischen
den Tunneln frisch eingeebnet.
Mallemort, Durance-Tal, Bouches-du-
Rhône, Frankreich, Ende März.

„Diese preiswerten kleinen Folientunnel
werden im Allgemeinen vom Landwirt
selbst aufgestellt ..."

PIERRE VILLIN, Richel Serres de France, Eygalières,
Bouches-du-Rhône, Frankreich.

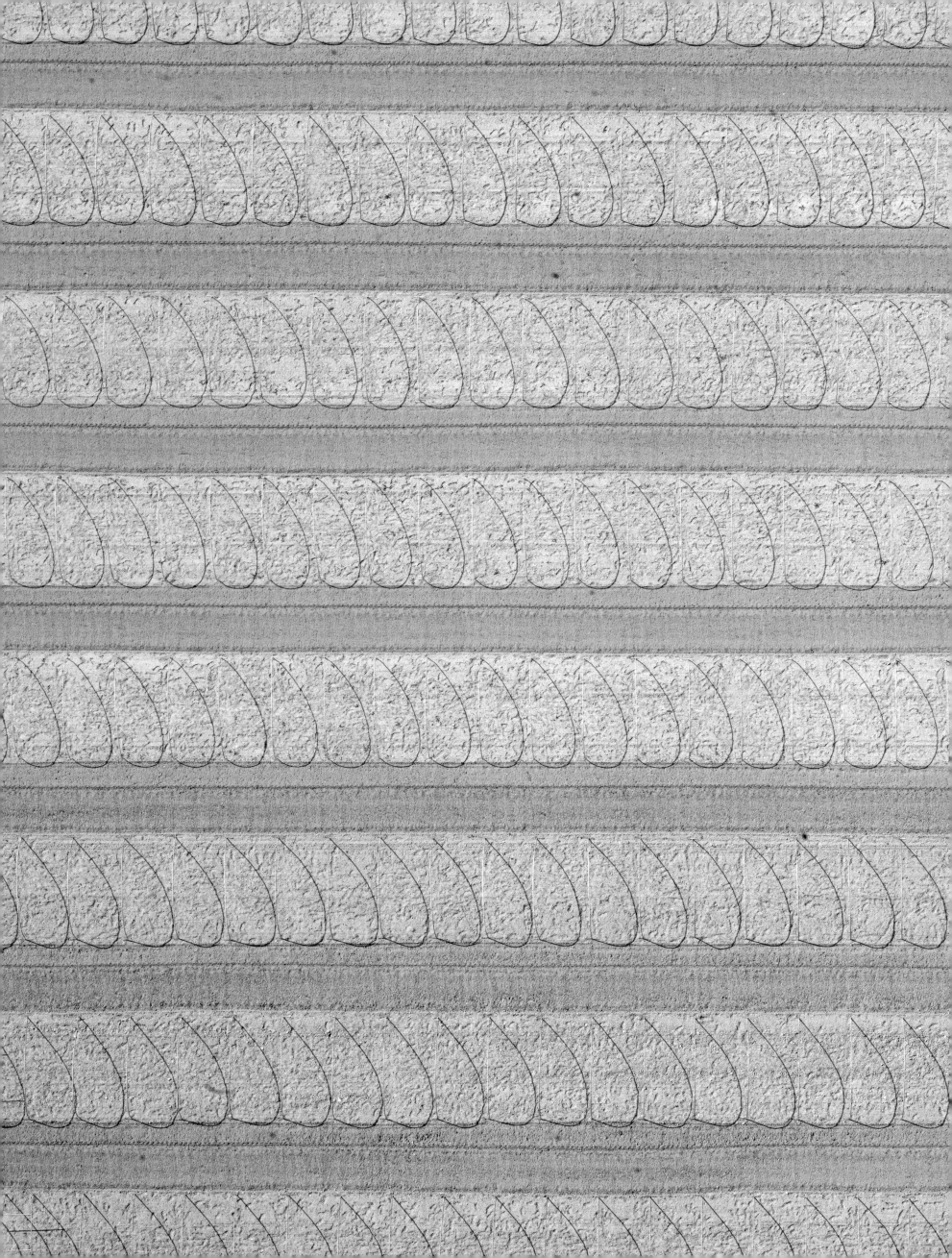

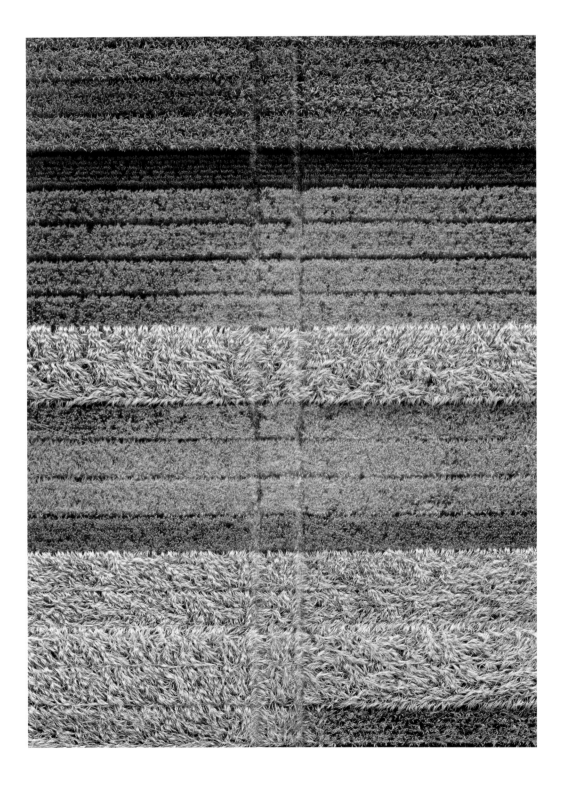

◁ **WHEAT AND BARLEY**
Crop for seed quality control, high-voltage power lines.
La Bâtie-Rolland, Drôme, France; June

"Industrial technique, faultless traceability, separation of varieties, the work of a seed selector is highly precise..."

JEAN-CLAUDE GRENIER, agronomist, Top Semence, La Bâtie-Rolland, Drôme, France

HARVESTED WHEAT AND HAY BALES ▷
Montvendre, Drôme, France; late July

"I prefer round bales."

GÉRARD VIGNARD, farmer, Montmeyran, Drôme, France

◁ **WEIZEN UND GERSTE**
Anbau zur Qualitätskontrolle des Saatguts.
Hochspannungsleitung.
La Bâtie-Rolland, Drôme, Frankreich, Juni.

„Industrielle Technik, einwandfreie Herkunft, Sortentrennung: Die Saatgutkontrolle erfordert äußerste Genauigkeit ..."

JEAN-CLAUDE GRENIER, Agraringenieur, Top semence, La Bâtie-Rolland, Drôme, Frankreich.

ABGEERNTETES WEIZENFELD UND STROHBALLEN ▷
Montvendre, Drôme, Frankreich, Ende Juli.

„Ich bevorzuge die runden Ballen."

GÉRARD VIGNARD, Landwirt, Montmeyran, Drôme, Frankreich.

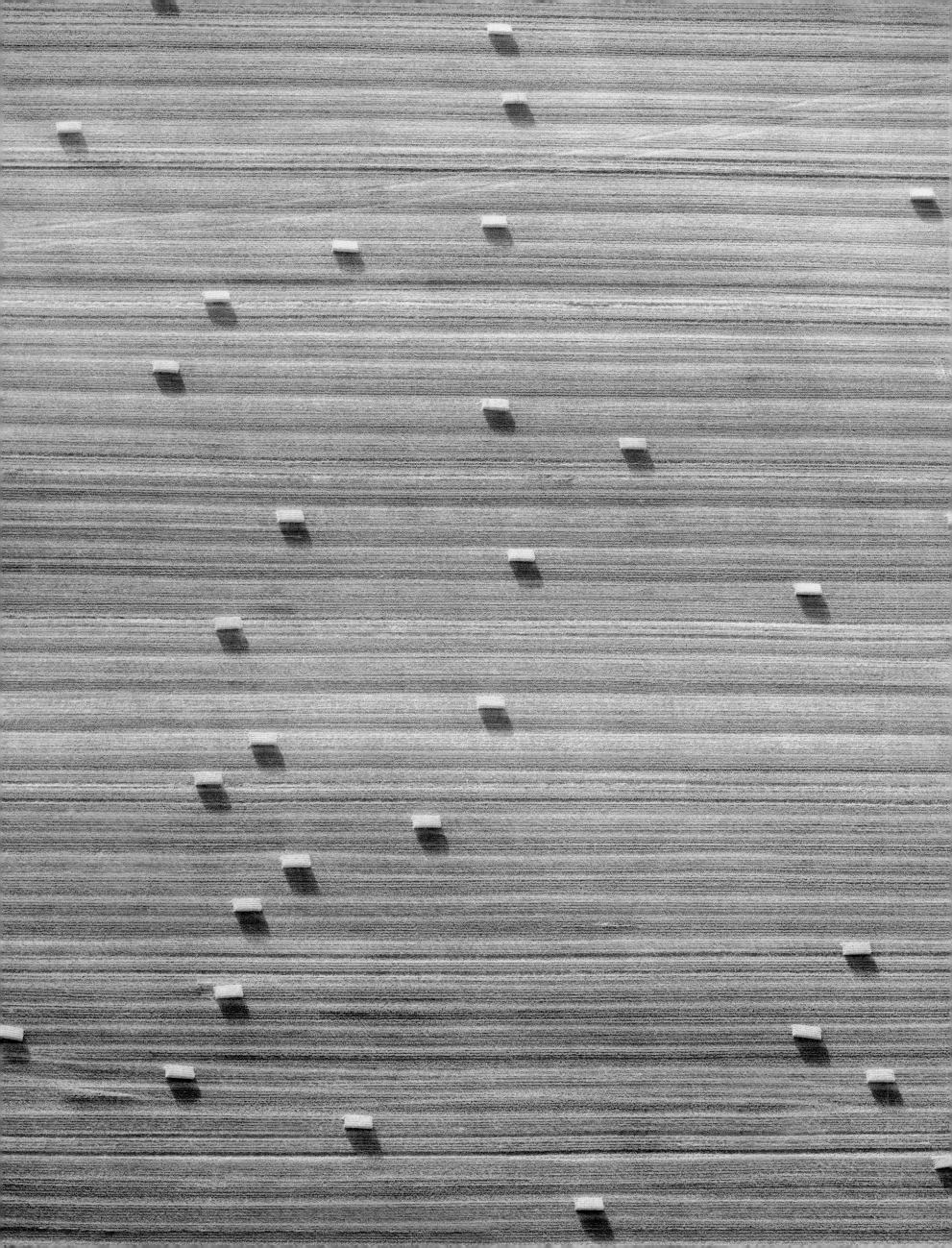

SWEET WILLIAMS
Crop of seed bearers for seedling
production.
Velleron, Vaucluse, France; early June

"Tourists come to take pictures of their
family in front of the flowering fields."

Bruno Doche, farmer, Velleron, Vaucluse, France

BARTNELKEN
Samenträgerkultur zur Saatgutproduktion.
Velleron, Vaucluse, Frankreich, Anfang Juni.

„Die Touristen machen hier
Familienfotos vor den blühenden
Feldern."

Bruno Doche, Landwirt, Velleron, Vaucluse,
Frankreich.

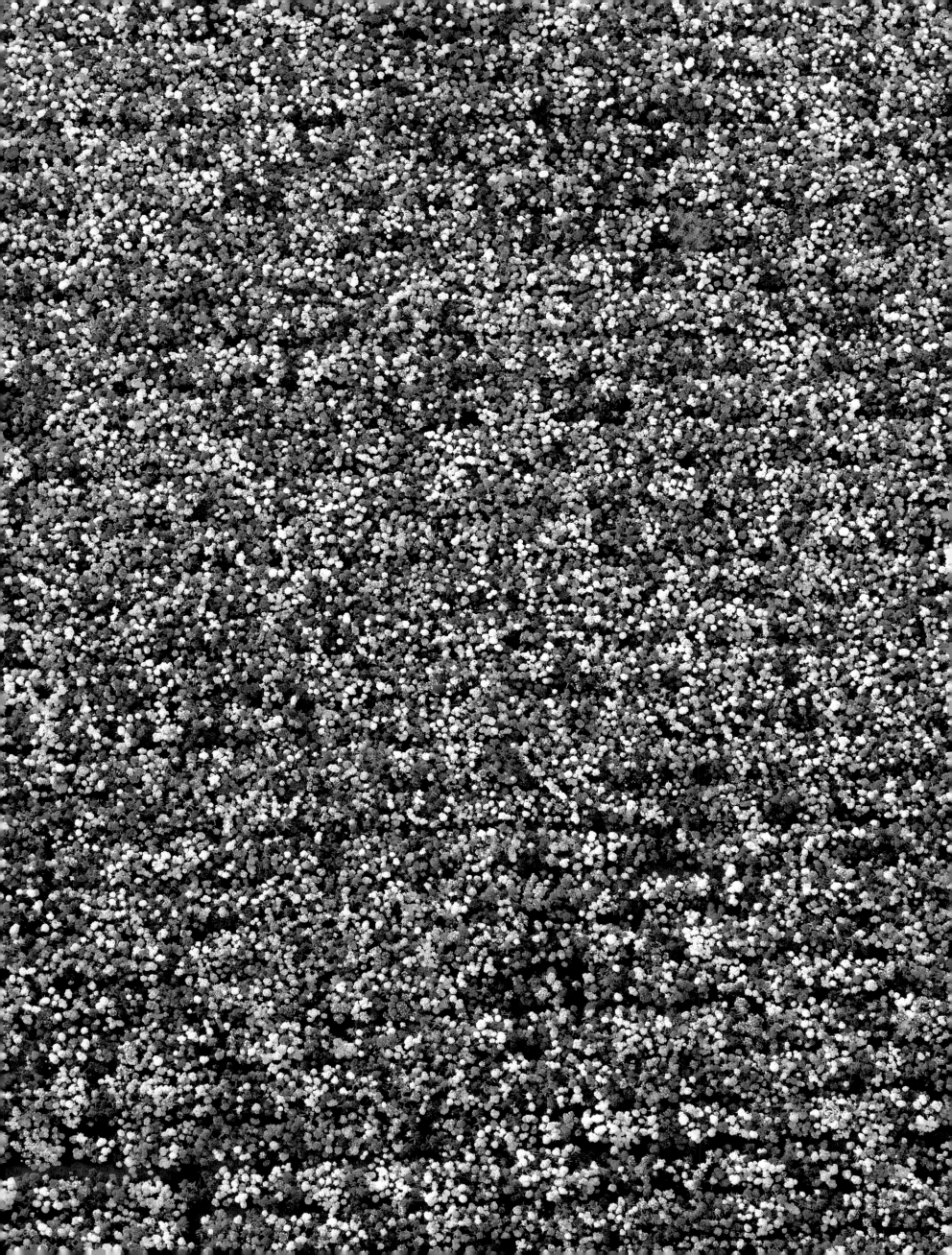

OLIVE GROVES
Plantation of young trees, six or seven
years old, on bare earth worked into
mounds and irrigation channels.
Plaine de la Crau, Bouches-du-Rhône,
France; July

"The 'appellation d'origine contrôlée'
is more than a georgraphical limit.
It also contains precise conditions of
production and processing. For example,
each olive tree must have at least
20 square metres of space."

M'HAMED BENNINA, wine and olive grower,
Le Mas de la Dame, les Baux-de-Provence,
Bouches-du-Rhône, France

OLIVENPLANTAGE
Pflanzung von jungen, sechs oder sieben
Jahre alten Bäumen und nackter Boden,
zu Wällen aufgeschüttet und von
Bewässerungsgräben durchzogen.
Crau-Ebene, Bouches-du-Rhône,
Frankreich, Juli.

„Die Herkunftsbezeichnung Appellation
d'origine contrôlée grenzt nicht nur das
Herkunftsgebiet ein: Bei der Produktion
und Verarbeitung gilt es, ein genaues
Pflichtenheft zu beachten. So muss
jeder Olivenbaum mindestens 20 m²
Platz haben."

M'HAMED BENNINA, Winzer und Olivenbauer,
Le Mas de la Dame, Les Baux-de-Provence,
Bouches-du-Rhône, Frankreich.

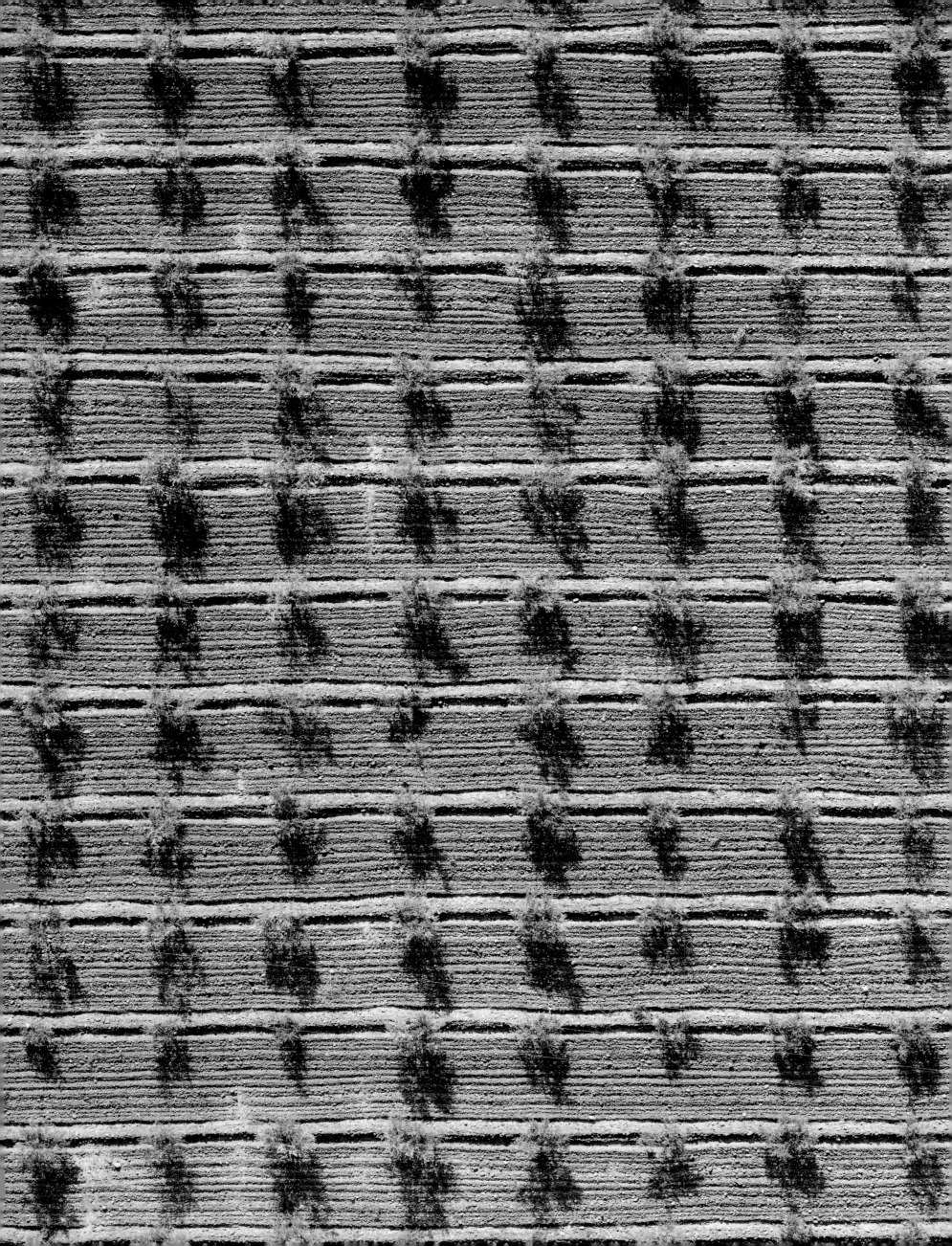

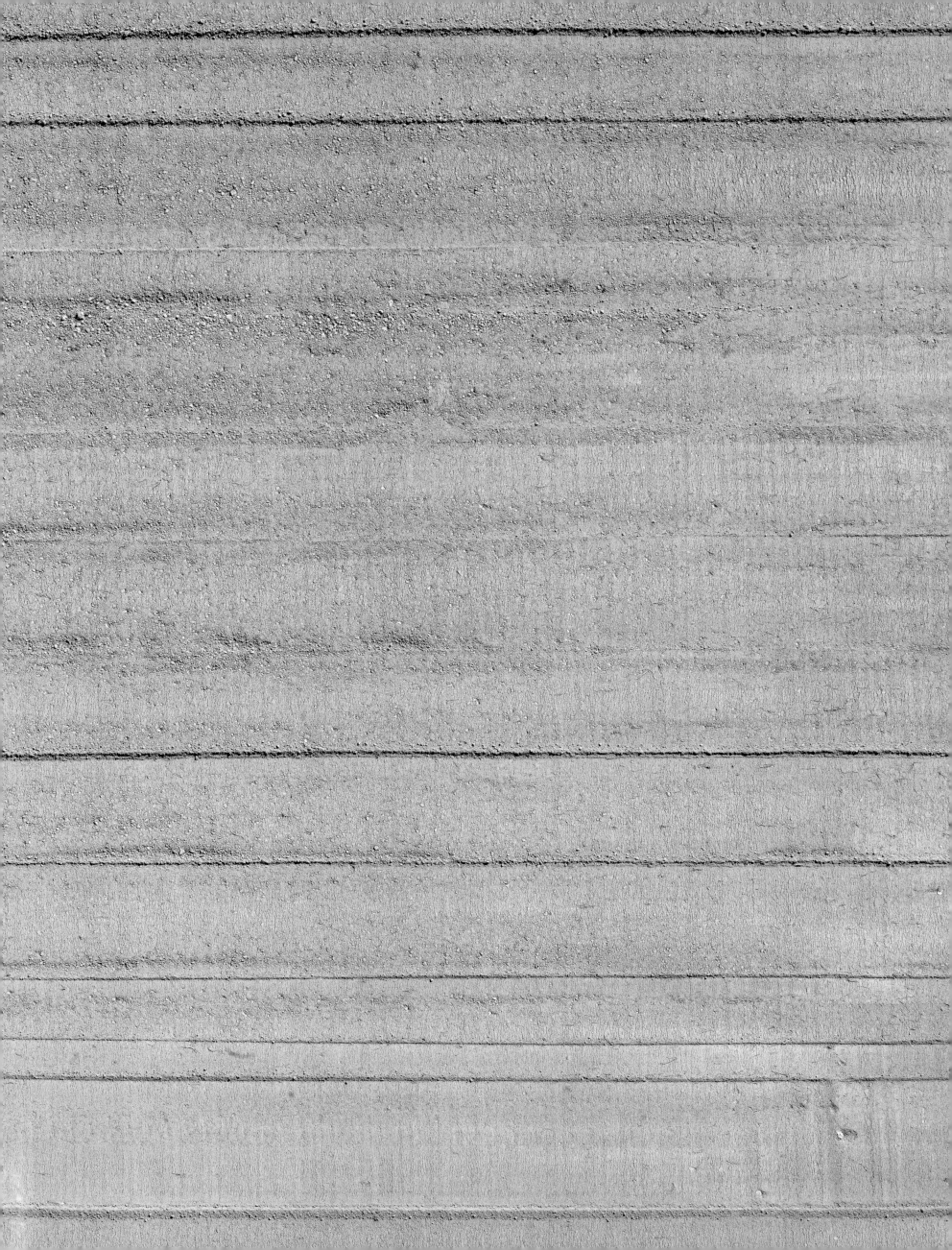

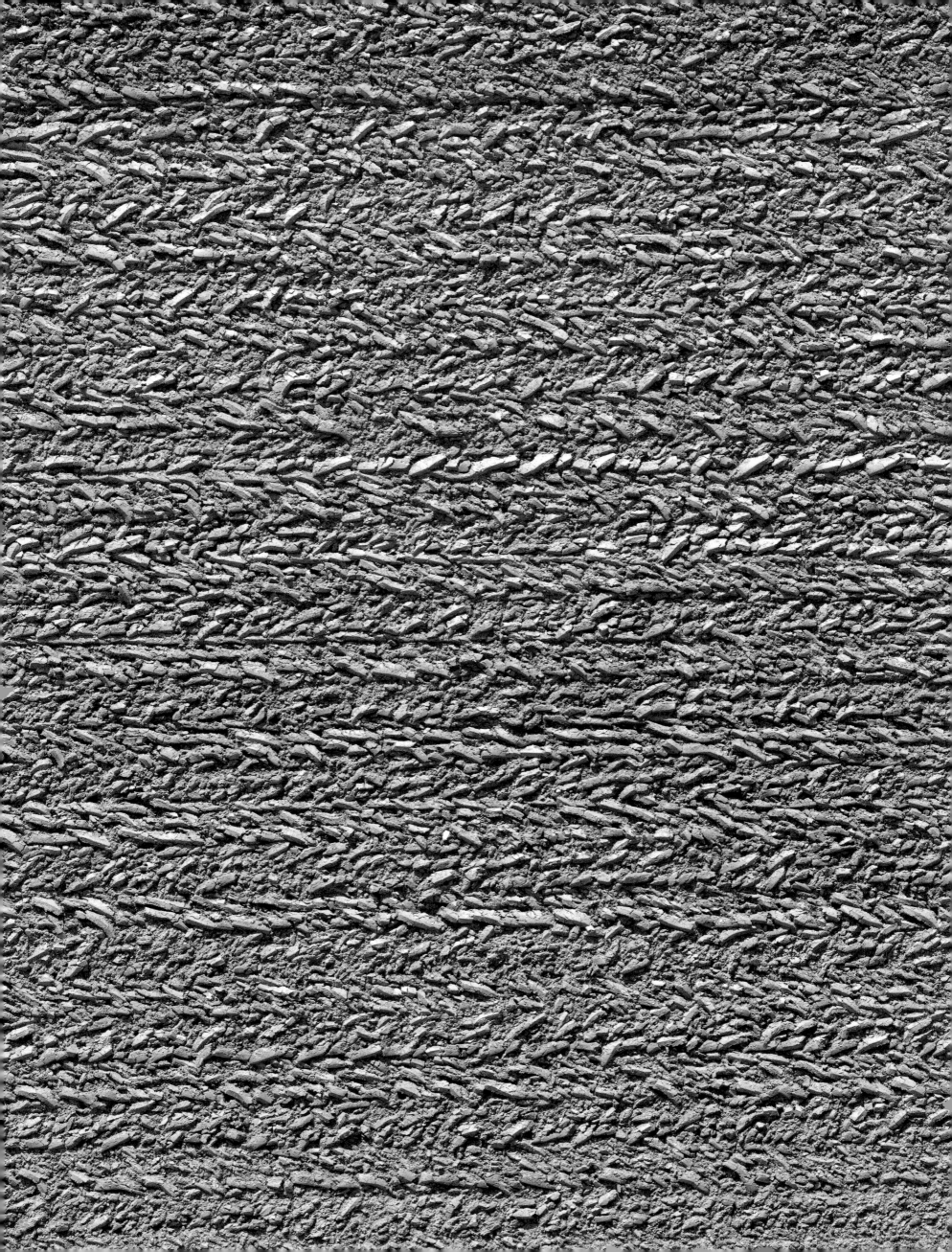

PAGE 20
HARROWED AND ROLLED LAND
The land is prepared for a crop of
vegetables by harrowing and rolling.
Lower Durance Valley, Vaucluse, France;
late March

SEITE 20
GEPFLÜGTER UND GEWALZTER ACKER
Vorbereitung des Bodens für eine
Gemüsekultur mit Egge und Ackerwalze.
Unteres Durance-Tal, Vaucluse, Frankreich,
Ende März.

PAGE 21
PLOUGHED LAND
Soil that has been recently ploughed.
Noville, Vaud canton, Switzerland; March

"I am a fan of the firm John Deere, the
worldwide number one manufacturer of
farming equipment. Its founder invented
the polished steel plough in 1837,
which allowed the cultivation of the
large prairies of the Mid-West of the USA.
The rich soil could no longer stick to the
blade, as it did on older cast-iron
ploughs. It was a commercial success
and a step forward for mankind."

JEAN-CHARLES REIHLE, farmer, Domaine de la
Grande-Île, Les Barges, Vouvry, Valais canton,
Switzerland

SEITE 21
GEPFLÜGTER ACKER
Kürzlich gepflügt.
Noville, Kanton Waadt, Schweiz, März.

„Ich bin begeisterter Anhänger der Firma
John Deere, dem weltweit führenden
Hersteller von Landmaschinen. Ihr
Gründer hat 1837 den Pflug aus
poliertem Stahl erfunden, mit dem man
die weiten Grassteppen im Mittleren
Westen der USA kultivieren konnte. Der
fette Boden blieb nicht mehr am
Streichblech kleben wie bei den alten
gusseisernen Pflügen. Das Gerät war ein
großer kommerzieller Erfolg und ein
Fortschritt für die Menschheit."

JEAN-CHARLES REIHLE, Landwirt, Domaine de la
Grande-Île, Les Barges, Vouvry, Kanton Wallis,
Schweiz.

SALAD, CABBAGES, ONIONS
The weeds that can be seen among the
cabbages are the only visible sign of
organic farming.
Galmiz, Fribourg canton, Switzerland;
late June

"This is without a doubt an organic crop,
where weeding is limited to manual or
mechanic methods, as weedkillers are
forbidden. Our company, created in
1948, distributes organic vegetables.
We benefited from a strong increase
in sales of organic produce between
1994 and 2004. It appears that the
demand is now in the process of
stabilising around the ten per cent of the
population mark."

ERNST MAEDER, director of Bio-Gemüse, Galmiz,
Fribourg canton, Switzerland

SALAT, KOHL, ZWIEBELN
Das Unkraut zwischen den Kohlköpfen ist
der einzig sichtbare Hinweis darauf, dass
es sich um eine Bio-Kultur handelt.
Galmiz, Kanton Freiburg, Schweiz, Ende Juni.

„Hier handelt es sich um eine Biokultur,
wo das Unkraut nur von Hand oder
mechanisch gejätet werden darf.
Unkrautvernichtungsmittel sind nicht
erlaubt. Unser Unternehmen wurde 1948
gegründet und vertreibt Biogemüse.
Zwischen 1994 und 2004 ist es stark
gewachsen. Ich habe den Eindruck,
dass sich der Anteil der Bevölkerung,
der Bioprodukte nachfragt, bei 10%
stabilisieren wird."

ERNST MAEDER, Geschäftsführer von Bio-Gemüse,
Galmiz, Kanton Freiburg, Schweiz.

**APRICOT ORCHARD
ON BARE GROUND**

La Roque-d'Anthéron, Bouches-du-Rhône,
France; late March

"Fruit and vegetables are graded
according to size, one of the quality
controls. For the client, it makes
selection easier and more reliable.
It also guarantees uniform ripening."

Oʟɪᴠɪᴇʀ Pᴏᴛᴛᴇʀᴀᴛ, member of the board of Migros
Vaud, Ecublens, Vaud canton, Switzerland

**APRIKOSENPLANTAGE
AUF NACKTEM BODEN**

La Roque-d'Anthéron, Bouches-du-Rhône,
Frankreich, Ende März.

„Die Größe von Früchten und Gemüse ist
ein Qualitätsmerkmal bei der Einteilung
in Güteklassen. Das erleichtert den
Kunden die Auswahl und schafft
Vertrauen. Außerdem ist so ein
gleichmäßiger Reifegrad gewährleistet."

Oʟɪᴠɪᴇʀ Pᴏᴛᴛᴇʀᴀᴛ, Vorstandsmitglied Migros Waadt,
Eclubens, Kanton Waadt, Schweiz.

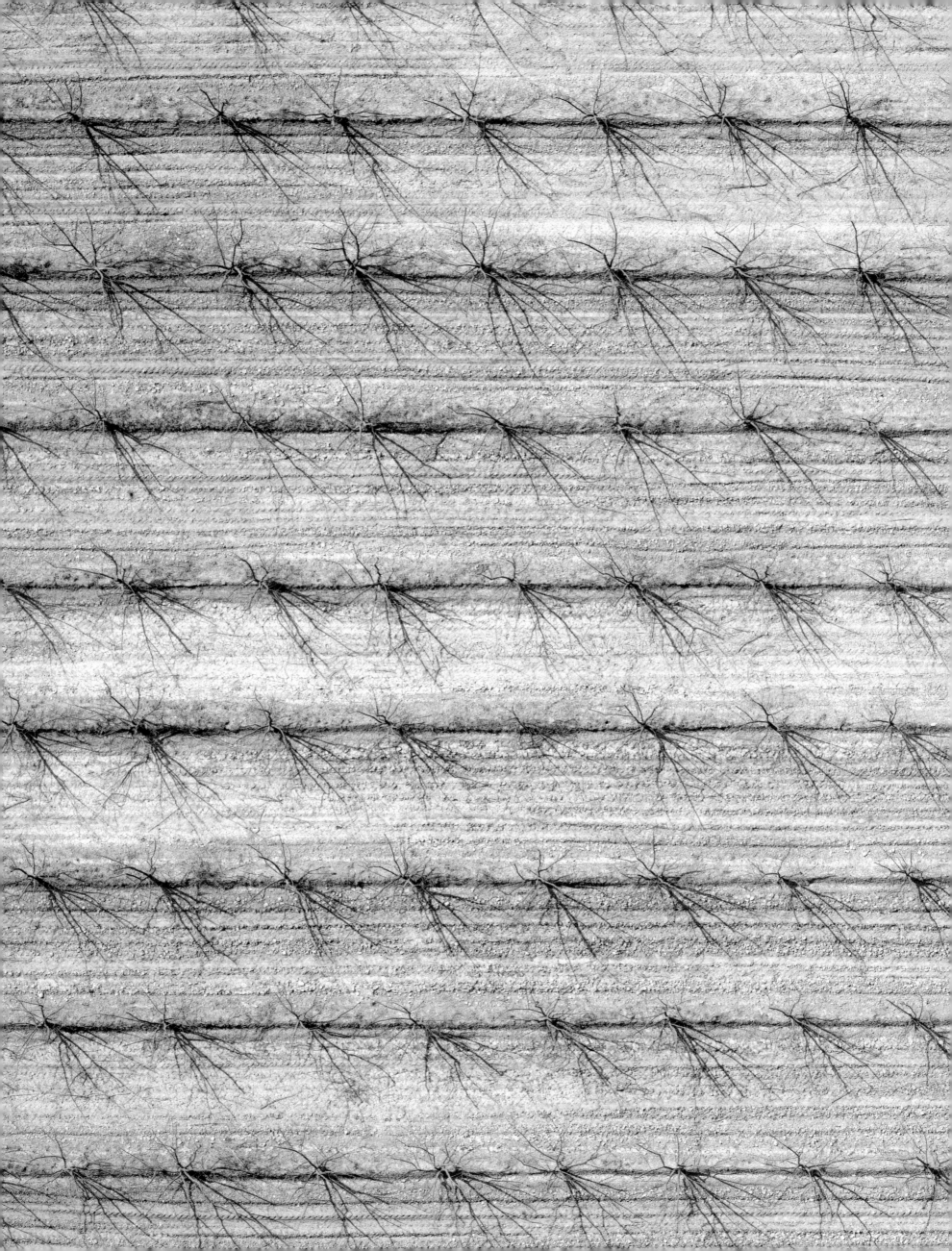

VINES ▷
Terraced plots, goblet-pruned.
Ollon, Vaud canton, Switzerland; March

◁ VINES
Wire-supported crop, ground is stony after flooding.
Chamoson, Valais canton, Switzerland;
November

"These vines (right), pruned into the traditional goblet shape on poorly accessible terraces, requires eight hundred hours of work per hectare. A wire-supported and mechanised vinyard (left) requires eight to ten times less time. And on top of this, we are constantly reducing the quantity in order to maintain the quality. The price of our wine is thus high, yet we offer our landscape and our way of life as a bonus in every bottle! Yes, I think we will be able to face the competition."

THIERRY ANET, winegrower and labourer, Aigle,
Vaud canton, Switzerland

WEINBERG ▷
Terrassierte Parzelle. Gobeleterziehung.
Ollon, Kanton Waadt, Schweiz, März.

◁ **WEINBERG**
Drahterziehung. Steiniger Boden,
angeschwemmt von einem Wildbach.
Chamoson, Kanton Wallis, Schweiz,
November.

„Die Bestellung dieses Weinbergs
(rechts), der in Gobeleterziehung auf
schwer zugänglichen Terrassen angelegt
ist, erfordert 800 Arbeitsstunden pro
Hektar. Für die Bearbeitung eines
Weinbergs in Drahterziehung (wie links)
benötigt man mithilfe von Maschinen
acht- bis zehnmal weniger Zeit.
Außerdem verzichten wir zugunsten der
Qualität immer mehr auf Quantität.
Darum ist unser Wein auch ein bisschen
teurer, aber in jeder Flasche steckt auch
ein Stück unserer Landschaft, unserer
Art zu leben. Doch, ich glaube, damit
können wir gegen die Konkurrenz
bestehen."

THIERRY ANET, Winzer und Kleinunternehmer, Aigle,
Kanton Waadt, Schweiz.

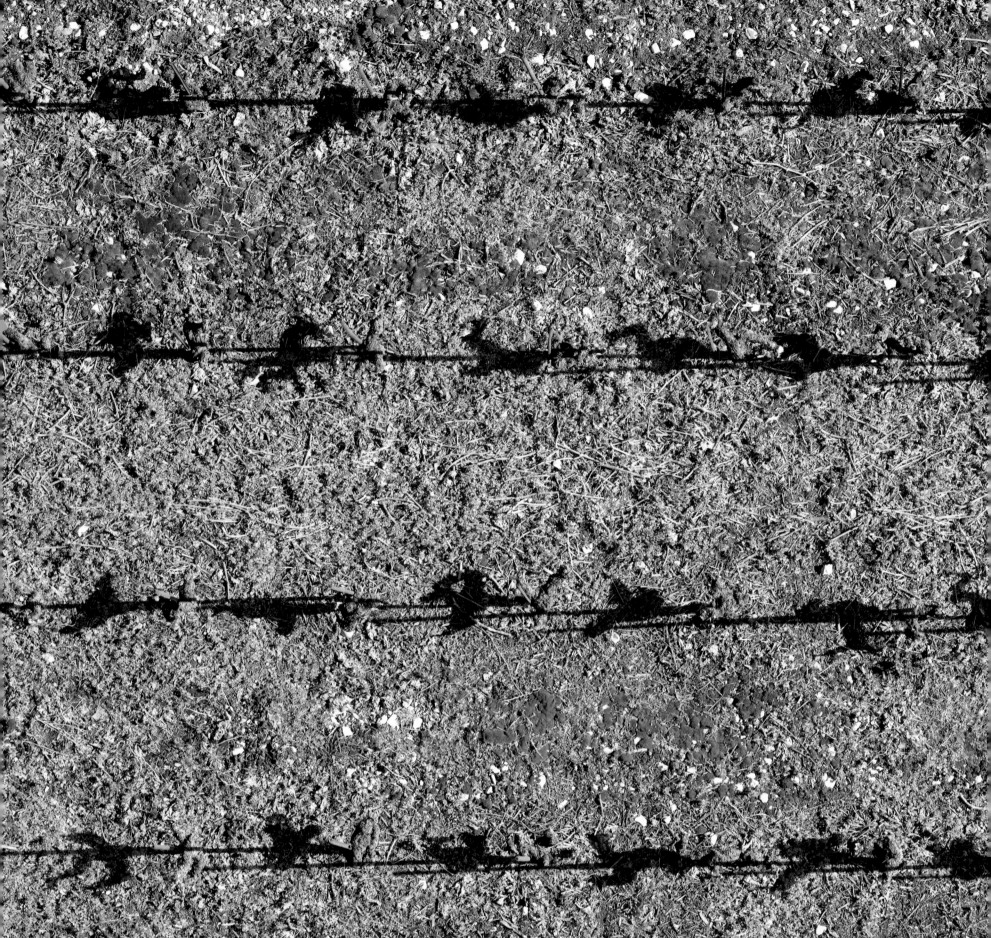

BARLEY, EXPERIMENTAL CROP
Domaine des Barges, Vouvry, Valais
canton, Switzerland; March

"In order to create a chequerboard of
experimental micro-plots, we treat the
separating strips, which are starting to
yellow, with herbicide. The lower part of
the image shows an area where we
broke off the test because the barley
had been weakened by an excess of
humidity."

Dr Daniele Fuog, biologist, Vouvry, Valais canton,
Switzerland

GERSTE, VERSUCHSKULTUR
Domaine des Barges, Vouvry, Kanton
Wallis, Schweiz, März.

„Wir behandeln die Ränder der kleinen,
gitterförmig angelegten
Versuchsparzellen, die hier gelb zu
werden beginnen, mit Herbiziden. Auf
den Parzellen am unteren Bildrand
haben wir den Versuch abgebrochen,
weil die Gerste zu viel Feuchtigkeit
abbekommen hatte und dadurch
geschwächt war."

Dr. Daniele Fuog, Biologe, Vouvry, Kanton Wallis,
Schweiz.

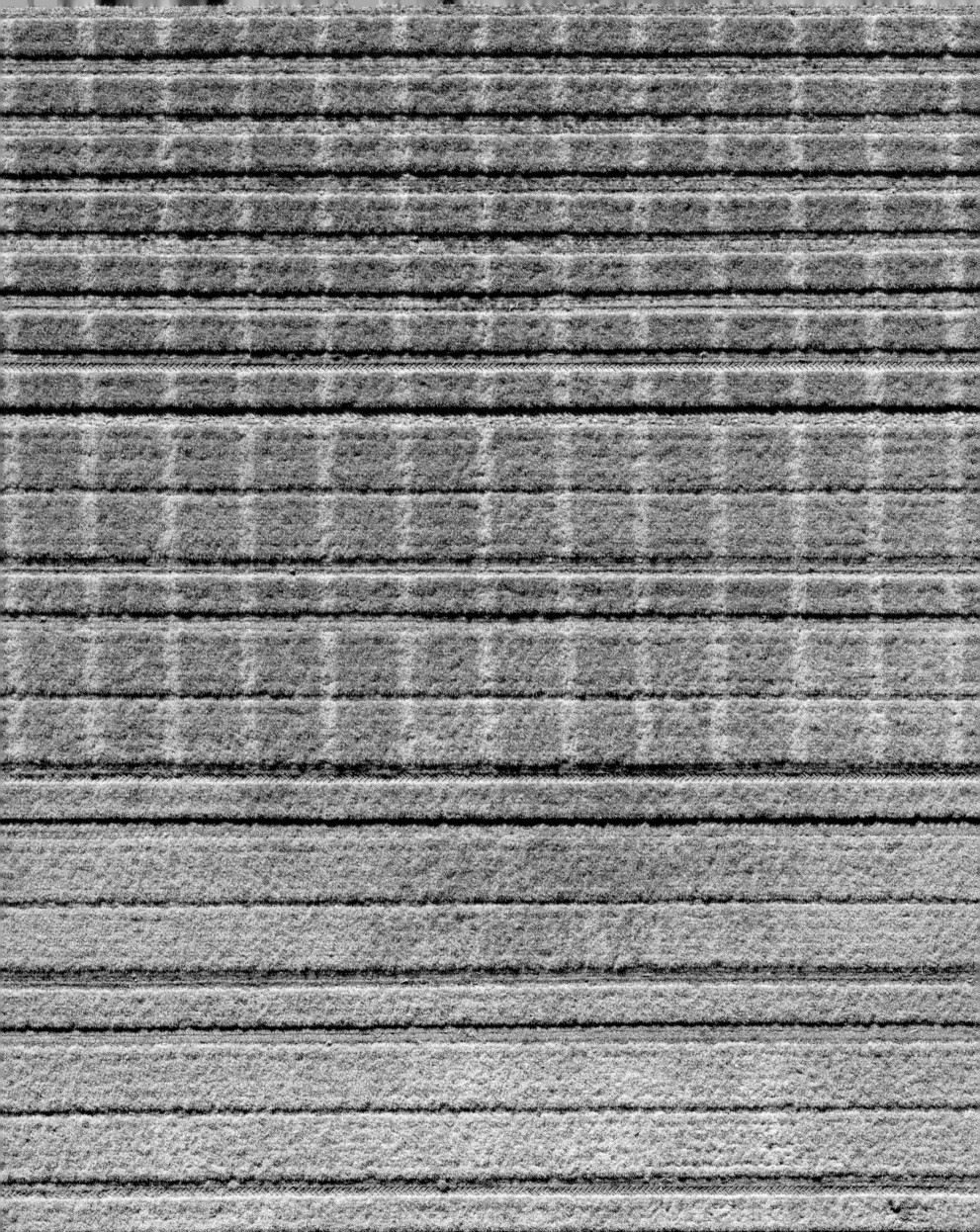

RED CABBAGE, WHITE CABBAGE
Crop of white and red cabbages at
different stages of maturity, with
hosepipe.
Chiètres, Fribourg canton, Switzerland;
late June

"The challange to the vegetable farmer is
to guarantee continuity of supply. Every
ten days he plants a new stage in his
assortment of salads and cabbages…
and every week he harvests in order to
supply the regional markets. This is as
regular as clockwork, whatever the
weather!"

RENÉ STEINER, agronomist and vegetable crop
advisor, Anet, Berne canton, Switzerland

WEISSKOHL, ROTKOHL
Rot- und Weißkohlfeld in vier
verschiedenen Wachstumsphasen.
Bewässerungsrohr.
Chiètres, Kanton Freiburg, Schweiz,
Ende Juni.

„Die Herausforderung für den
Gemüsebauer besteht darin, eine
konstante Versorgung sicherzustellen.
Alle zehn Tage bepflanzt er einen neuen
Abschnitt mit seinen Salaten und
Kohlsorten … und jede Woche beliefert
er die regionalen Märkte mit frisch
geerntetem Gemüse. Pünktlich wie ein
Uhrwerk, trotz aller Unwägbarkeiten des
Wetters."

RENÉ STEINER, Agronom, Gemüsebauberater,
Anet, Kanton Bern, Schweiz.

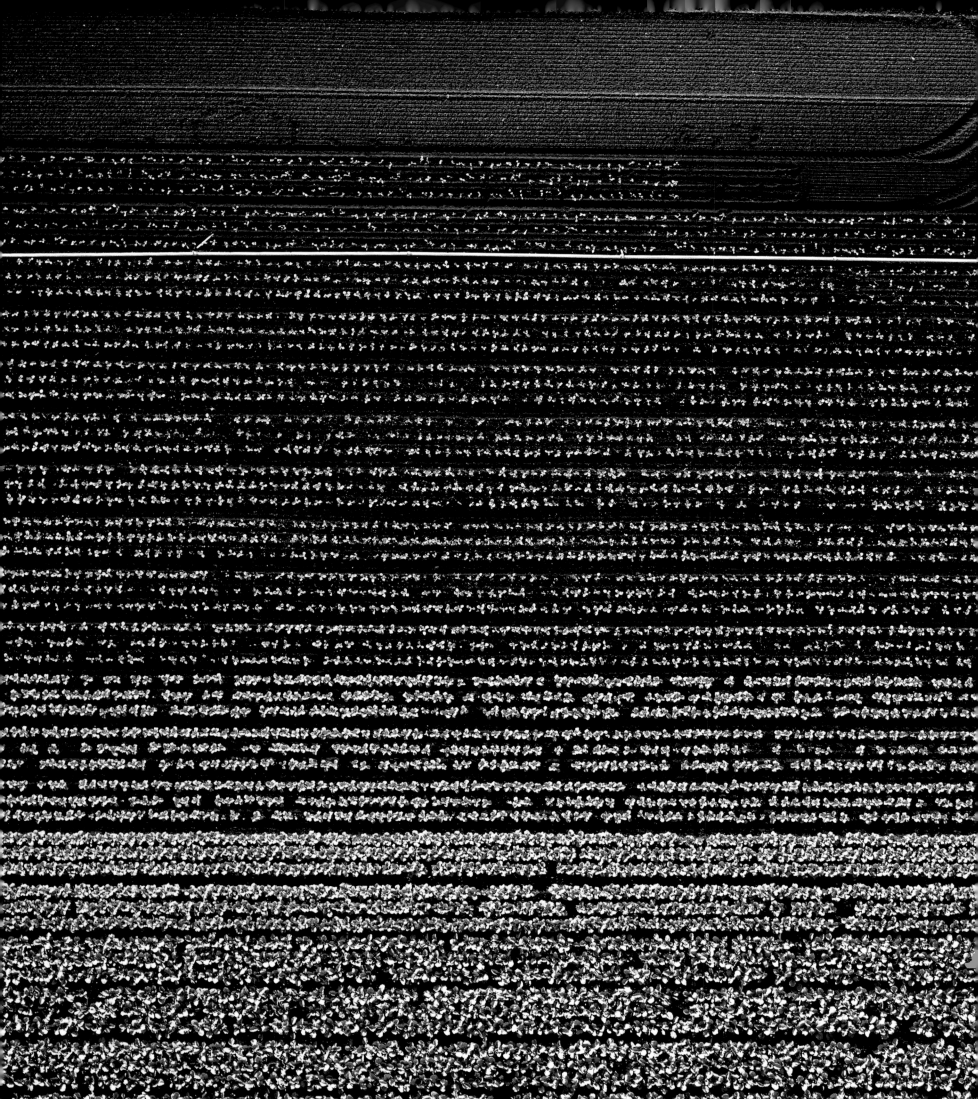

TRUFFLE FARM

Plantation of green truffle oaks.
The fungus inhibits the development of
the grasses (white rings) around the trees
that produce the truffles.
Near Rognes, Vaucluse, France; late March

"The truffle itself is as exciting as the
suspense of hunting them with dogs:
its size, its odour, the fact that it is 20cm
under ground. It's magical. I am doing
this full time."

Géo Balme, truffle grower and harvester,
L'Isle-sur-la-Sorgue, Vaucluse, France

TRÜFFELKULTUR

Grüneichenpflanzung mit Trüffelkultur.
Rund um die Bäume, die Trüffeln
„produzieren", wächst kein Gras
(weißer Rand), weil der Pilz dessen
Wachstum verhindert.
Umgebung von Rognes, Vaucluse,
Frankreich, Ende März.

„Die Trüffelsuche ist genauso aufregend
wie die Jagd: die Hunde, die Spannung,
die Größe, der Duft ... Trüffeln wachsen
20 cm unter der Erde – faszinierend! Ich
habe sie zu meinem Beruf gemacht."

Géo Balme, Trüffelzüchter und -sammler,
L'Isle-sur-la-Sorgue, Vaucluse, Frankreich.

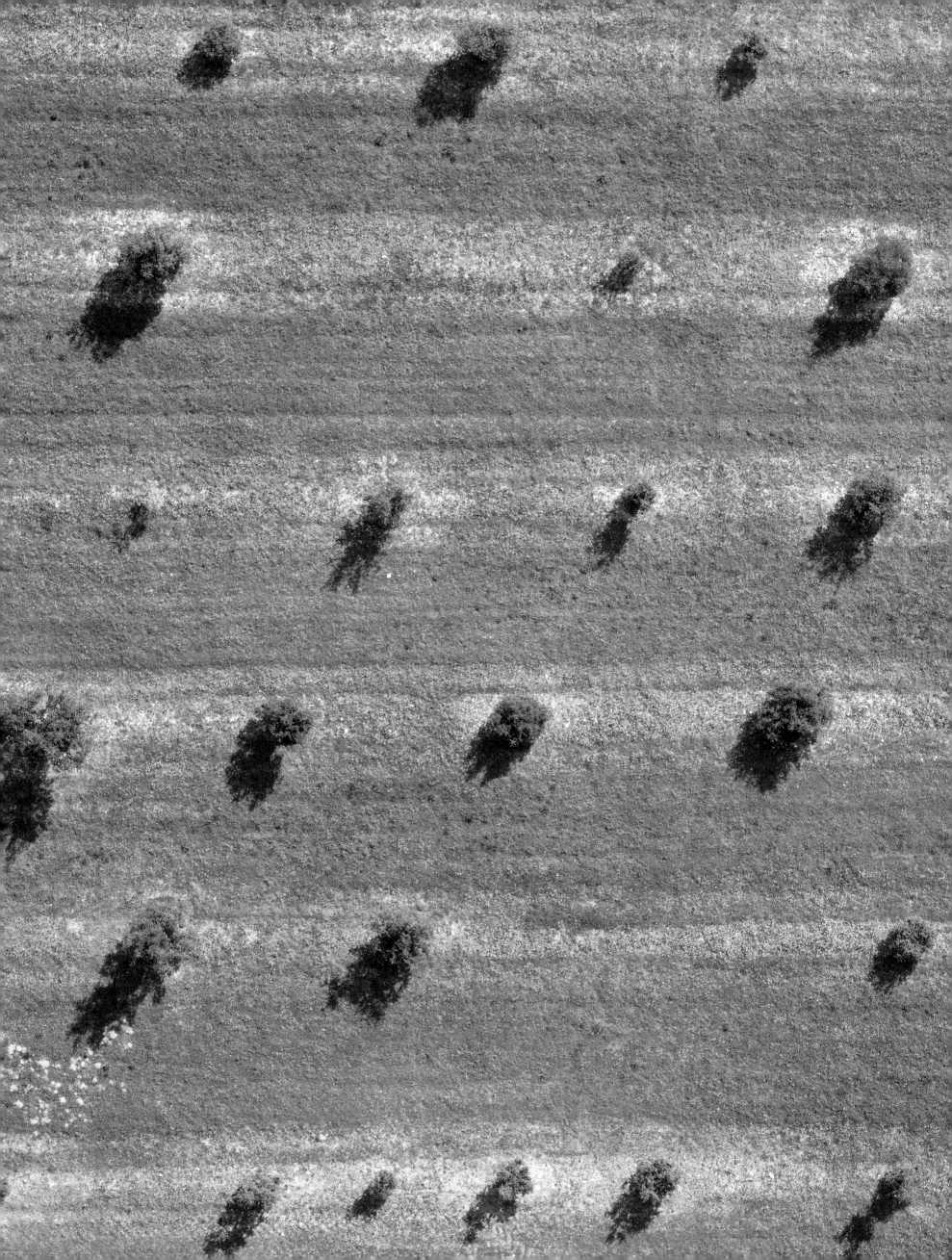

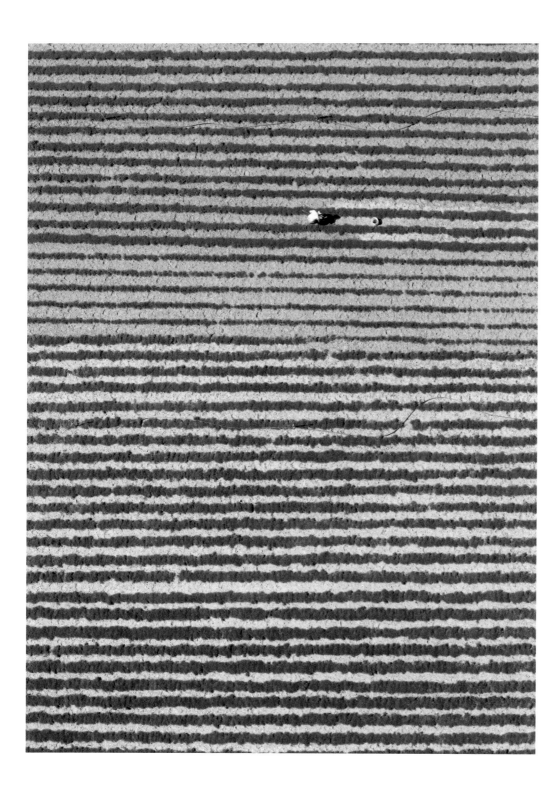

◁ THYME

Organic crops at different stages: top, two-year-old plants; centre, yearlings; bottom, three-year-old plants, manual weeding and hosepipe.
Orsières, Val d'Entremont, Valais canton, Switzerland; late July

"On the Rhône plain, at 450m above sea level, I organically cultivate a number of hectares of apple and pear trees. Here, at 1500m, apart from grass meadows, I organically grow a few thousand square metres of aromatic and medicinal plants (camomile, alchemilla, thyme, sage, hyssop...), and in summer I graze my hundred-odd sheep at altitudes of up to 3000m."

ARMEL PERRION, farmer, Liddes, Valais canton, Switzerland

WORMWOOD ▷

Crop under plastic straw bedding, second year.
Liddes, Val d'Entremont, Valais canton, Switzerland; late July.

"This wormwood plantation gave me a hard time: a soil fungus attacked half the crop. The other half should give a good yield for another two seasons. Then the plantation will be finished, the plastic removed and recycled. I export my wormwood produce (a few hundred kilos per year) to France, to Savoyard distilleries, which transform it into a traditional liqueur."

ARMEL PERRION, farmer, Liddes, Valais canton, Switzerland

◁ THYMIAN

Biokultur in verschiedenen Stadien: oben zweijährige Pflanzen, in der Mitte einjährige und unten dreijährige. Ernte von Hand. Bewässerungsschlauch.
Orsières, Val d'Entremont, Kanton Wallis, Schweiz, Ende Juli.

„In der Rhône-Ebene, auf 450 m Höhe, betreibe ich auf mehreren Hektar biologischen Apfel- und Birnenanbau. Hier, auf 1500 m Höhe, wo es in erster Linie Heuwiesen gibt, baue ich auf einigen Tausend Quadratmetern Bio-Aroma- und Arzneipflanzen an (Kamille, Frauenmantel, Thymian, Salbei, Ysop usw.). Und im Sommer lasse ich meine rund hundert Schafe bis auf 3000 m weiden."

ARMEL PERRION, Landwirt, Liddes, Kanton Wallis, Schweiz.

BEIFUSS ▷

Anbau auf Plastikfolie, zweites Jahr.
Liddes, Val d'Entremont, Kanton Wallis, Schweiz, Ende Juli.

„Dieser Beifuß hat mir ziemlich viele Sorgen gemacht: Die Hälfte der Pflanzen ist von einem Bodenpilz befallen. Die andere Hälfte dürfte noch zweimal eine gute Ernte abgeben. Dann ist die Kultur erschöpft, und die Folie wird entfernt und recycelt. Ich exportiere den Beifuß (einige hundert Kilo im Jahr) nach Frankreich, in die Savoyen. Dort wird daraus ein traditioneller Likör gemacht."

ARMEL PERRION, Landwirt, Liddes, Kanton Wallis, Schweiz.

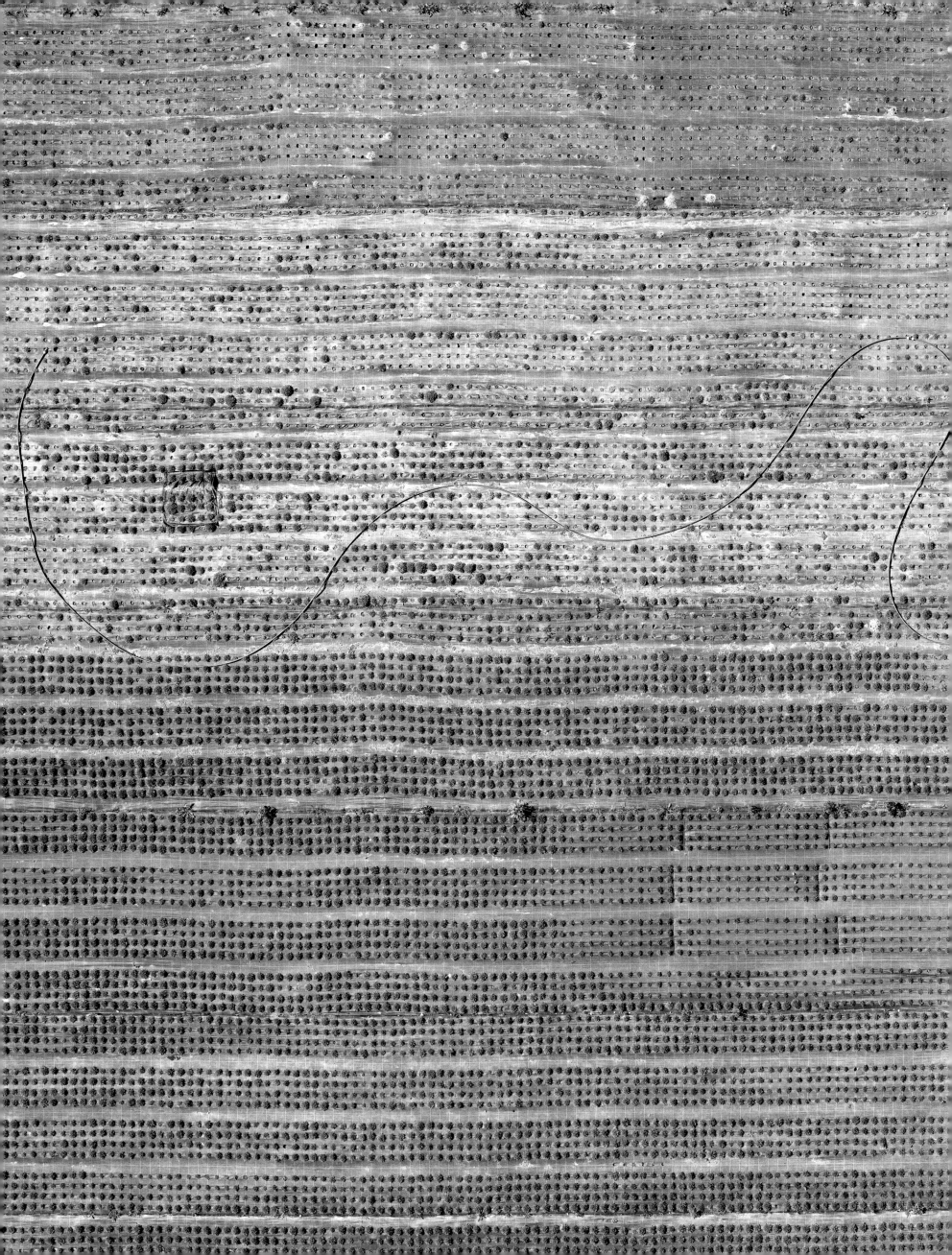

PEAR ORCHARD
Plantation on grasslands.
Cadenet, Vaucluse, France; late March

"In order to appeal, a fruit must be fresh,
bright in colour, large and ripe. Yet we
are also concerned with food safety,
social protection and environmental
requirements: we participate in the
global partnership for a safe and
sustainable agriculture, which comes
into force in 2006."

OLIVIER POTTERAT, member of the board of Migros
Vaud, Ecublens, Vaud canton, Switzerland

BIRNBÄUME
Pflanzung auf grasbewachsenem Boden.
Cadenet, Vaucluse, Frankreich, Ende März.

„Eine Frucht macht Appetit, wenn sie
frisch, reif und von kräftiger Farbe und
ausgewogener Größe ist. Doch wir
kümmern uns auch um Fragen der
Ernährung, der sozialen Sicherung und
der Umwelt: Wir beteiligen uns an der
Weltweiten Partnerschaft für sichere
und nachhaltige Landwirtschaft
(EUREPGAP), die 2006 in Kraft tritt."

OLIVIER POTTERAT, Vorstandsmitglied von Migros
Waadt, Ecublens, Kanton Waadt, Schweiz.

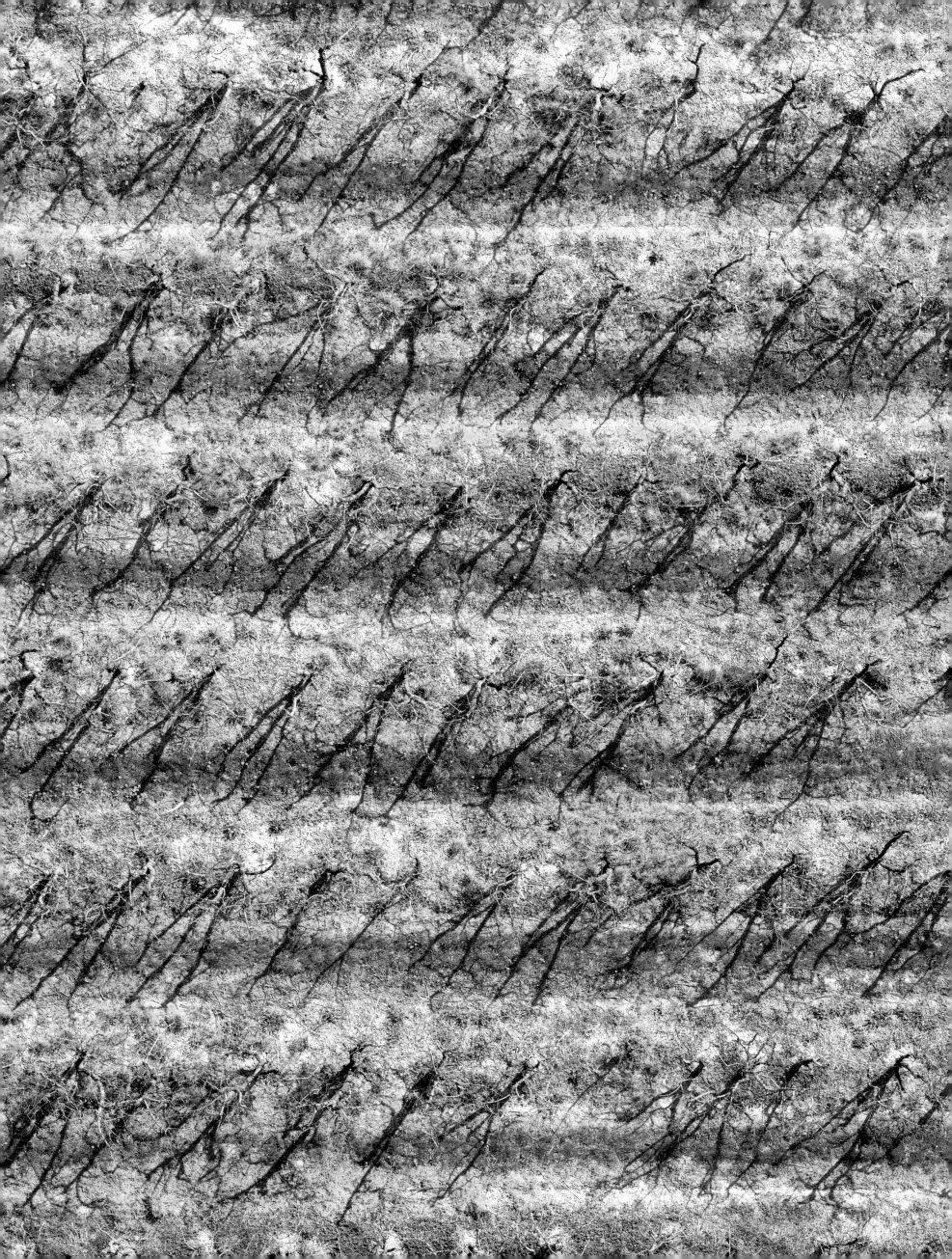

SUNFLOWERS

Crop ready for the harvest, the plant is
dry, and the heads droop towards the
ground.
Near Arles, Bouches-du-Rhône, France;
September

"Our research project on the genetic
improvement of the sunflower will take
many years, and the cooperation of
many countries: Italy, the United States,
Bulgaria, Rumania, Morocco…"

HERVÉ SERIEYS, agronomic engineer,
Mauguio Station, National Institute for
Agronomic Research, Montpelier, Hérault, France

SONNENBLUMEN

Erntebereites Feld. Die Pflanzen sind
trocken, und die Blüten neigen sich zum
Boden.
Umgebung von Arles, Bouches-du-Rhône,
Frankreich, September.

„Unser Forschungsprojekt zur
genetischen Verbesserung von
Sonnenblumen ist auf viele Jahre
angelegt und findet in Zusammenarbeit
mit mehreren Ländern statt: Italien, den
USA, Bulgarien, Rumänien, Marokko
usw."

HERVÉ SERIEYS, Agraringenieur, Forschungsstation
Mauguio, Nationales Institut für landwirtschaftliche
Forschung, Standort Montpellier, Hérault,
Frankreich.

◁ SALTERN
Inflorescences of gypsum, which settles before the table salt.
Saltern of Aigues-Mortes, Gard, France; May

"Our company exploits over 30,000 hectares in the Camargue, mostly inaccessible to the public. The Aiges-Mortes saltern alone, at around 10,000 hectares, is larger than the city of Paris!"

JACQUES BALOSSIER, director of Salins du Midi and Salins de l'Est, Aigues-Mortes, Gard, France

SALTERN ▷
Preparation of the 'saltern table' by mutiple tractor passes.
The quality of the harvested 'salt cake' depends on the flatness that is obtained.
Saltern of Aigues-Mortes, Gard, France; May

"After evaporation by the sun, the 'salt cake' is collected at the end of summer. This is our harvest; we are the farmers of the sea."

PATRICK FERDIER, head salt merchant, Salins du Midi and Salins de l'Est, Aigues-Mortes, Gard, France

◁ SALZGÄRTEN
Gipsabscheidungen. Gips fällt aus, bevor sich Speisesalz absetzt.
Salzwerk Aigues-Mortes, Gard, Frankreich, Mai.

„Unser Unternehmen bewirtschaftet in der Camargue mehr als 30.000 ha, die der Öffentlichkeit zu großen Teilen nicht zugänglich sind. Allein der Salzgarten von Aigues-Mortes ist größer als das Zentrum von Paris!"

JACQUES BALOSSIER, Leiter der Salzwerke Salins du Midi und Salines de l'Est, Aigues-Mortes, Gard, Frankreich.

SALZGARTEN ▷
Vom Traktor geglättetes Salzfeld.
Die Qualität der Salzernte hängt von der Ebenheit der Fläche ab.
Salzwerk Aigues-Mortes, Gard, Frankreich, Mai.

„Wenn das Wasser am Ende des Sommers durch die Sonne verdunstet ist, wird das Salz geerntet. Das ist unsere Erntezeit, wir sind die Bauern des Meeres."

PATRICK FERDIER, Leiter der Salzherstellung der Salzwerke Salins du Midi und Salines de l'Est, Aigues-Mortes, Gard, Frankreich.

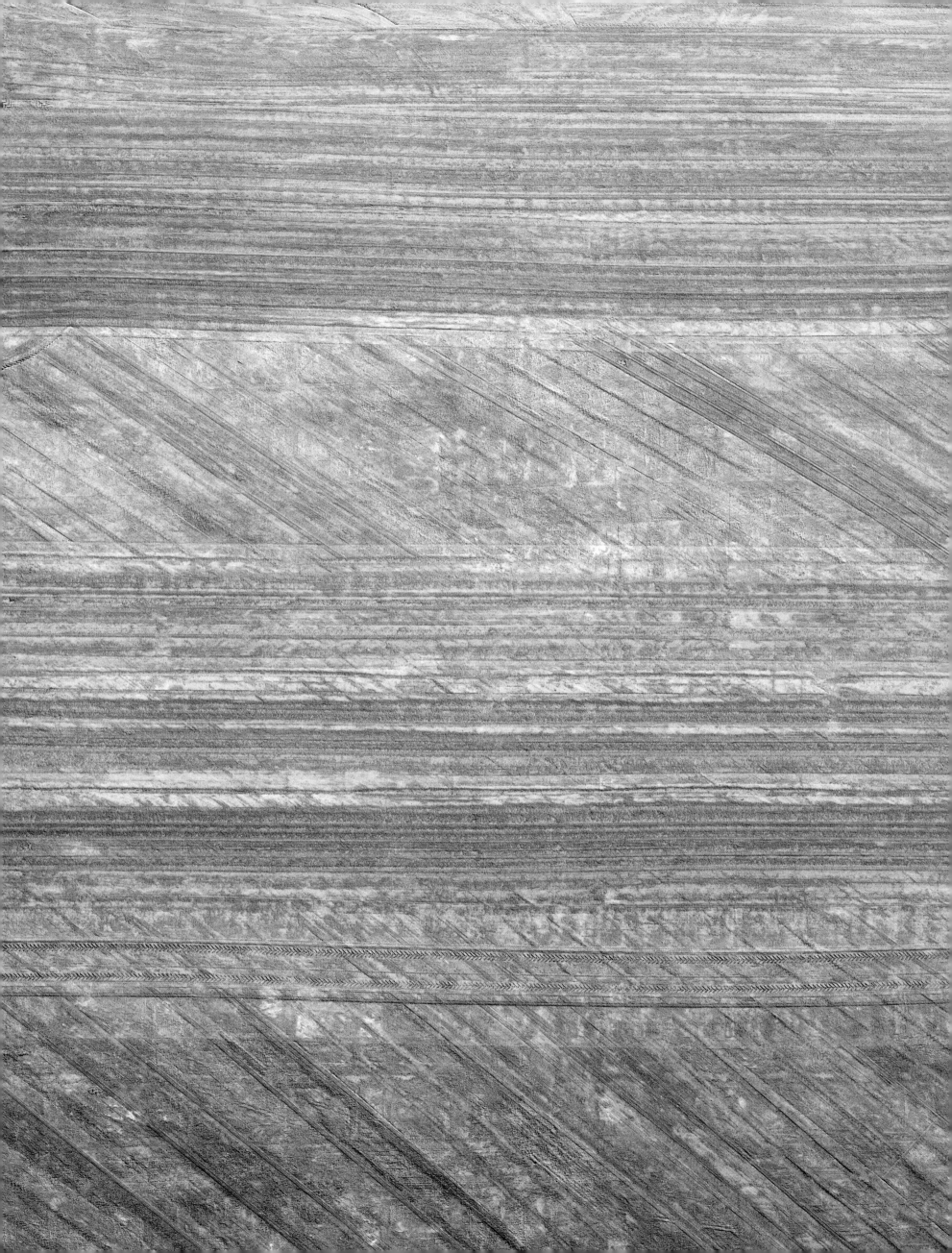

SALTERN

Saltern table in production season.
Bottom: cord of salt, the orange colour
of the water is due to algae.
Berre-l'Étang, Bouches-du-Rhône, France;
July

"A saltern is an entirely man-made
environment, which produces both
economic (salt) and ecological wealth:
each grade of salinity corresponds to a
particular group of fauna and flora, of
which pink flamingos are symbolic.
We fear a certain fundamentalism in
environmental management, which
could lead to abandoning these areas to
nature. This would be a major economic,
cultural and ecological loss."

JACQUES BALOSSIER, director of the Salins du Midi
and Salins de l'Est saltworks, Aigues-Mortes,
Gard, France

SALZGARTEN

Salzfeld in der Produktionsphase.
Unten: Salzstreifen. Die orange Färbung
des Salzes entsteht durch eine Algenart.
Berre-l'Étang, Bouches-du-Rhône,
Frankreich, Juli.

„Ein Salzgarten ist ein von
Menschenhand erschaffenes Milieu, das
sowohl einen ökonomischen (Salz) als
auch einen ökologischen Reichtum
hervorbringt: Jeder Salzkonzentration
entspricht eine spezifische Flora und
Fauna, für die die Flamingos zum
Symbol geworden sind. Wir fürchten
einen gewissen Fundamentalismus im
Umweltschutz, der dazu führen würde,
dass man die Salzgärten wieder der
Natur überließe, was ein schwerer
ökonomischer, kultureller und
ökologischer Verlust wäre."

JACQUES BALOSSIER, Leiter der Salzwerke Salins
du Midi und Salines de l'Est, Aigues-Mortes,
Gard, Frankreich.

SALAD PLANTATION

Planting on plastic foil weighed down with
clods of clay, crates of salad seedlings,
at the bottom of the image, recently
planted seedlings.
Chateaurenard, Vaucluse, France;
late March

"Each year we produce one hundred
million transplantable vegetables
(25 per cent of the Swiss market) from
seeds originating from around the world:
Japan, the United States, France, Italy
and above all Holland."

DANIEL MARCHAND, agronomic engineer, Lonay,
Vaud canton, Switzerland

SALATPFLANZUNG

Pflanzung auf mit Lehmklumpen
beschwerter Plastikfolie. Kisten mit
Salatsetzlingen.
Unterer Bildrand: frisch verpflanzte
Setzlinge.
Châteaurenard, Vaucluse, Frankreich,
Ende März.

„Wir produzieren jährlich 10 Millionen
Gemüsesetzlinge (25% des
schweizerischen Marktes) aus Saatgut
aus der ganzen Welt: Japan, USA,
Frankreich, Italien ... und vor allem
Holland."

DANIEL MARCHAND, Agraringenieur, Lonay, Kanton
Waadt, Schweiz.

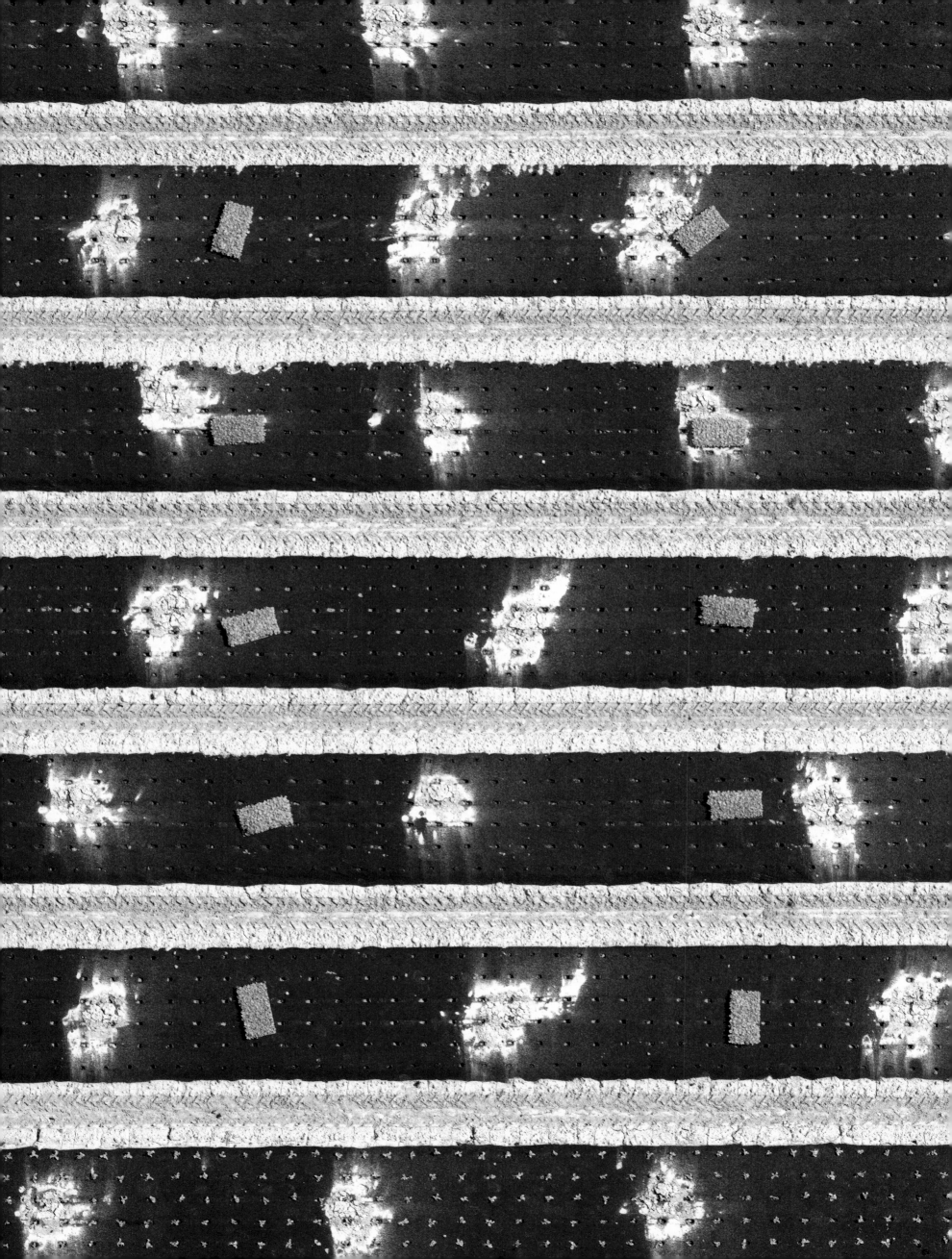

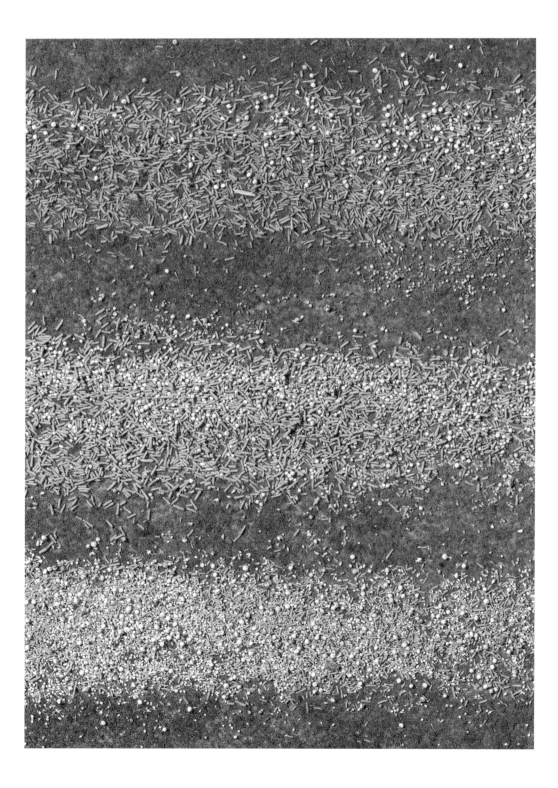

◁ CARROTS, TURNIPS
Spreading of unsold vegetables.
Cadenet, Vaucluse, France; late March

"I've been growing carrots for forty
years. In vegetable farming, one often
has unsold stock. These carrots and
turnips spread over the grass will dry in
the sun, and will be absorbed into the
soil when we plough."

GÉRALD BÉZERT, farmer, Velleron, Vaucluse, France

PROVENÇAL BUTTERNUT SQUASH ▷
The land marked with the grid of a harrow,
plants in flower.
Saint-Rémy-de-Provence, Bouches-du-
Rhône, France; July

"I planted these squashes in May.
The ground was already covered by the
beginning of August. I harvested them in
October, and was able to sell everything
to a wholesaler whom I have been
working with for a long time."

François Gonfond, farmer, Saint-Rémy-de-
Provence, Bouches-du-Rhône, France

◁ MÖHREN, WEISSE RÜBEN
Verwertung der unverkauften Ware als
Düngematerial.
Cadenet, Vaucluse, Frankreich, Ende März.

„Ich baue seit 40 Jahren Möhren an. Im
Gemüseanbau hat man oft unverkaufte
Ware. Diese im Gras verteilten Möhren
und Rüben werden in der Sonne
getrocknet und dann beim Pflügen unter
den Ackerboden gearbeitet."

GÉRALD BÉZERT, Landwirt, Velleron, Vaucluse,
Frankreich.

PROVENZALISCHE MOSCHUSKÜRBISSE ▷
Bodenprägung durch das Profil der
Ackerwalze. Pflanzen in der Blüte.
Saint-Rémy-de-Provence, Bouches-du-
Rhône, Frankreich, Juli.

„Ich habe diese Kürbisse im Mai
gepflanzt. Im August war schon der
ganze Boden bedeckt. Im Oktober habe
ich dann geerntet und alles an einen
Großhändler verkauft, mit dem ich schon
lange zusammenarbeite."

FRANÇOIS GONFOND, Landwirt, Saint-Rémy-
de-Provence, Bouches-du-Rhône, Frankreich.

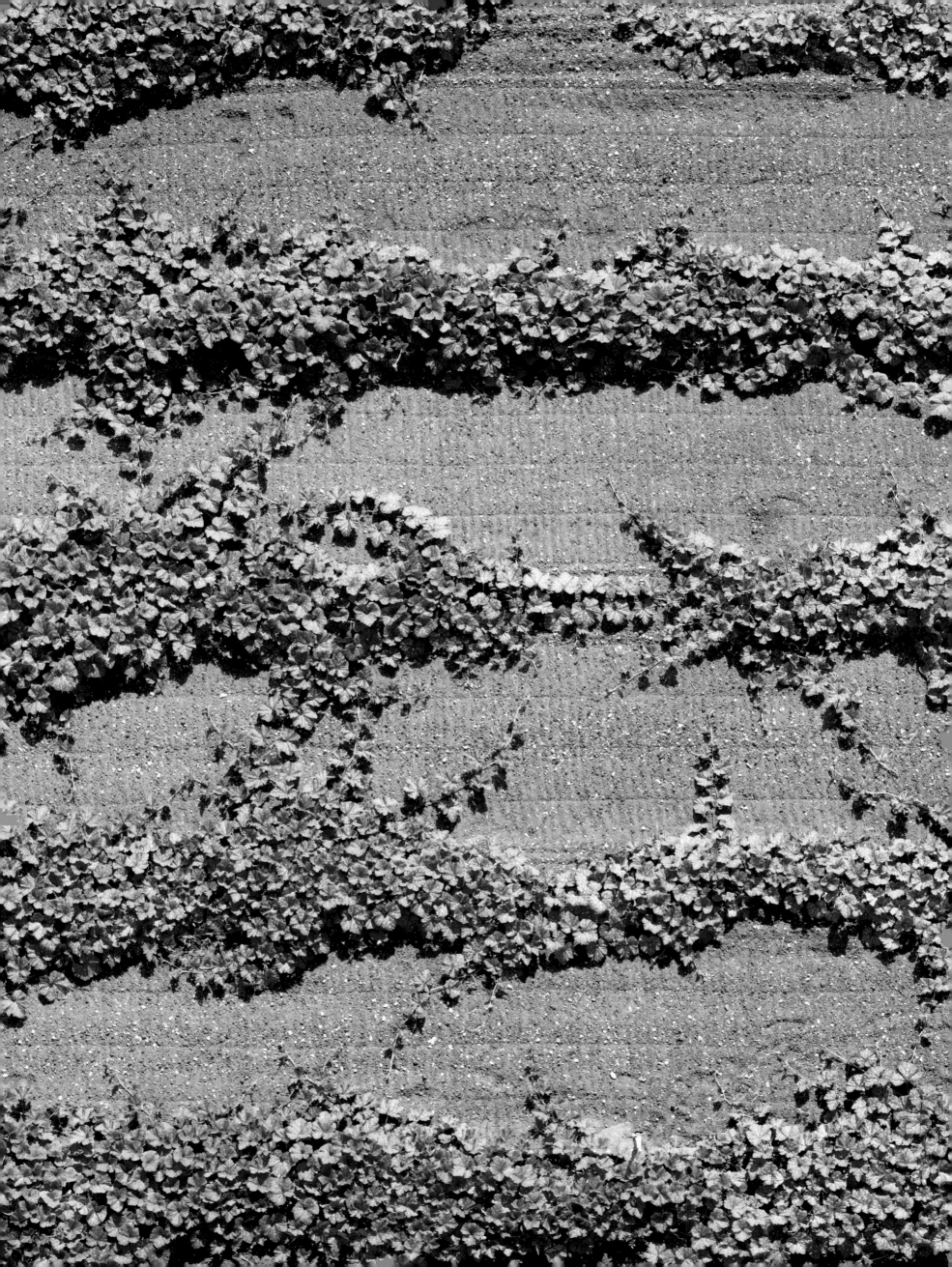

FLOWERING BABY'S BREATH
Crop-bearing seedlings for seed
production.
Velleron, Vaucluse, France; early June

"The seed merchants tried to move the
production elsewhere, but they came
back. Primarily for climatic reasons,
germination and crop purity are at their
best here."

BRUNO DOCHE, farmer, Velleron, Vaucluse, France

BLÜHENDES SCHLEIERKRAUT
Samenträgerkultur zur Saatgutproduktion.
Velleron, Vaucluse, Frankreich, Anfang Juni.

„Die Saatguthändler haben versucht,
die Produktion zu verlagern, doch davon
sind sie wieder abgekommen.
Vor allem aus klimatischen Gründen sind
Keimfähigkeit und Reinheit der Ernte hier
optimal."

BRUNO DOCHE, Landwirt, Velleron, Vaucluse,
Frankreich.

PEACH ORCHARD
In full blossom.
Saint-Marcel-lès-Valence, Drôme, France;
late March

"In addition to suffering from
competition from southern Europe, we
do not know how to treat the sharka
virus, which affects our peach and
apricot trees. Thousands of hectares of
orchard have already been felled around
Valence. In a few years time, there will
be no tree-fruit crop left in this region.
We have re-orientated towards high-
quality free-range poultry, which we
raise with our own grain."

FRANÇOISE AND BRUNO URBAI, farmers,
Saint-Marcel-lès-Valence, Drôme, France

PFIRSICHPLANTAGE
In voller Blüte.
Saint-Marcel-lès-Valence, Drôme, Frankreich,
Ende März.

„Wir haben nicht nur mit der Konkurrenz
aus Südeuropa zu kämpfen – unsere
Pfirsich- und Aprikosenbäume haben
auch noch das Sharkavirus, gegen das
es kein Mittel gibt. Rund um Valence
sind bereits Tausende von Hektar
Obstplantagen gerodet worden. In ein
paar Jahren wird es in dieser Region
keinen Obstanbau mehr geben.
Wir haben uns umorientiert und
verkaufen nun Qualitätsgeflügel direkt
ab Hof, das wir mit eigenem Getreide
aufziehen."

FRANÇOISE UND BRUNO URBAIN, Landwirte,
Saint-Marcel-lès-Valence, Drôme, Frankreich.

PEPPERS IN POLYTUNNELS
Polytunnels, galvanised steel structure
with polythene film, ripped in places.
Near Arles, Bouches-de-Rhône, France;
September

"I invested in polytunnels to grow red
peppers – one hectare of vegetable
tunnels. The results did not meet the
bank's expectations, and I had to close
down."

ROBERT MACCARI, farmer, Arles, Bouches-du-Rhône,
France

PAPRIKAPFLANZEN IM FOLIENTUNNEL
Folientunnel mit Gerüst aus verzinktem
Stahl. Abdeckung aus stellenweise
zerrissener Polyethylenfolie.
Umgebung von Arles, Bouches-du-Rhône,
Frankreich, September.

„Ich habe in die Tunnels investiert, um
rote Paprika anzubauen – ein Hektar
Folientunnel. Die Erträge reichten nicht
an die Erwartungen der Bank heran, und
ich musste schließen."

ROBERT MACCARI, Landwirt, Arles, Bouches-du-Rhône,
Frankreich.

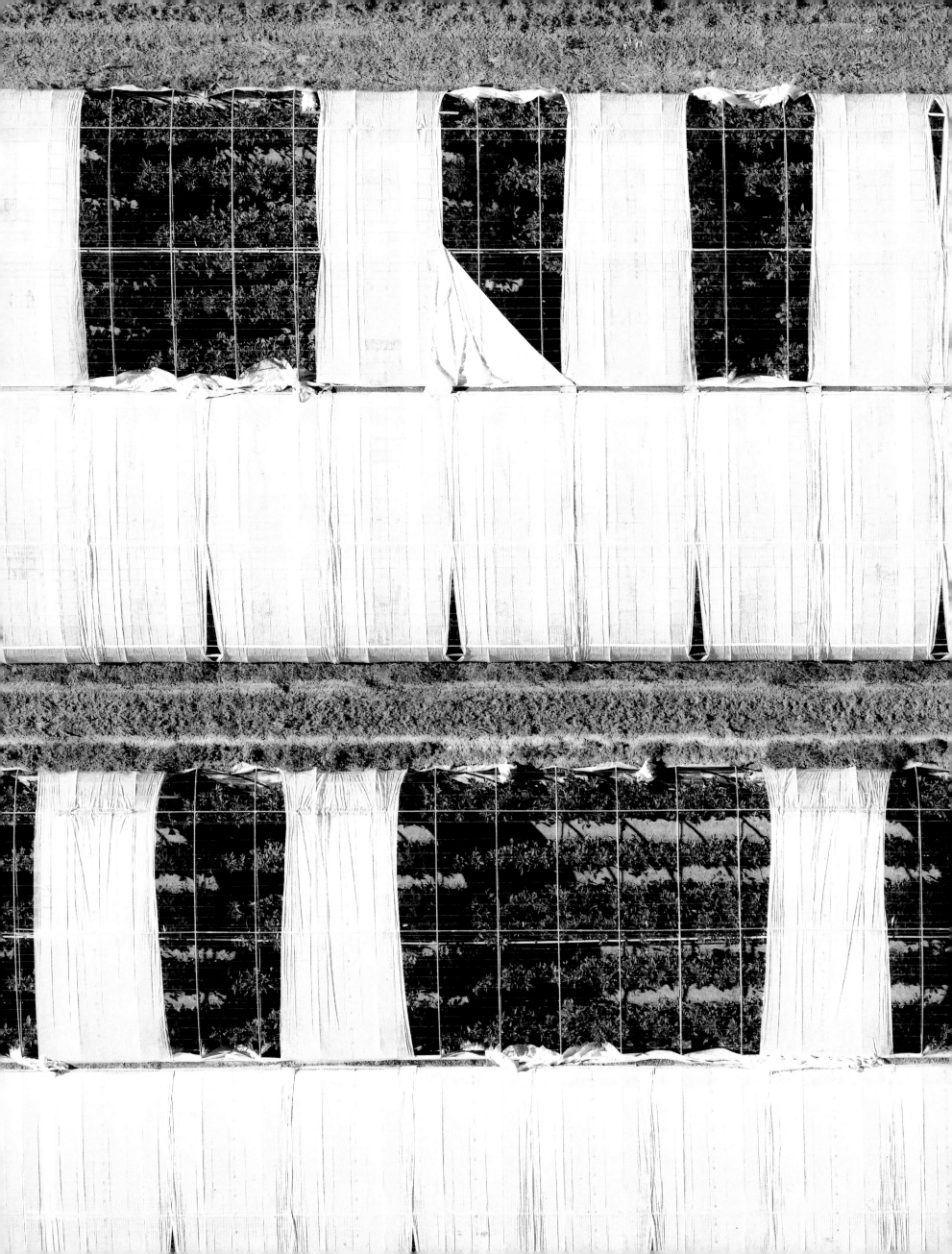

PAGE 54
POTATOES
Young plants on peaty ground.
Two lines left unplanted to provide an
access route for the tractor.
Bavois, Vaud canton, Switzerland; May

"The potato is very labour intensive:
firstly in winter, we need to condition
the plants. Then, in the fields, we fight
against loss due to disease or inclement
weather. Many farmers have given up. It
is a difficult crop and a hard profession."

JEAN-CHARLES REIHLE, farmer, Domaine de la
Grande-Île, Les Barges, Vouvry, Valais canton,
Switzerland

SEITE 54
KARTOFFELN
Angehäufte junge Pflanzen auf Torfboden.
Über die beiden unbepflanzten Reihen
kann der Traktor das Feld passieren.
Bavois, Kanton Waadt, Schweiz, Mai.

„Der Kartoffelanbau ist arbeitsintensiv
und aufwändig: zuerst, wenn die
Kartoffeln im Winter vorkeimen, und
dann, auf dem Feld, wenn man gegen
Krankheiten und witterungsbedingte
Ernteverluste kämpft. Viele haben den
Anbau aufgegeben. Die Kultivierung ist
schwierig, ein echter Beruf."

JEAN-CHARLES REIHLE, Landwirt, Domaine de la
Grande-Île, Les Barges, Vouvry, Kanton Wallis,
Schweiz.

PAGE 55
PEAS FOR LIVESTOCK
A crop of high-protein peas in its early
stages of growth.
Saint-Marcel-lès-Valence, Drôme, France;
late March

"I have just ordered two hundred tonnes
of high-protein pea seed for our members.
After the harvest, we combine our
produce to sell it to a livestock feed
manufacturer."

PAUL VINDRY, agricultural adviser, Valsoleil
cooperative, Montelier, Drôme, France

SEITE 55
FUTTERERBSEN
Futtererbsen in der ersten
Wachstumsphase.
Saint-Marcel-lès-Valence, Drôme,
Frankreich, Ende März.

„Ich habe für unsere Mitglieder gerade
200 Tonnen Saatgut für Futtererbsen
bestellt. Nach der Ernte verkaufen wir
die Erträge gemeinsam an einen
Futtermittelhersteller."

PAUL VINDRY, Agrarfachmann, Genossenschaft
Valsoleil, Montelier, Drôme, Frankreich.

CUT RYE
Fodder variety for livestock. Swathes
ready to be loaded.
Illarsaz, Valais canton, Switzerland;
late March

"My entire production is intended for the
fattening of beef. Meat is so much more
tender if you leave it to hang, but it is
rarely hung long enough because
coldroom storage is expensive."

FLAVIEN CORNUT, farmer, Vouvry, Valais canton,
Switzerland

GESCHNITTENER ROGGEN
Futtergetreide für das Vieh. Zum Aufladen
bereite Schwaden.
Illarsaz, Kanton Wallis, Schweiz,
Ende März.

„Ich habe mich auf die Bullenmast
spezialisiert. Damit das Fleisch zart ist,
muss es gut abgehangen sein. Das ist
jedoch selten der Fall, weil die Lagerung
im Kühlhaus teuer ist."

FLAVIEN CORNUT, Landwirt, Vouvry, Kanton Wallis,
Schweiz.

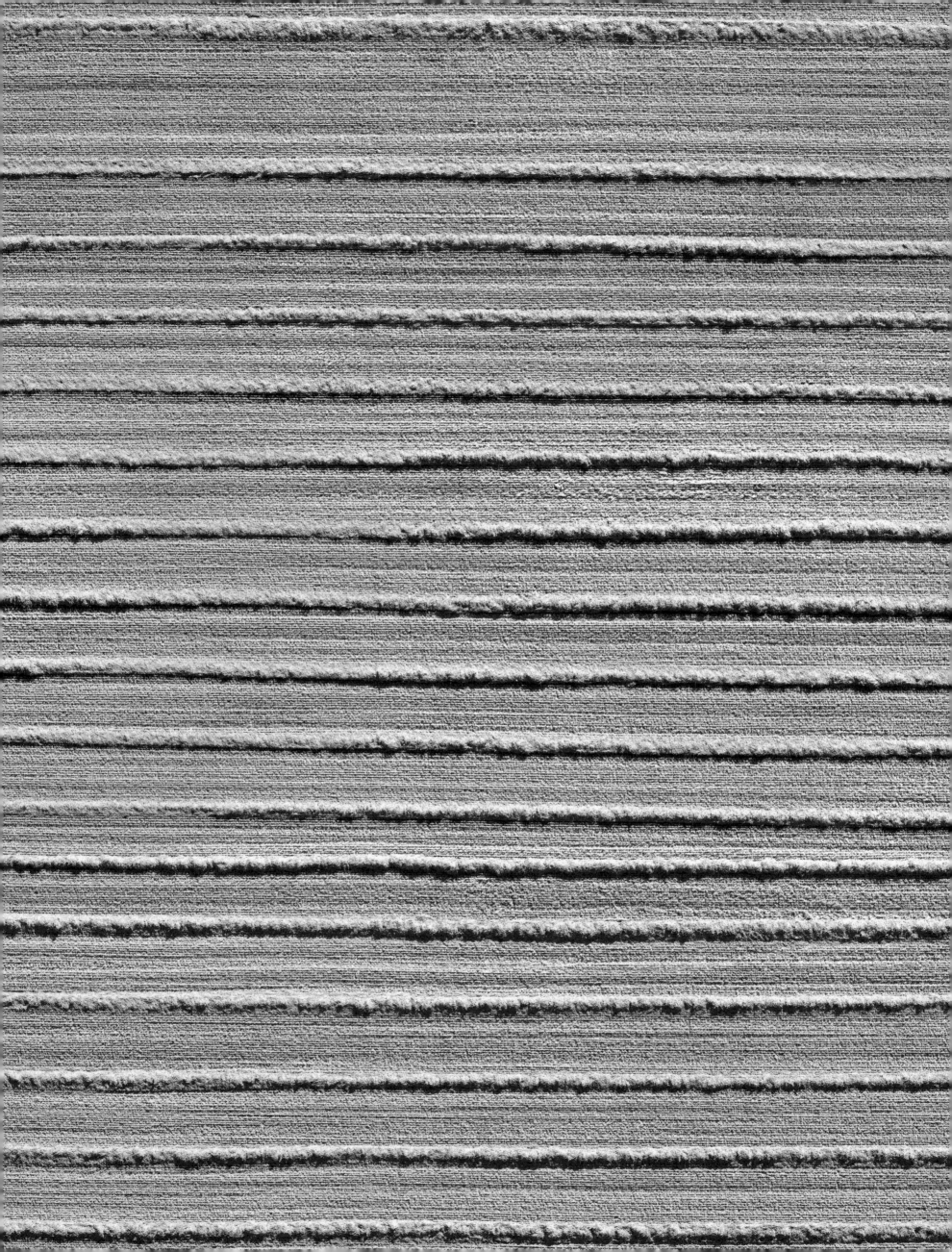

KALE COVERED WITH SNOW
Noville, Vaud canton, Switzerland;
early February

"These kales have taken a hard frost, so
we will only be able to use their hearts."

Pierre Trollux, vegetable producer, Noville, Vaud
canton, Switzerland

WIRSING IM SCHNEE
Noville, Kanton Waadt, Schweiz,
Anfang Februar.

„Diese Wirsingköpfe haben starken Frost
abbekommen, man kann nur noch die
Herzen verwerten."

Pierre Trollux, Gemüseproduzent, Noville,
Kanton Waadt, Schweiz.

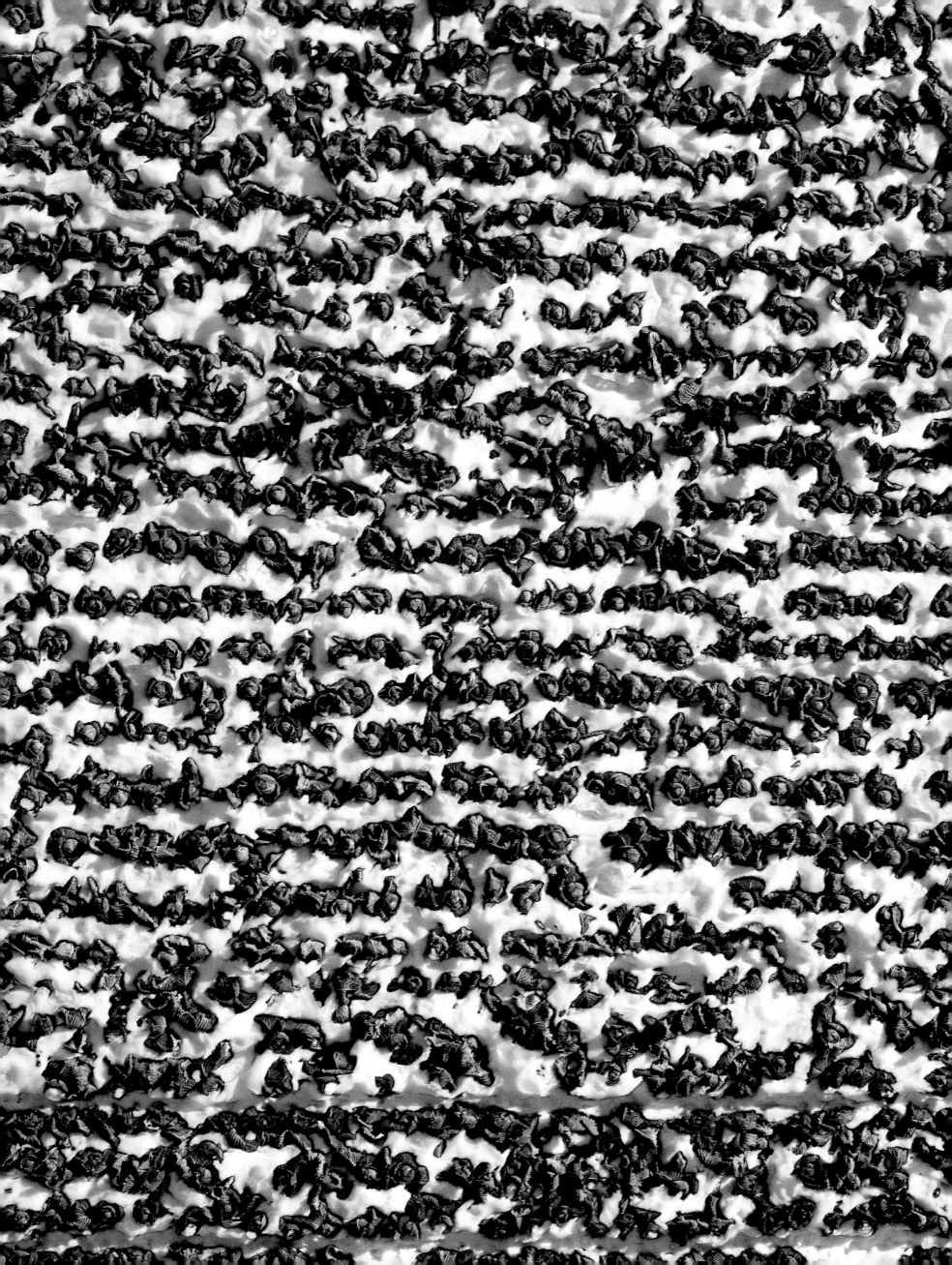

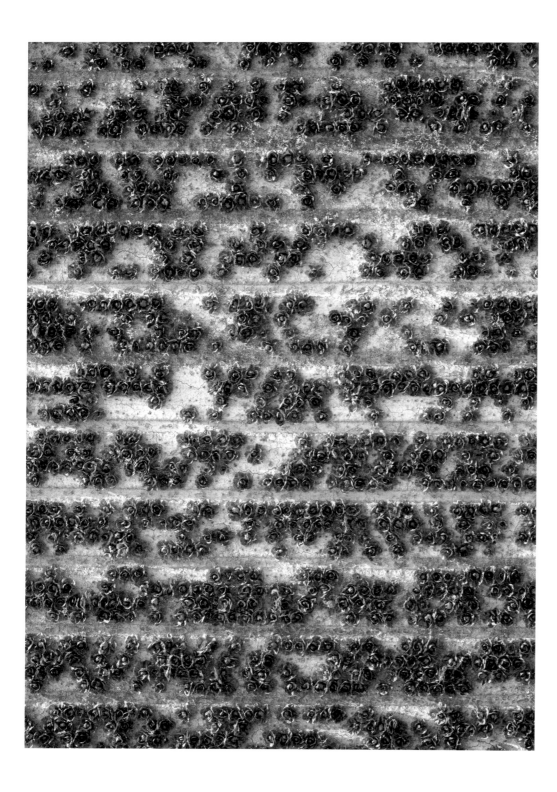

ONIONS ▷
Onion crop prior to harvest, stalks laid flat.
Montvendre, Drôme, France; late July

"A few weeks before the onion harvest,
we lay the green stems flat in order to
allow the onions to grow and mature.
The smell is very intense; some people
even have to protect their eyes."

EVELYNE MARENDAZ, agronomist, Service romand
de Vulgarisation agricole, Lausanne, Vaud
canton, Switzerland

◁ RADICCHIO
Crop of radicchio or red endive.
Noville, Vaud canton, Switzerland;
early September.

"The lettuces planted in this sandy and
clayey soil suffered from drought shortly
after having been planted in July. Then a
white crust formed, due to heavy rain,
over-watering or a local flood."

ROLAND STOLL, vegetable grower, Yverdon-les-
Bains, Vaud Canton, Switzerland

ZWIEBELN ▷
Zwiebelfeld vor der Ernte, umgeknicktes
Laub.
Montvendre, Drôme, Frankreich, Ende Juli.

„Einige Wochen vor der Zwiebelernte
wird das noch grüne Laub umgeknickt,
damit die Zwiebeln reif und größer
werden. Der Geruch ist sehr intensiv,
manch einer muss sogar seine Augen
schützen."

ÉVELYNE MARENDAZ, Agraringenieurin,
Service romand de Vulgarisation agricole,
Lausanne, Kanton Waadt, Schweiz.

◁ ROTBLÄTTRIGER CHICORÉE
Chicoréekultur.
Noville, Kanton Waadt, Schweiz,
Anfang September.

„Die Salate in diesem sandigen
Lehmboden haben kurz nach dem
Pflanzen im Juli zu viel Trockenheit
abbekommen. Dann hat sich nach
einem heftigen Regen, zu starker
Bewässerung oder einer Überflutung am
Boden eine weiße Kruste gebildet."

ROLAND STOLL, Gemüseproduzent, Yverdon-les-
Bains, Kanton Waadt, Schweiz.

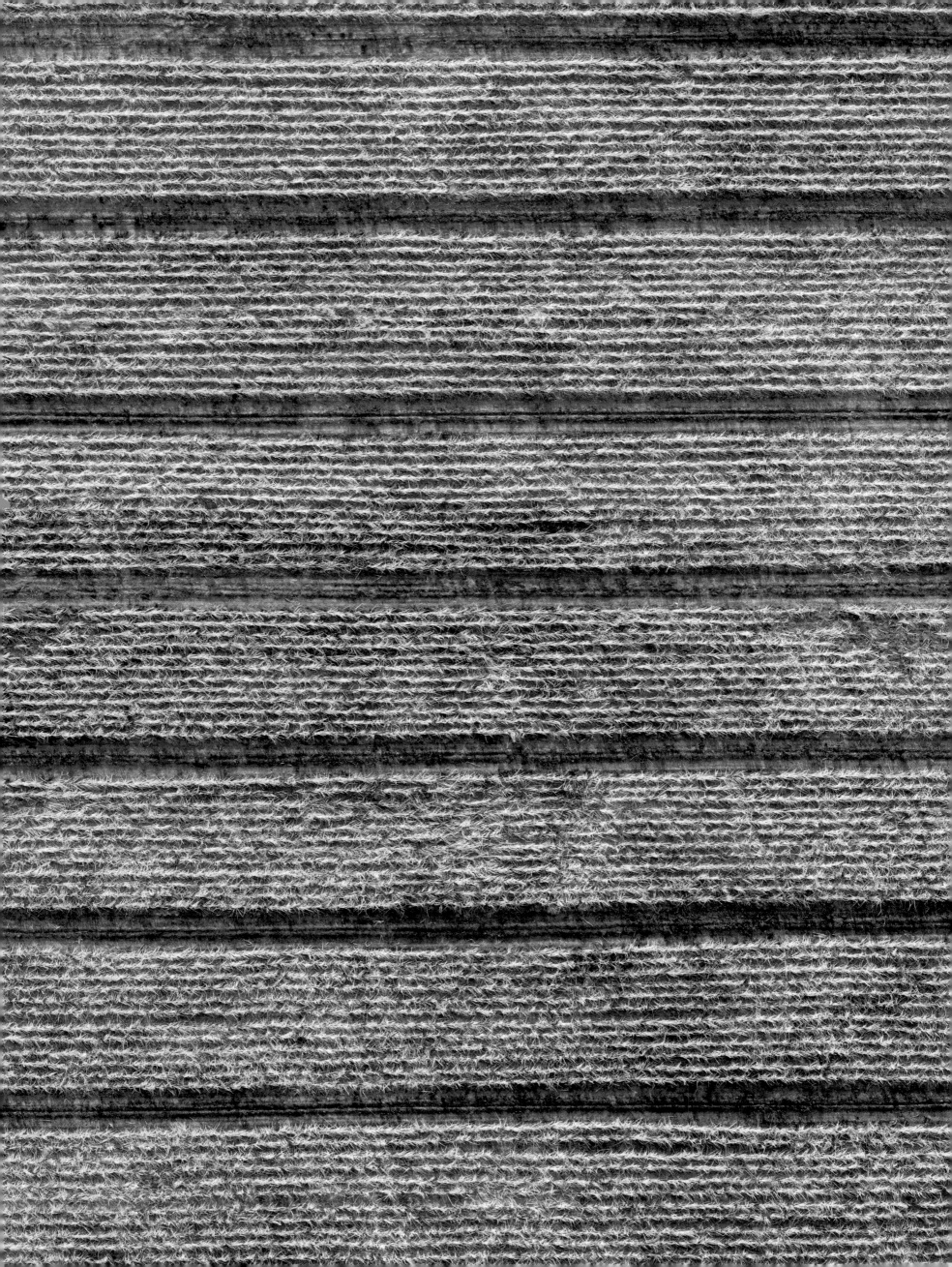

WHEAT, EXPERIMENTAL CROP
Open-air test of fungicides with different
molecular composition chosen in
greenhouses, on two varieties of wheat
(lighter and darker green on the image).
Les Barges, Vouvry, Valais canton,
Switzerland; late April

"Statistics dictate the geometry of these
trials: the performance of the products
is compared on a homogenous, and
therefore limited, surface; a few grams
of products from our laboratory are
tested on very small areas; the same
treatment is repeated at various random
points."

Dr Daniele Fuog, biologist, Vouvry, Valais canton,
Switzerland

WEIZEN, VERSUCHSKULTUR
Freiluftversuch an zwei Weizensorten
(auf dem Bild hell- und dunkelgrün) mit
verschiedenen Fungiziden von
unterschiedlicher molekularer
Beschaffenheit, die zuvor im
Treibhausversuch ausgewählt wurden.
Les Barges, Vouvry, Kanton Wallis,
Schweiz, Ende April.

„Die Versuchsanordnungen erfolgen
nach statistischen Maßgaben: Es gilt,
die Wirksamkeit der Produkte auf einer
homogenen und damit begrenzten
Fläche zu vergleichen. Die jeweils nur
in Gramm-Mengen in unseren Labors
produzierten Fungizide werden auf
kleinster Fläche getestet. Diese
Behandlung wird an verschiedenen,
zufällig gewählten Punkten wiederholt."

Dr. Daniele Fuog, Biologe, Vouvry, Kanton Wallis,
Schweiz.

POTATOES

Experimental crop, the double mounds are
untreated control plantations, the multiple
mounds are treated plants.
Domaine des Barges, Vouvry, Valais
canton, Switzerland; late April.

"On 30 June 1997, during our trials, we
made an exceptional discovery: within
one of the control lines, browned by
disease, was a green and healthy potato
plant! It was a natural mutant, resistant
to the fungus attacks. Since then, we
have beeen conserving it preciously, by
replanting it each year (to the right of
the unsown area of the photograph)."

URBAIN ANDERAU, farm researcher, Vouvry, Valais
canton, Switzerland

KARTOFFELN

Versuchskultur. Die unbehandelte
Kontrollgruppe wächst in den doppelt
gehäufelten Reihen, die behandelten
Pflanzen befinden sich in den mehrfach
gehäufelten Reihen.
Domaine des Barges, Vouvry, Kanton
Wallis, Schweiz, Ende April.

„Am 30. Juni 1997 haben wir im
Rahmen unserer Versuche eine
interessante Entdeckung gemacht:
Unter den kranken, braunen Pflanzen
einer unbehandelten Kontrollreihe
befand sich eine grüne, gesunde
Kartoffelpflanze. Es handelte sich um
eine natürliche Mutation, die resistent
gegen den Pilzbefall war. Seitdem hegen
und pflegen wir sie und bauen sie jedes
Jahr wieder an (auf der rechten Bildseite
auf dem noch nicht eingesäten
Abschnitt).

URBAN ANDERAU, Agrarforscher, Vouvry, Kanton
Wallis, Schweiz.

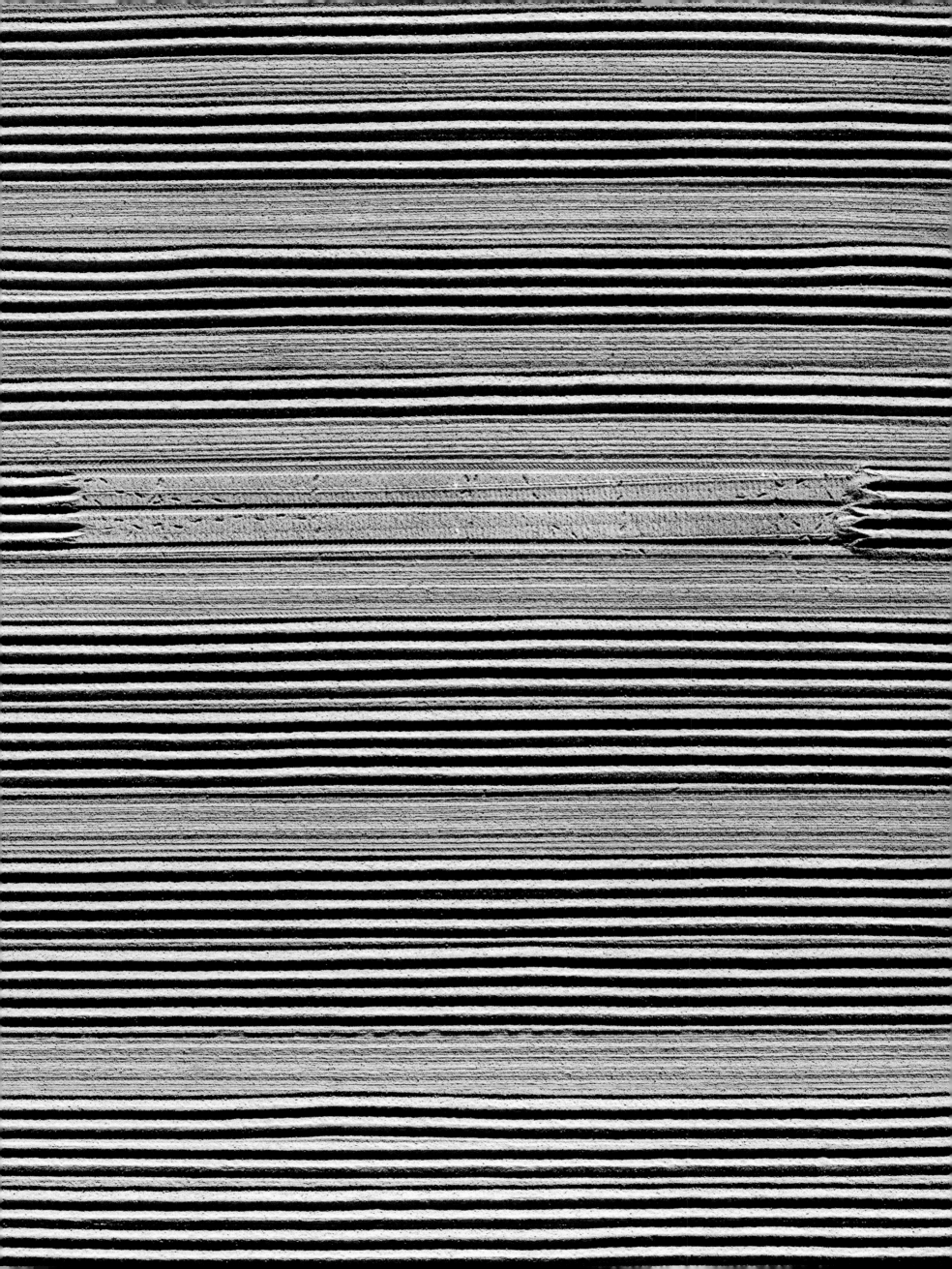

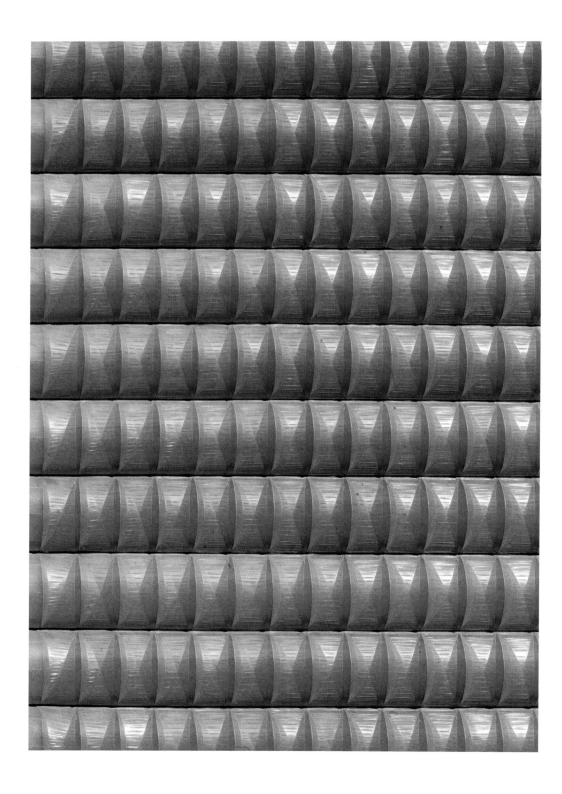

◁ GREENHOUSE LETTUCES
Twinned vegetable tunnels, simple
polythene cover.
Saint-Rémy-de-Provence, Bouches-de-
Rhône, France; July

"I know this farm well. They grow lettuces
in open-air production. The tunnels are
cold, that is unheated. The advantage of
this system is that there is no loss of
land between the tunnels."

Pierre Villin, Richel Serres de France, Eygalières,
Bouches-du-Rhône, France

POLYTUNNELS ▷
Polythene film stretched over a galvanised
steel structure 8m wide.
Saint-Rémy-de-Provence, Bouches-de-
Rhône, France; July

"Due to the intensity of sunlight in the
south of France, we give a three-year
warranty on the plastic film. The
European maps of solar radiation allow
us to calculate the durability of the
films, and adjust our guarantees: up to
five summers in the north, two in the
south."

Didier Strolin, agricultural polythene film
salesman, Arles, Bouches-du-Rhône, France

◁ SALAT UNTER FOLIENTUNNELN
Zusammenhängende Tunnels für den
Gemüseanbau, einfache Abdeckung,
Polyethylen.
Saint-Rémy-de-Provence, Bouches-
du-Rhône, Frankreich, Juli.

„Ich kenne den Betrieb gut. Dort wird
Freilandsalat angebaut. Die Tunnels sind
kalt, also unbeheizt. Der Vorteil dieses
Systems besteht darin, dass zwischen
den Tunneln kein Boden verloren geht."

Pierre Villin, Richel Serres de France, Eygalières,
Bouches-du-Rhône, Frankreich.

FOLIENTUNNEL IM GEMÜSEANBAU ▷
Über eine 8 m breite, verzinkte
Stahlkonstruktion gebreitete
Polyethylenfolie.
Saint-Rémy-de-Provence, Bouches-
du-Rhône, Frankreich, Juli.

„Unter Berücksichtigung der
Sonneneinstrahlung in Südfrankreich
geben wir drei Jahre Garantie auf die
Plastikfolie. Mithilfe von Karten, die
Aufschluss über die Sonnenstrahlung in
Europa geben, können wir die
Haltbarkeit der Folien errechnen und
entsprechende Garantien geben: bis zu
fünf Jahren im Norden und zwei im
Süden."

Didier Strolin, Verkäufer von landwirtschaftlich
genutzten Polyethylenfolien, Arles,
Bouches-du-Rhône, Frankreich.

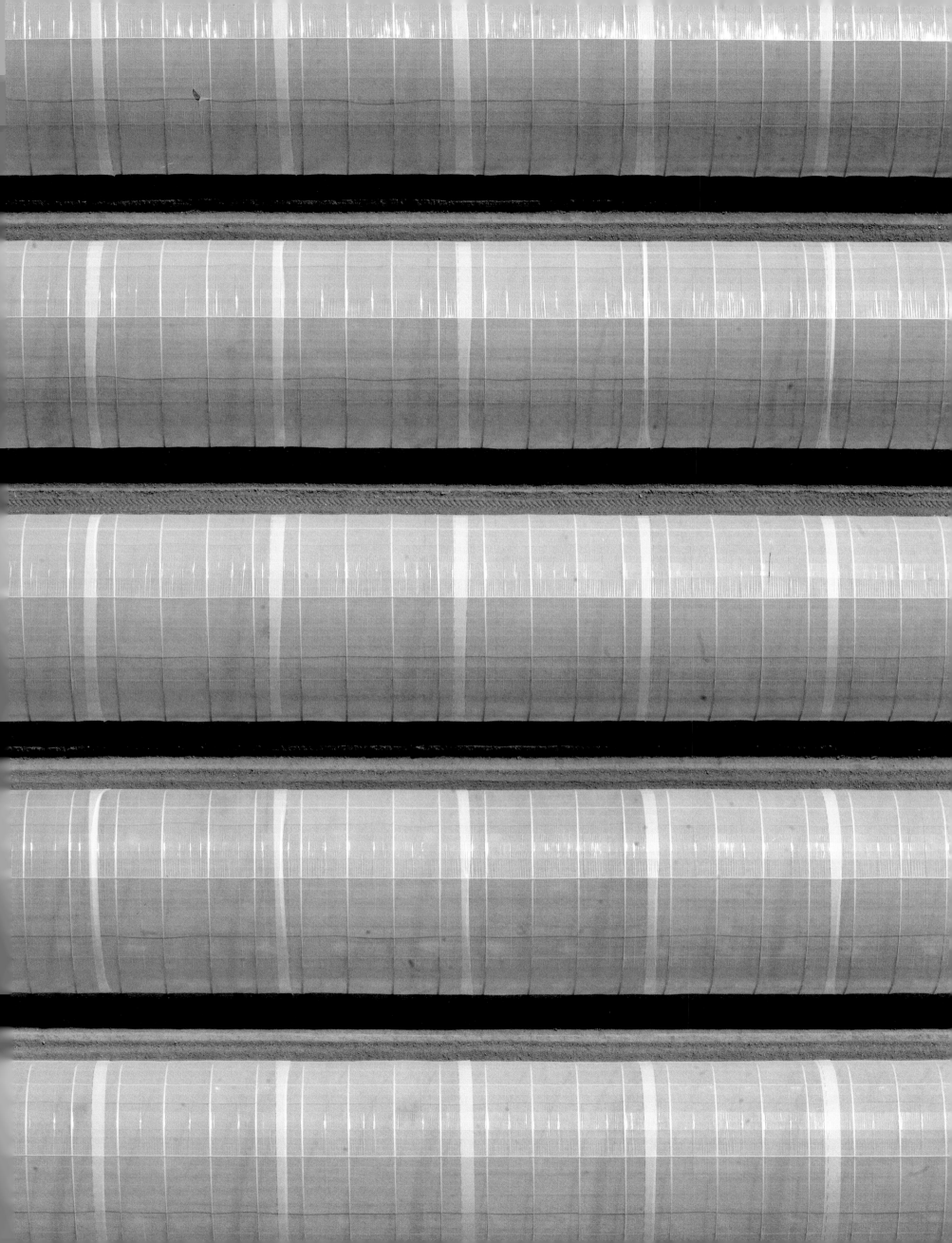

OYSTER AND MUSSEL PARK
Galvanised steel structures, nylon pockets
and algae (green marks).
Thau Lake, Hérault, France; May

"Once a month we have the mussels and
oysters analysed. If the European
standards are not met, production is
halted. Tourism is growing at Thau Lake.
Our oyster and mussel parks take up too
much space in the eyes of windsurfers
and other tourists that use the lake."

MARIE-THÉRÈSE VIGUIER, oyster and shellfish farmer,
Bouzigues, Thau Lake, Hérault, France

AUSTERN- UND MUSCHELZUCHT
Ständerwerke aus verzinktem Stahl,
Netztaschen aus Nylon und Algen
(grüne Flecken).
Étang de Thau, Hérault, Frankreich, Mai.

„Wir lassen die Austern und Muscheln
monatlich in einem Labor untersuchen.
Wenn die europäischen Normen
überschritten werden, unterbrechen wir
die Produktion. Der Etang de Thau wird
zunehmend touristisch genutzt. Unsere
Austern- und Muschelzucht nimmt in
den Augen der Windsurfer und anderer
Wassersportler zu viel Platz ein."

MARIE-THÉRÈSE VIGUIER, Austern- und
Muschelzüchterin. Bouzigues, Étang de Thau,
Hérault, Frankreich.

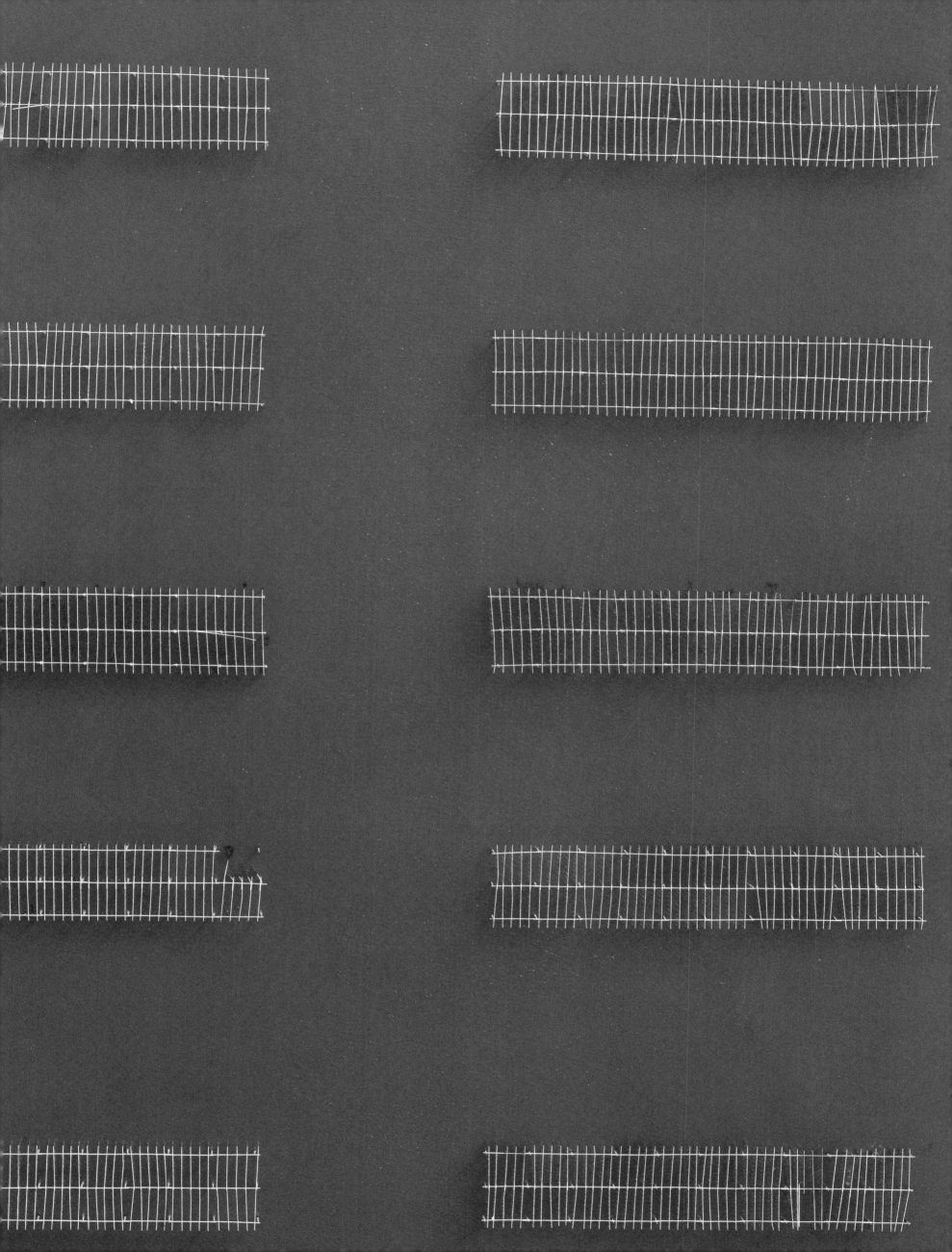

MELONS

Crop of late melons on black plastic
bedding, covered with a polythene veil that
is weighed down with earth.
Each plant is 'earthed up' in the plantation
with white sand.
Saint-Rémy-de-Provence, Bouches-du-
Rhône, France; July

"The industrialisation of the cultivation
and the harvesting of the melon has
not changed its flavour. Here at the
packaging factory, we eliminate not only
damaged melons, but also, with the help
of an infra-red reader, those which do
not have a sufficient sugar content.
A good melon is quite simply a sweet
melon."

AMANDINE TÉTU, biotechnologist, Cavaillon,
Vaucluse, France

MELONEN

Spätmelonen auf schwarzem Plastik,
Abdeckung: mit Erde beschwerte
Polypropylenfolie.
Die Setzlinge werden bei der Pflanzung
mit weißem Sand umschüttet.
Saint-Rémy-de-Provence, Bouches-
du-Rhône, Frankreich, Juli.

„Die Industrialisierung von Anbau und
Ernte der Melonen hat keinen Einfluss
auf ihren Geschmack. Hier in der
Verpackungsfabrik werden nicht nur
die schadhaften Exemplare aussortiert,
sondern auch die Früchte, deren
Zuckergehalt sich bei der
Infrarotprüfung als zu niedrig erweist.
Denn eine gute Melone ist schlicht
und einfach ein süße Melone."

AMANDINE TÉTU, Ingenieurin der Biotechnologie,
Cavaillon, Vaucluse, Frankreich.

MORELLO CHERRY ORCHARD, SNOW
Domaine des Barges, Vouvry, Valais
canton, Switzerland; April

"The marks right at the top of the image
are where we came to pull the jeep out
with the tractor. In the centre are horse
tracks. The two diagonal lines were
made by hares. The rest are probably fox
tracks, and maybe also a dog."

BERNARD MONNIER, farmer, and CHARLY BRESSOUD,
horticulturist, Vouvry, Valais canton, Switzerland

VERSCHNEITE SAUERKIRSCHPLANTAGE
Domaine des Barges, Vouvry, Kanton
Wallis, Schweiz, April.

„Die Spuren oben im Bild sind
entstanden, als wir den Jeep mit dem
Traktor rausgezogen haben. In der Mitte,
das sind Hufspuren von Pferden. Die
beiden Diagonalen, das waren Hasen.
Und die restlichen Spuren sind von
einem Fuchs oder einem Hund."

BERNARD MONNIER, Landwirt, und CHARLY BRESSOUD,
Gärtner, Vouvry, Kanton Wallis, Schweiz.

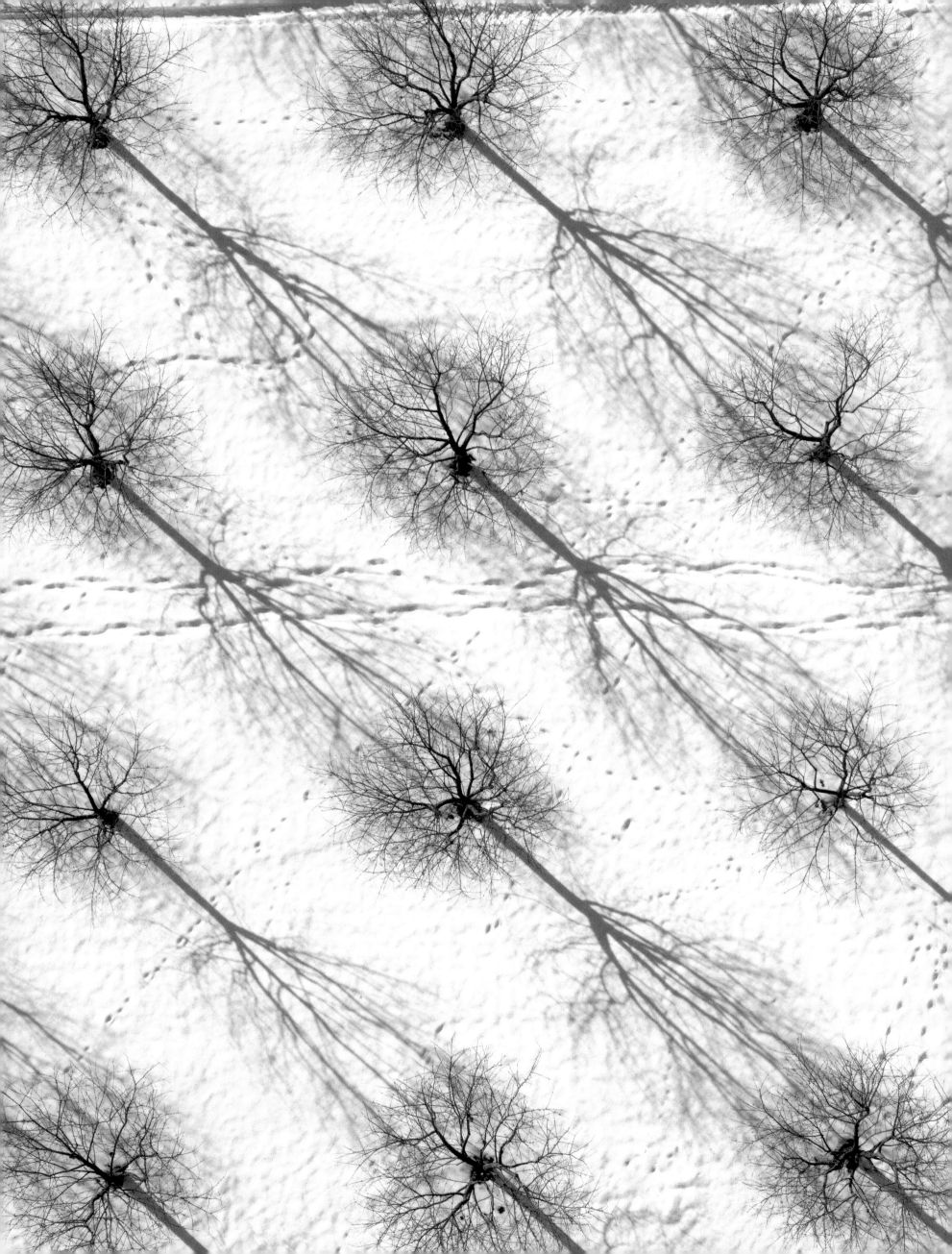

RAPE
A field of rape in bloom.
Chavornay, Vaud canton, Switzerland; May

"There are two sorts of oil which cause
no health concerns, and which are even
supposed to help prevent cardiovascular
illness and cancer: olive oil and
rapeseed oil."

ELIO RIBOLI, doctor of medicine, International
Cancer Research Centre, Lyon, Rhône, France

SEITE 74
RAPS
Rapsfeld in voller Blüte.
Chavornay, Kanton Waadt, Schweiz, Mai.

„Es gibt zwei Öle, die absolut
unbedenklich sind und die
wahrscheinlich sogar
Herzkreislaufkrankheiten und Krebs
vorbeugen: Oliven- und Rapsöl."

ELIO RIBOLI, Doktor der Medizin, Internationales
Krebsforschungszentrum, Lyon, Rhône,
Frankreich.

PAGE 75
MAIZE
Maize plants emerging from very peaty
ground. Green marks of weeds: bindweed.
Bavois, Vaud canton, Switzerland; May

"My great-grandfather turned these
marshes into fields. This black peat is
very fertile, it need little fertiliser, but it
is slowly disappearing, due, partly, to
agricultural activity."

DANDIEL KELLER-GFELLER, farmer, La Bernoise, Vaud
canton, Switzerland

SEITE 75
MAIS
Maiskeimlinge auf stark torfhaltigem
Untergrund. Grüne Unkrautsprenkel:
Ackerwinde.
Bavois, Kanton Waadt, Schweiz, Mai.

„Mein Urgroßvater hat dieses Sumpfland
kultiviert. Der schwarze Torf ist ein sehr
fruchtbarer Boden. Er muss nur wenig
gedüngt werden, doch er wird immer
weniger. Das liegt auch an der
landwirtschaftlichen Nutzung."

DANIEL KELLER-GFELLER, Landwirt, La Bernoise,
Bavois, Kanton Waadt, Schweiz.

WHEAT IN THE BLADE
The shades of greens and yellows are due
to irregular spreading of fertilizer.
Bellechasse Prison, Galmiz, Fribourg
canton, Switzerland; late May

"A vast industrial enterprise wants to
develop the prison land. It will create
jobs, but I believe the decision should be
thought about carefully before giving up
the land as it plays an important social
role: tilling the soil, working the fields or
the vegetable processing line, and
seeing the result of their labours every
day, gives the inmates the desire and
hope to reintegrate themselves into
society."

JÜRG GUTKNECHT-GYSI, market gardener, Ried,
Fribourg canton, Switzerland

GRÜNER WEIZEN
Die verschiedenen Grün- und
Gelbfärbungen sind durch unregelmäßig
versprühte Düngemittel bedingt.
Strafanstalt Bellechasse, Galmiz, Kanton
Freiburg, Schweiz, Ende Mai.

„Hier auf dem Land der Strafanstalt will
sich ein großes Industrieunternehmen
ansiedeln, das Arbeitsplätze schafft.
Meiner Meinung nach sollte man sich
gut überlegen, ob man das Anwesen
wirklich aufgeben will, denn es hat eine
wichtige soziale Funktion: Die Häftlinge,
die das Land bestellen und auf den
Feldern oder am Band in der
Gemüseverarbeitung stehen, haben
täglich das Resultat ihrer Arbeit vor
Augen. Das gibt ihnen Hoffnung und
ermutigt sie, sich in die Gesellschaft
zu integrieren."

JÜRG GUTKNECHT-GYSI, Gemüsebauer, Ried, Kanton
Freiburg, Schweiz.

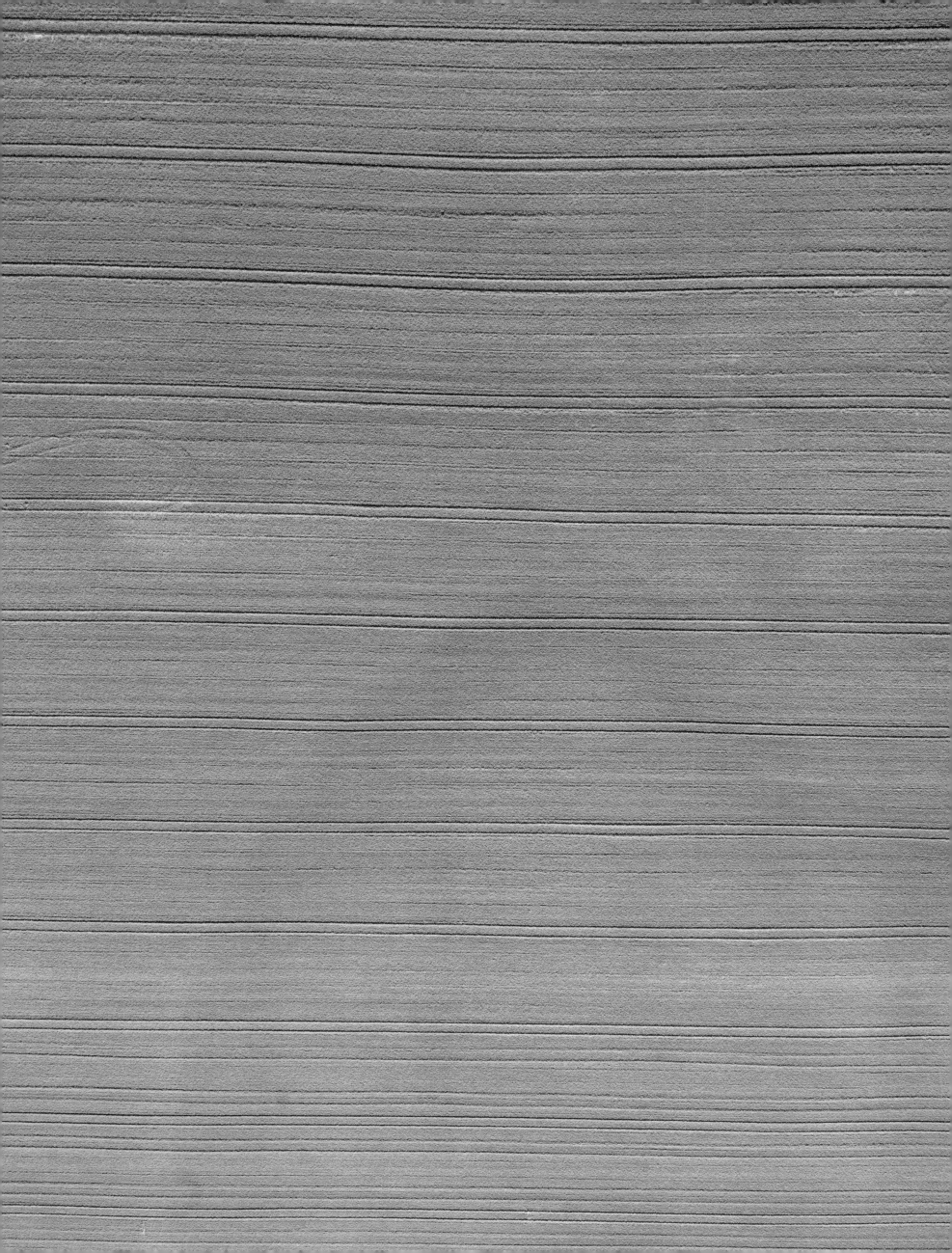

APPLE ORCHARD
Ground partly grassed over, hose pipe.
Saint-Marcel-lès-Valence, Drôme, France;
late March

"The entry of the eastern states, such as
Poland, into the European Community
threatens to change the international
apple market, within which France holds
one of the commanding positions."

BRUNO HUEBOURG, arboricrop advisor, Saint-Rémy-
de Provence, Bouches-du-Rhône, France

APFELPLANTAGE
Boden teilweise mit Gras bewachsen,
Bewässerungsschläuche.
Saint-Marcel-lès-Valence, Drôme,
Frankreich, Ende März.

„Mit der Osterweiterung der EU drohen
Länder wie Polen den internationalen
Markt für Äpfel zu verändern.
Gegenwärtig hält Frankreich dort eine
Spitzenposition."

BRUNO HUCBOURG, Obstbauberater, Saint-Rémy-
de-Provence, Bouches-du-Rhône, Frankreich.

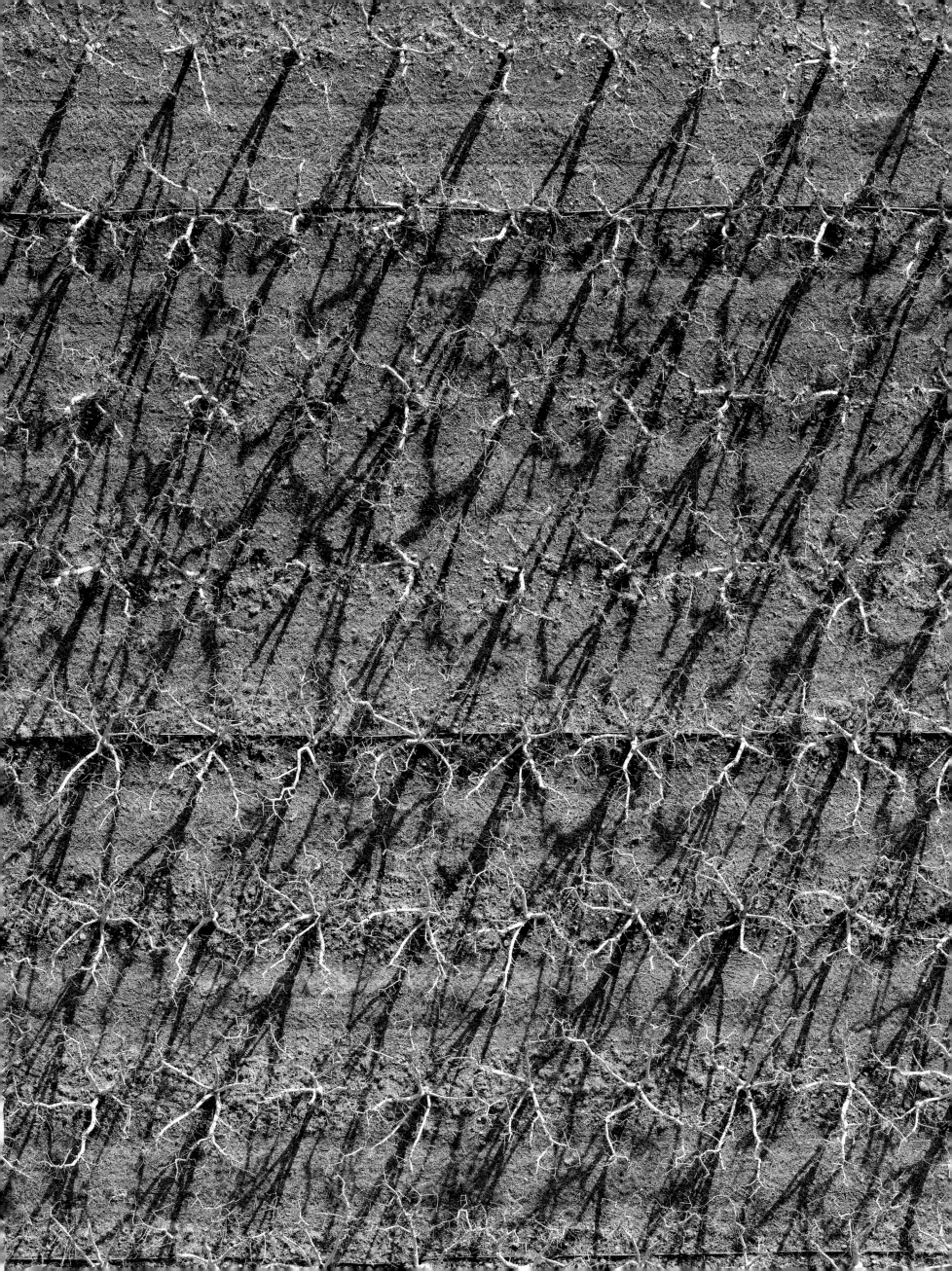

WHITE CABBAGES ▷

Lower Durance Valley, Bouches-du-Rhône, France; September

"The whole of Europe produces normal cabbages which weigh two to three kilos, and are then cut into two or four sections before being sold. In Switzerland, the norm has been reduced to one kilo per cabbage. This is Swiss perfection: we need mini-cabbages for the mini-households of today."

PIERRE TROLLUX, vegetable producer, Noville, Vaud canton, Switzerland

◁ RED CABBAGE

High-density mini-cabbage plantation, the plants in the lower half of the image were planted ten days after those in the upper half.
Noville, Vaud canton, Switzerland; early September

"Small vegetables for small households: in my opinion the rest of Europe will follow suit!"

MAX BALADOU, crop technician, Morges, Vaud canton, Switzerland

WEISSKOHL ▷

Unteres Durance-Tal, Bouches-du-Rhône, Frankreich, September.

„In ganz Europa werden normale, 2 bis 3 kg schwere Kohlköpfe produziert, die in Hälften oder Vierteln verkauft werden. In der Schweiz liegt die Norm inzwischen bei 1 kg pro Kohlkopf. So ist er, der schweizerische Perfektionismus: Die Mini-Haushalte von heute bekommen Mini-Kohlköpfe."

PIERRE TROLLUX, Gemüseproduzent, Noville, Kanton Waadt, Schweiz.

◁ ROTKOHL

Feld mit Mini-Rotkohl, dicht bepflanzt. Das obere Drittel des Bildes wurde zehn Tage später bepflanzt.
Noville, Waadt, Schweiz, Anfang September.

„Kleines Gemüse für kleine Haushalte: Ich glaube, das kommt in ganz Europa!"

MAX BALADOU, Gemüsebautechniker, Morges, Kanton Waadt, Schweiz.

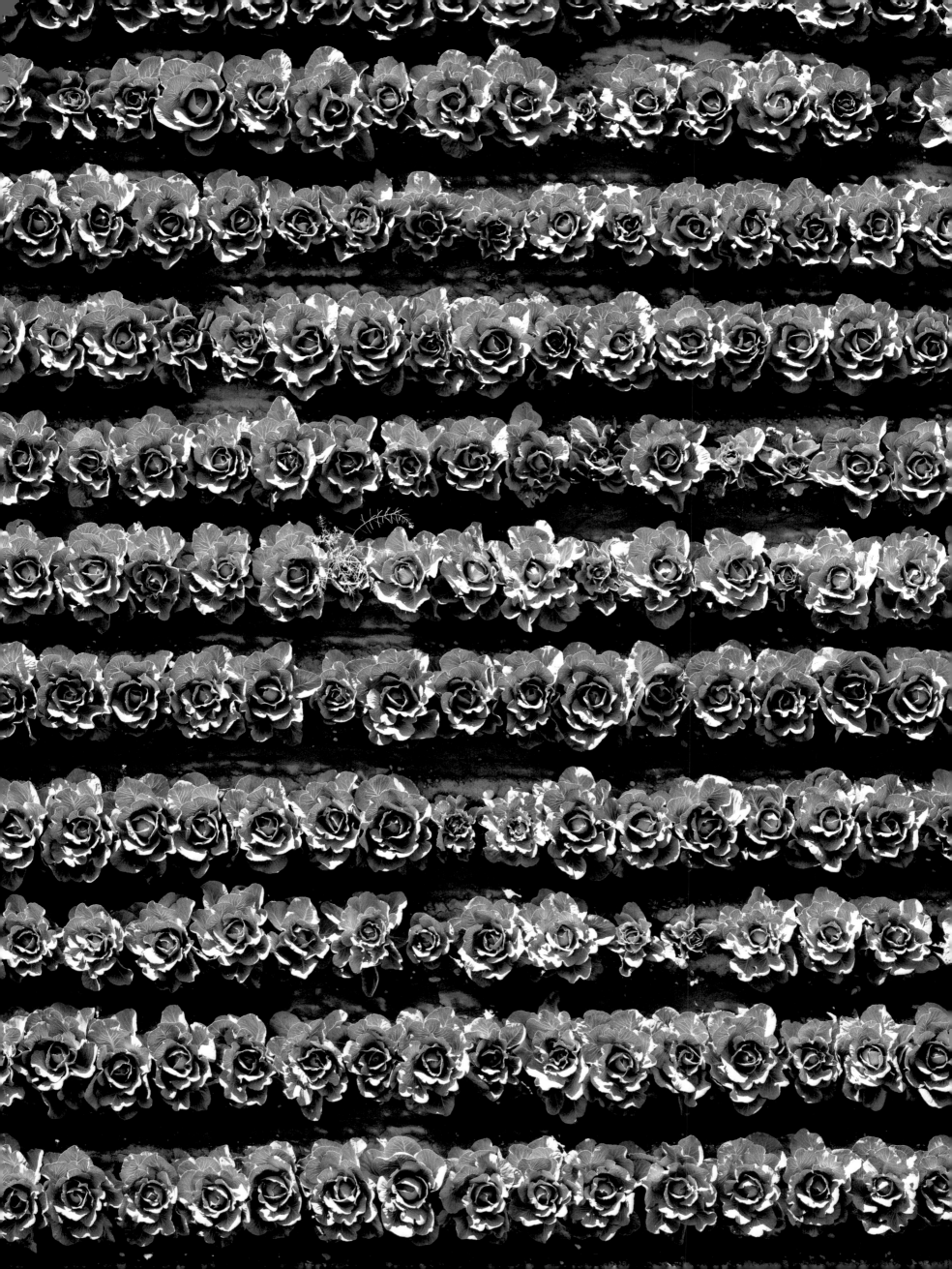

MAIZE SEEDLINGS

Maize seedlings on sandy ground, grassy access track to the left.
Near Noville, Vaud canton, Switzderland; late April

"Here farmers decided to enlarge the size of the fields and to bury drainage pipes, so they could mechanize. In other areas of the Rhône Plain one finds the occasional field that has not been reparcelled, and is still irrigated and drained by open ditches."

FLAVIEN CORNUT, farmer, Vouvry, Valais canton, Switzerland

MAISKEIMLINGE

Maiskeimlinge auf sandigem Grund.
Links mit Gras bewachsener Zugangsweg.
Umgebung von Noville, Kanton Waadt, Schweiz, Ende April.

„Hier haben die Bauern sich entschieden, die Parzellen zu vergrößern und die Entwässerungsrohre unterirdisch zu verlegen, um die Arbeit zu mechanisieren. In anderen Regionen der Rhône-Ebene sieht man hier und da noch Landstücke, wo noch keine Flurbereinigung stattgefunden hat, mit kleinen bewässerten Wiesen und offenen schmalen Entwässerungskanälen."

FLAVIEN CORNUT, Landwirt, Vouvry, Kanton Wallis, Schweiz.

SUNFLOWERS
A collection of different species of wild
sunflowers planted on square micro-plots
of twenty-five plants.
Mauguio, Hérault, France; May

"Domesticated and selected species
have a tendency to progressively lose
their genetic diversity. In order to
understand and control this, we use
collections of wild species as a source
of variety. These allow us to continually
improve and enrich the cultivated
species."

JEAN-MARIE PROSPERI, agronomic engineer,
Mauguio Station, National Institute for
Agronomic Research, Montpelier, Hérault, France

SONNENBLUMEN
Sammlung verschiedener
Wildsonnenblumenarten, angebaut auf
Mikroparzellen zu je 25 Setzlingen.
Mauguio, Hérault, Frankreich, Mai.

„Die durch Selektion domestizierten
Sorten neigen zum Verlust ihrer
genetischen Diversität. Um diese
Entwicklung zu verstehen und zu
kontrollieren, setzen wir Sammlungen
verwandter Wildsorten ein, die für
genetische Vielfalt sorgen. So können
wir die Kultursorten kontinuierlich
verbessern und bereichern."

JEAN-MARIE PROSPERI, Agraringenieur,
Forschungsstation Mauguio, Nationales Institut
für landwirtschaftliche Forschung. Standort
Montpellier, Hérault, Frankreich.

◁ FORGET-ME-NOTS IN BLOOM
Crop of seed-bearers for seed production.
Velleron, Vaucluse, France; early June

"The lower Rhône Plain exports large
quantities of seed. It offers numerous
advantages: long periods of sunlight,
good ventilation, dry clean air, highly
developed irrigation..."

JEAN-CLAUDE GRENIER, agronomist at Top Semence,
La Bâtie-Rolland, Drôme, France

RED FLAX IN BLOOM ▷
Crop of seed-bearers for seed production,
weeds.
Velleron, Vaucluse, France; early June

"The entire world production of red flax
comes from the Rhône Valley, between
Valence and Avignon. The largest part is
exported to the United States where it is
planted along motorways."

ALIX REY, agricultural technician, Clause Tézier,
Valence, Drôme, France

◁ BLÜHENDE VERGISSMEINNICHT
Samenträgerkultur zur Saatgutproduktion.
Velleron, Vaucluse, Frankreich, Anfang Juni.

„Die untere Rhône-Ebene exportiert viele
Samen. Sie verfügt über zahlreiche
Vorteile: lange Sonneneinstrahlung, gute
Windverhältnisse, trockene, gute Luft, ein
ausgereiftes Bewässerungssystem ..."

JEAN-CLAUDE GRENIER, Agraringenieur, Top semence,
La Bâtie-Rolland, Drôme, Frankreich.

BLÜHENDER ROTER FLACHS ▷
Samenträgerkultur zur Saatgutproduktion,
Unkraut.
Velleron, Vaucluse, Frankreich, Anfang Juni.

„Die gesamte Weltproduktion von rotem
Flachs stammt aus dem Rhône-Tal
zwischen Valence und Avignon. Ein
Großteil wird in die USA exportiert, wo
damit Autobahnen begrünt werden."

ALIX REY, Agrartechniker, Clause Tézier, Valence,
Drôme, Frankreich.

POTATOES, MAIZE, GRASS
Above, mounded potatoes, bush; below,
maize seedlings separated by a grass strip;
peaty soil.
Chiètres, Fribourg canton, Switzerland;
late May

"In the top left of the image, a bush or
young tree was planted to 'diversify the
landscape' and act as a perch for birds
of prey. It allows the farmer to obtain a
subsidy. Below, in the middle of the
maize, the large grassy band 5 or 6m
wide is there to comply with ecological
requirements (an insect refuge) and is
rewarded with another subsidy."

JÜRG GUTKNECHT-GYSI, market gardener, Ried,
Fribourg canton, Switzerland

KARTOFFELN, MAIS, GRAS
Oben: aufgehäufte Kartoffeln, Strauch.
Unten: eingesätes Maisfeld, abgetrennt
durch einen Grasstreifen. Torfboden.
Chiètres, Kanton Freiburg, Schweiz,
Ende Mai.

„Der Strauch oder junge Baum oben links
im Bild wurde zur 'Diversifizierung der
Landschaft' und als Ruheplatz für
Raubvögel gepflanzt. Damit hat der
Landwirt Anrecht auf eine Subvention.
Der 5 bis 6 m breite Grasstreifen unten
im Maisfeld ist ein Tribut an die Umwelt
(Lebensraum für Insekten) und wird
ebenfalls mit Subventionen belohnt."

JÜRG GUTKNECHT-GYSI, Gemüsebauer, Ried, Kanton
Freiburg, Schweiz.

MAIZE

Maize stubble after the harvest.
In the region of Saint-Andinol, Bouches-du-
Rhône, France; late October

"In Quebec at the end of summer, we go
to a farm to collect corn cobs to organise
a 'corn peeling': we make a large wood
fire to cook the cobs, then we peel and
eat them. Often two ears are coloured,
and whoever finds one of these
becomes the king or queen of the party."

CLAUDINE DESCHÉNES, landscape architect,
Montreal, Quebec, Canada

MAIS

Maisstoppelfeld nach der Ernte.
Region Saint-Andiol, Bouches-du-Rhône,
Frankreich, Ende Oktober.

„In Québec geht man am Ende des
Sommers zum Bauern, um Maiskolben
für die 'épluchette de blé d'Inde' zu
holen, ein traditionelles
Maiskolbenessen: Man macht ein
großes Holzfeuer, grillt die Maiskolben
darin, schält und isst sie. Es gibt häufig
zweifarbige Maiskolben, und die, die sie
bekommen, sind König und Königin des
Festes."

CLAUDINE DESCHÉNES, Landschaftsarchitektin,
Montreal, Québec, Kanada.

BATAVIA SALAD IN POLYTUNNELS
Two stages of growth of blond batavia
salad, under a steel structure with
transparent polythene film.
Lower Durance Valley, Vaucluse, France;
late October

"Lettuce is offered more and more often
as a ready-to-eat product: it is sold in
plastic bags in a controlled chilled
environment... it's fresh, it's crunchy
and it's practical."

GÉRALD BÉZERT, farmer, Velleron, Vaucluse, France

BATAVIASALAT IM FOLIENTUNNEL
Grüner Bataviasalat in zwei
unterschiedlichen Wachstumsphasen
unter verzinkter Stahlkonstruktion und
transparenter Polyethylenfolie.
Unteres Durance-Tal, Vaucluse, Frankreich,
Ende Oktober.

„Salat wird immer häufiger verzehrfertig
angeboten: im Plastikbeutel, gekühlt,
hygienisch abgepackt ... Er ist frisch,
knackig und praktisch."

GÉRALD BÉZERT, Landwirt und Gemüsebauer,
Velleron, Vaucluse, Frankreich.

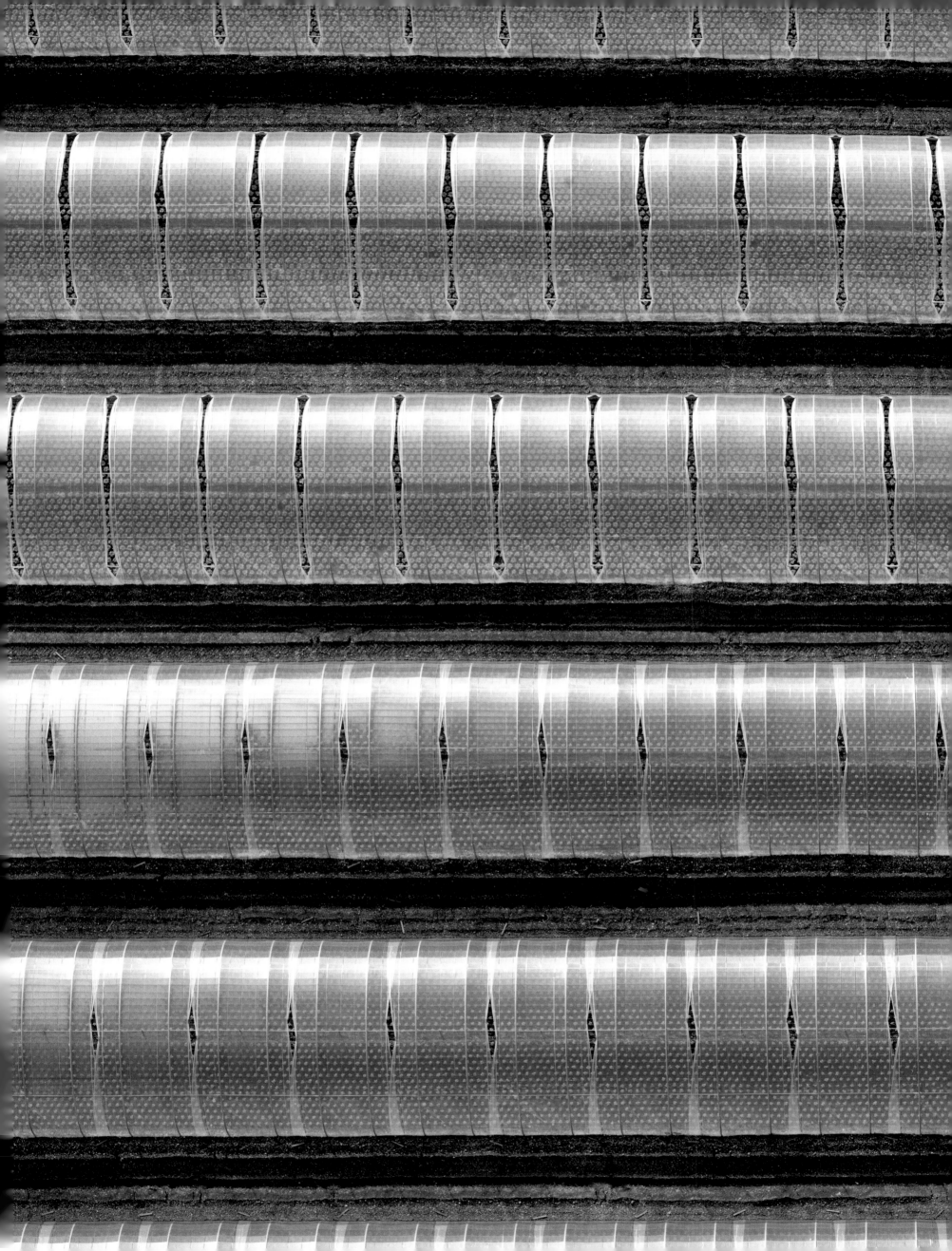

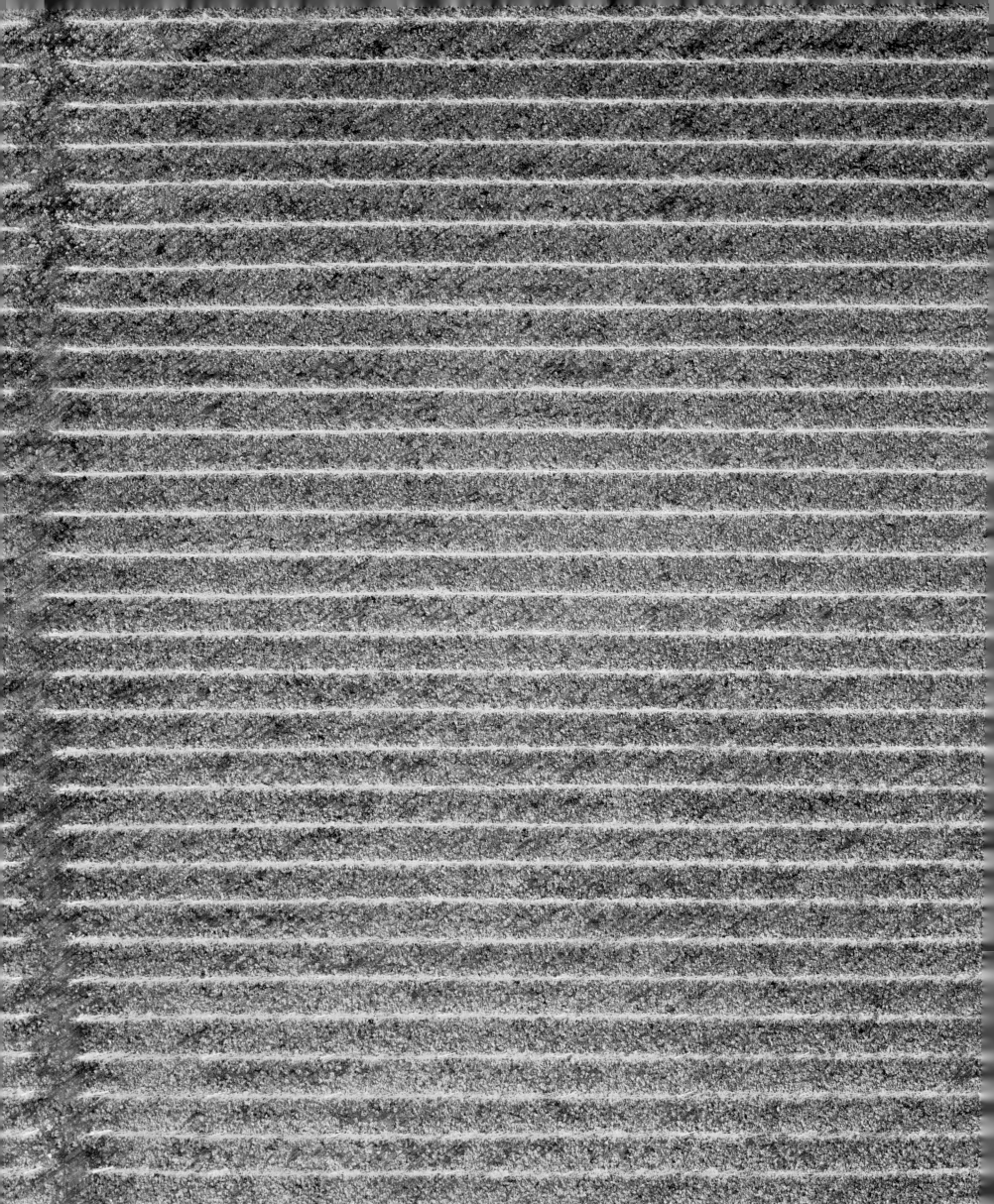

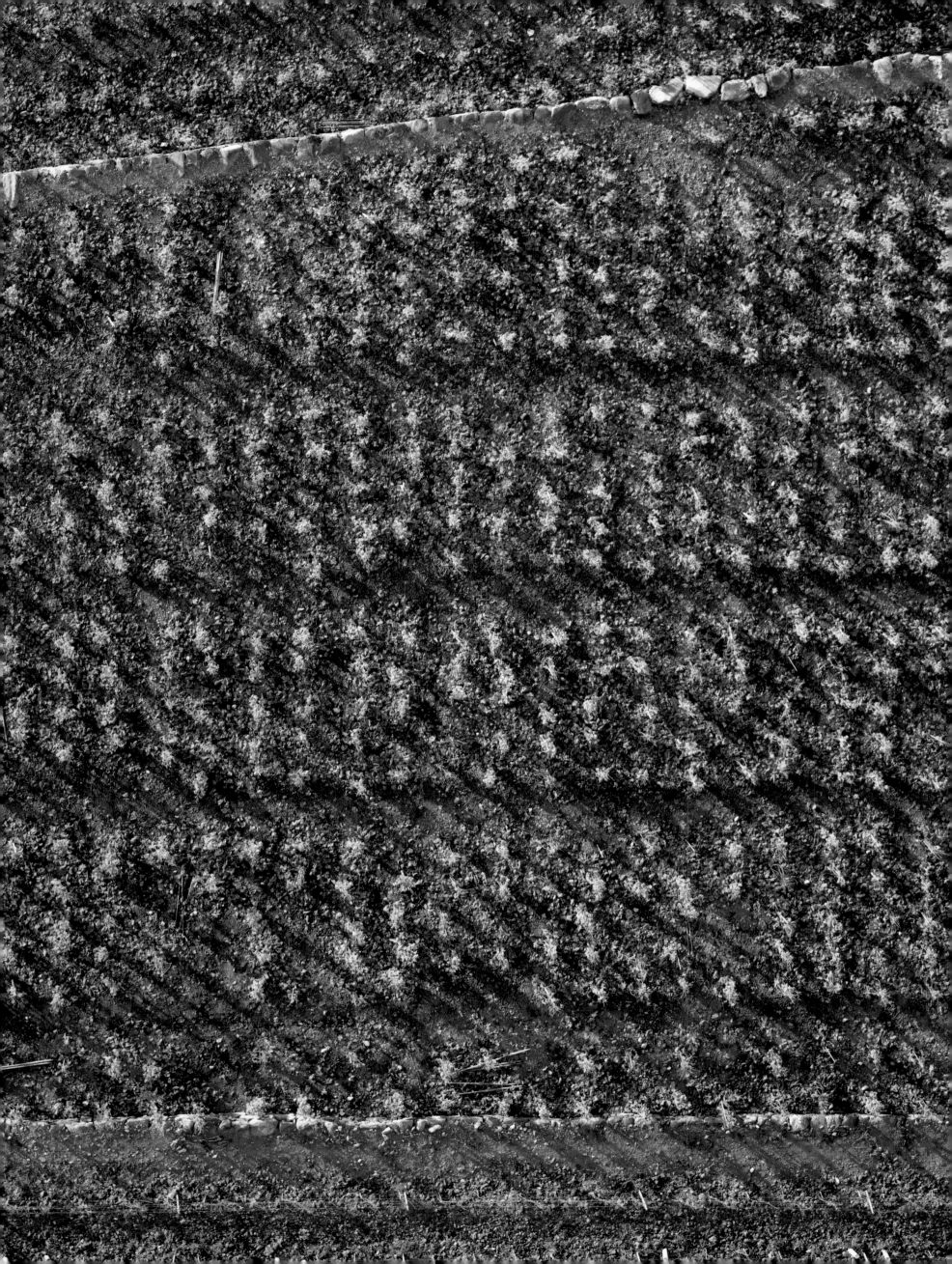

VINEYARD IN AUTUMN
White grapes, stony ground covered with
fallen leaves, access track.
Chamoson, Valais canton, Switzerland;
November

"Our dégustation and direct-sales centre
has brought together over 70 vintners. It
is thanks to the work of all these small
individual producers that the large-scale
producers have been forced to improve."

Jean-Paul Bruchez, sommelier, Leytron Wine
Centre, Valais canton, Switzerland

WEINBERG IM HERBST
Weiße Rebsorte, steiniger, von Weinlaub
bedeckter Boden, Zugangsweg.
Chamoson, Kanton Wallis, Schweiz,
November.

„Hier in diesem Zentrum haben sich über
70 Kellereien zusammengeschlossen.
Neben dem Direktverkauf gibt es auch
Weinproben. Der Arbeit dieser kleinen
Winzer ist es zu verdanken, dass auch
die großen ihren Qualitätsstandard
verbessern mussten."

Jean-Paul Bruchez, Sommelier, Önothek von
Leytron, Kanton Wallis, Schweiz.

TERRACED VINES, LOW WALLS
Goblet-pruned white grapes.
Riddes, Valais canton, Switzerland; November

"We start with the asparagus in April
with six men, and then six women arrive
for the strawberries in May and the apricots
in June. We are fifteen for the pears in
August, then twenty-five for the apples
and grapes until the end of October. We
keep the six men on until Christmas to
prune the trees, then in winter they all
go to Portugal, which is why there are
only three of us — myself, my father and
my brother — to prune these few vines."

Pascal Gilloz, farmer, Riddes, Valais canton,
Switzerland

TERRASSENFÖRMIG ANGELEGTER
WEINBERG, MÄUERCHEN
Gobeleterziehung, weiße Rebsorte.
Riddes, Kanton Wallis, Schweiz, November.

„Zur Spargelzeit im April beginnen wir
mit sechs Männern, dann kommen für
die Erdbeeren im Mai und die Aprikosen
im Juni sechs Frauen dazu. Für die
Birnen im August sind wir 15, dann bis
Ende Oktober 25 für die Äpfel und den
Wein. Für das Beschneiden der Bäume
behalten wir bis Weihnachten sechs
Männer hier, und im Winter sind alle in
Portugal. Dann sind wir nur noch zu
dritt, mein Vater, mein Bruder und ich,
um die paar Parzellen Wein zu
beschneiden."

Pascal Gilloz, Landwirt, Riddes, Kanton Wallis,
Schweiz.

PADDYFIELD
Rice stubble burnt after the harvest.
Near Arles, Bouches-du-Rhône, France;
September

"I burn the rice straw because it does
not decompose well."

Denis Pelouzet, farmer, Saint-Etienne-du-Grès,
Bouches-du-Rhône, France

REISFELD
Abgebranntes Reisfeld nach der Ernte.
Umgebung von Arles, Bouches-du-Rhône,
Frankreich, September.

„Ich verbrenne das Reisstroh, weil es
sonst sehr schlecht verrottet."

Denis Pelouzet, Landwirt, Saint-Étienne-du-Grès,
Bouches-du-Rhône, Frankreich.

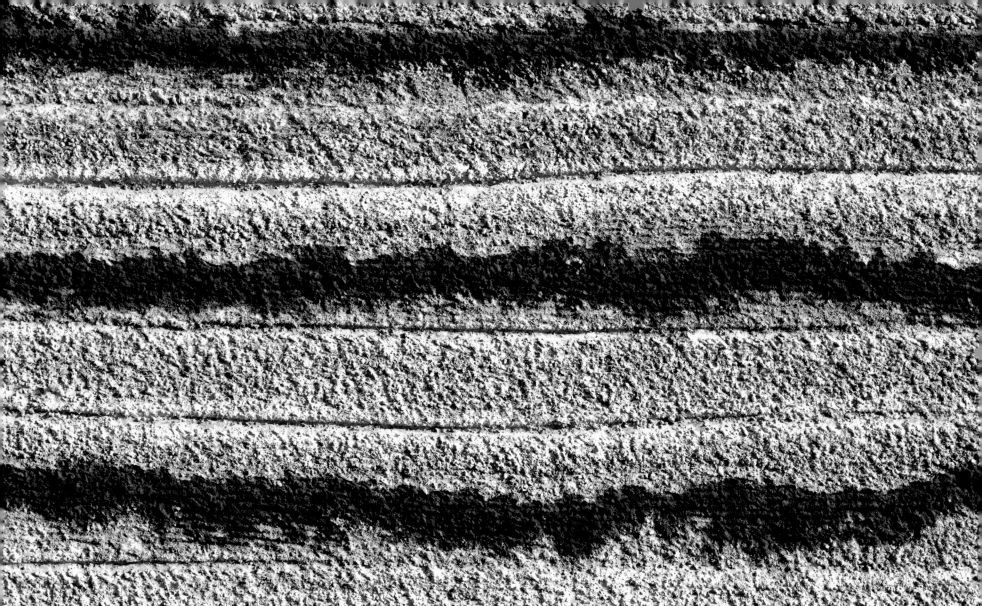

NURSERY

Production of garden plants in pots.
Senas, Bouches-du-Rhône, France;
September

"Potted plants require constant
attention, but they can be sold
throughout the year."

GILLES PUJANTE, horticulturalist, nurseryman
and landscaper, Saint-Rémy de Provence,
Bouches-du-Rhône, France

BAUMSCHULE

Produktion von Gartenpflanzen im Topf.
Senas, Bouches-du-Rhône, Frankreich,
September.

„Topfpflanzen machen viel Arbeit, doch
man kann sie das ganze Jahr über
verkaufen."

GILLES PUJANTE, Gärtner und Landschaftsgestalter,
Saint-Rémy de Provence, Bouches-du-Rhône,
Frankreich.

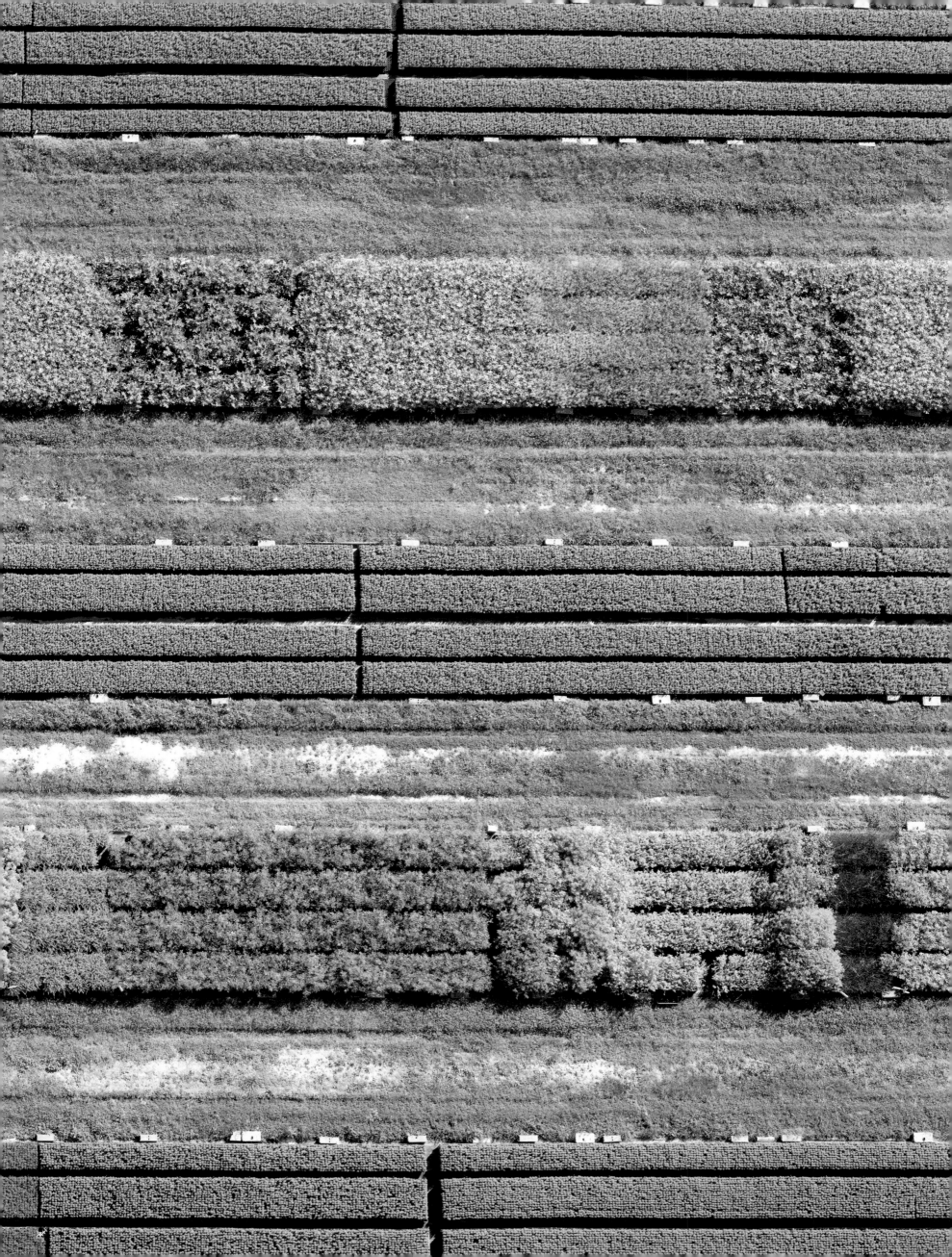

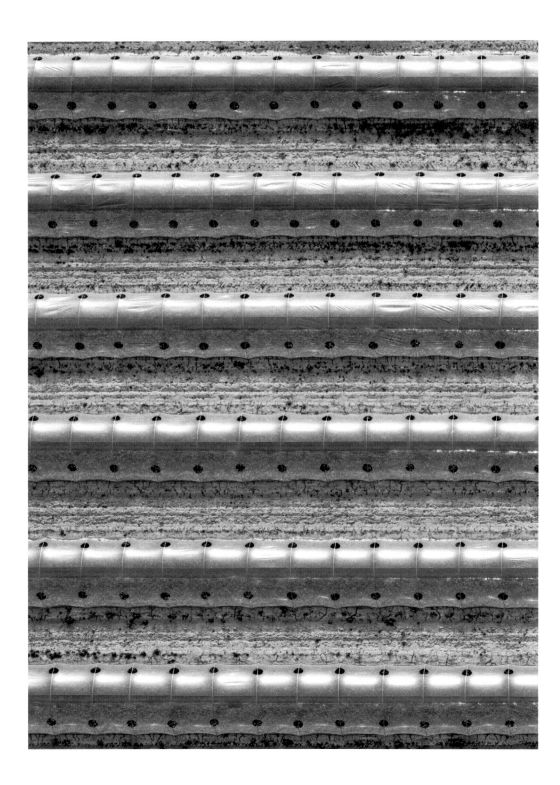

◁ MELONS
Late crop, started under a polytunnel; the
holes help with aeration and pollination.
Cadenet Region, Vaucluse, France;
early June

"Cultivating the crop in polytunnels
allows us to guarantee delivery dates
despite weather changes."

PIERRE VILLIN, Richel Serres de France, Eygalières,
Boûches-de-Rhône, France

MELONS ▷
Outdoor melon crop in a field with a
windbreak made of giant reeds.
Cadenet Region, Vaucluse, France; early
June

"The first netted melons arrived from
America around 1965. They do not split,
there is less waste and they are more
resistant to shocks and pressure.
Today 90 per cent of the melons grown
outdoors are netted melons. The smooth
melon, which is more fragile, is almost
only grown in greenhouses."

EDOUARD AND STÉPHANE DRÔME, arboriculturists at
EARL Drôme, La Capelle-Masmolène, Gard, France

◁ **MELONEN**
Spätmelonen. Anzucht im Folientunnel,
die Löcher dienen der Belüftung und
Bestäubung.
Region Cadenet, Vaucluse, Frankreich,
Anfang Juni.

„Mit dem Anbau im Folientunnel kann
man das Lieferdatum trotz ungünstiger
Witterungsbedingungen garantieren."

PIERRE VILLIN, Richel Serres de France, Eygalières,
Bouches-du-Rhône, Frankreich.

MELONEN ▷
Freilandkultur mit Windschutz aus
Schilfrohr.
Region Cadenet, Vaucluse, Frankreich,
Anfang Juni.

„Die ersten Netzmelonen wurden hier
1965 angebaut. Da sie nicht aufplatzen,
gibt es weniger Ausschuss. Außerdem
sind sie sehr druck- und stoßfest. Heute
sind 90% der Freilandmelonen
Netzmelonen. Die früher reifen
Honigmelonen werden fast nur noch im
Treibhaus angebaut."

EDOUARD UND STÉPHANE DROME, Obstbauern, EARL
Drome, La Capelle-Masmolène, Gard, Frankreich.

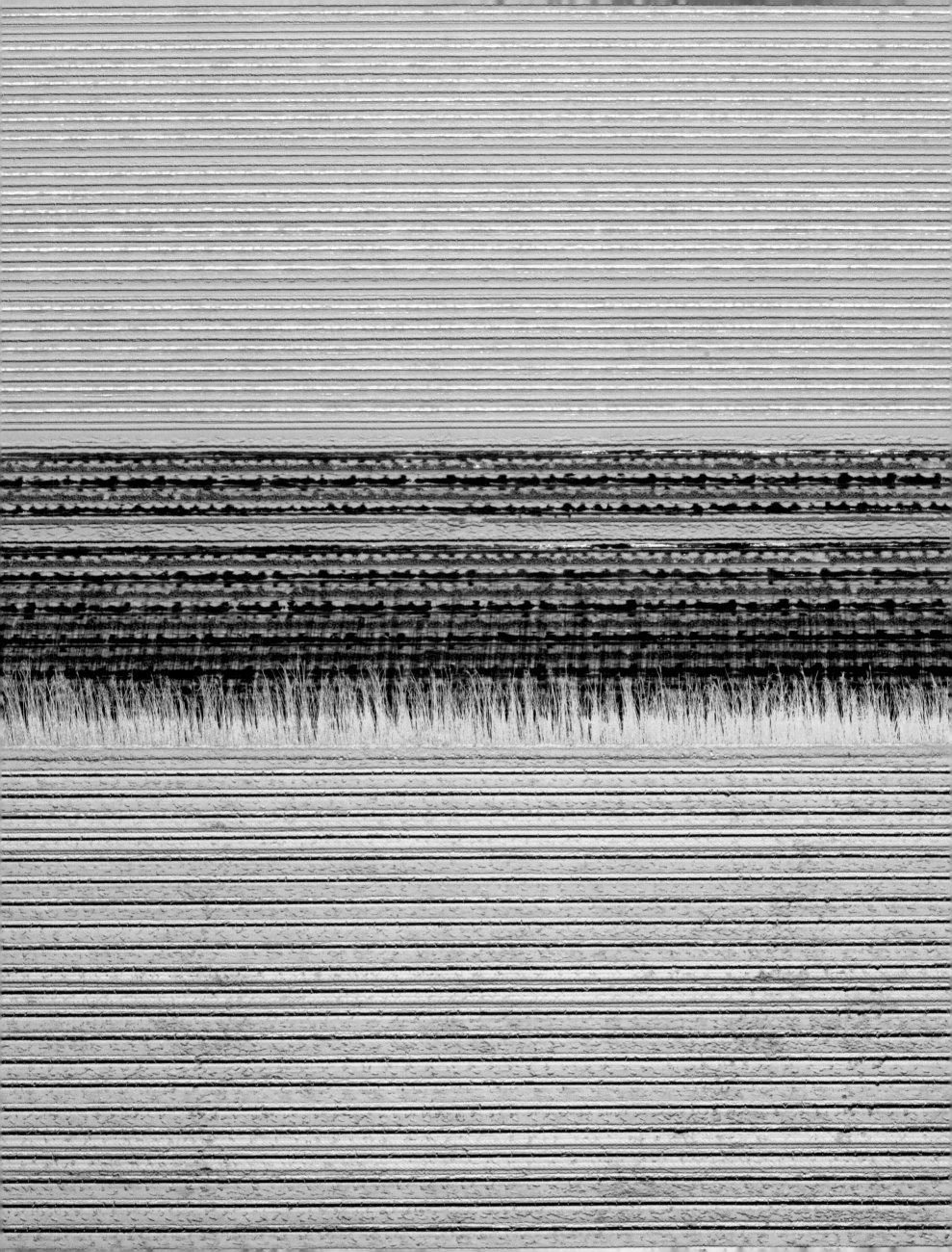

DELPHINIUMS

Seed-bearing crop for seed production: violet species and sweet alyssum self-seeded from the previous year.
Velleron, Vaucluse, France; early June

"If the seed purity is insufficient or if their germination capability is below standard, the seed merchants do not pay for the crop."

BRUNO DOCHE, farmer, Velleron, Vaucluse, France

RITTERSPORN

Samenträgerkultur zur Saatgutproduktion: violette Sorte, außerdem nachwachsendes weißes Steinkraut aus der Kultur des Vorjahres.
Velleron, Vaucluse, Frankreich, Anfang Juni.

„Wenn das Saatgut nicht über die erforderliche Reinheit oder die vertraglich zugesicherte Keimfähigkeit verfügt, bezahlt der Samenhändler die Ernte nicht."

BRUNO DOCHE, Landwirt, Velleron, Vaucluse, Frankreich.

OLIVE GROVES

Trees with more than one trunk, pruned
into goblets, on scratched soil.
La Fare-les-Oliviers, Bouches-du-Rhône,
France; September

"The month of January 1956 was so
mild that the tree sap had already risen.
On the 31st, the men were pruning in
short sleeves. During the night the
temperature dropped to -18 °C, and this
lasted a month! When the thaw came we
heard the trees split one after the other.
What a catastrophe! Not a single olive
for five years. In March the olive trees
were cut down, and later in spring the
shoots grew out of the stumps. This is
why, today, each of these trees forms a
circle of many trunks. This pruning into
a goblet shape clears the heart of the
tree in order to favour the fruiting
branches and the ripening of the olives."

JEAN-BAPTISTE QUENIN, miller, Moulin des Barres,
Maussane-les-Alpilles, Bouches-du-Rhône,
France

OLIVENPLANTAGE

Mehrstämmige Bäume im Gobeletschnitt,
gegrubberter Boden.
La Fare-les-Oliviers, Bouches-du-Rhône,
Frankreich, September.

„Der Januar 1956 war so mild, dass die
Bäume schon ausschlugen. Am 31.
beschnitten die Männer die Bäume in
Hemdsärmeln. Nachts ist die Temperatur
dann auf -18 °C gefallen, und es ist einen
Monat lang so kalt geblieben. Als es
dann taute, hörte man einen Baum nach
dem anderen zerbersten. Eine
Katastrophe. Fünf Jahre lang keine
einzige Olive. Im März wurden die
Olivenbäume gefällt, im Frühjahr sind
dann neue Schösslinge rund um die
Stümpfe ausgetrieben. Daher haben die
Bäume heute mehrere Stämme.
Außerdem liegt durch den Gobeletschnitt
das Herz des Baumes offen, was Platz für
die Fruchtzweige schafft und der Reifung
der Oliven zugute kommt."

JEAN-BAPTISTE QUENIN, Müller, Moulin des Barres,
Maussane-les-Alpilles, Bouches-du-Rhône,
Frankreich.

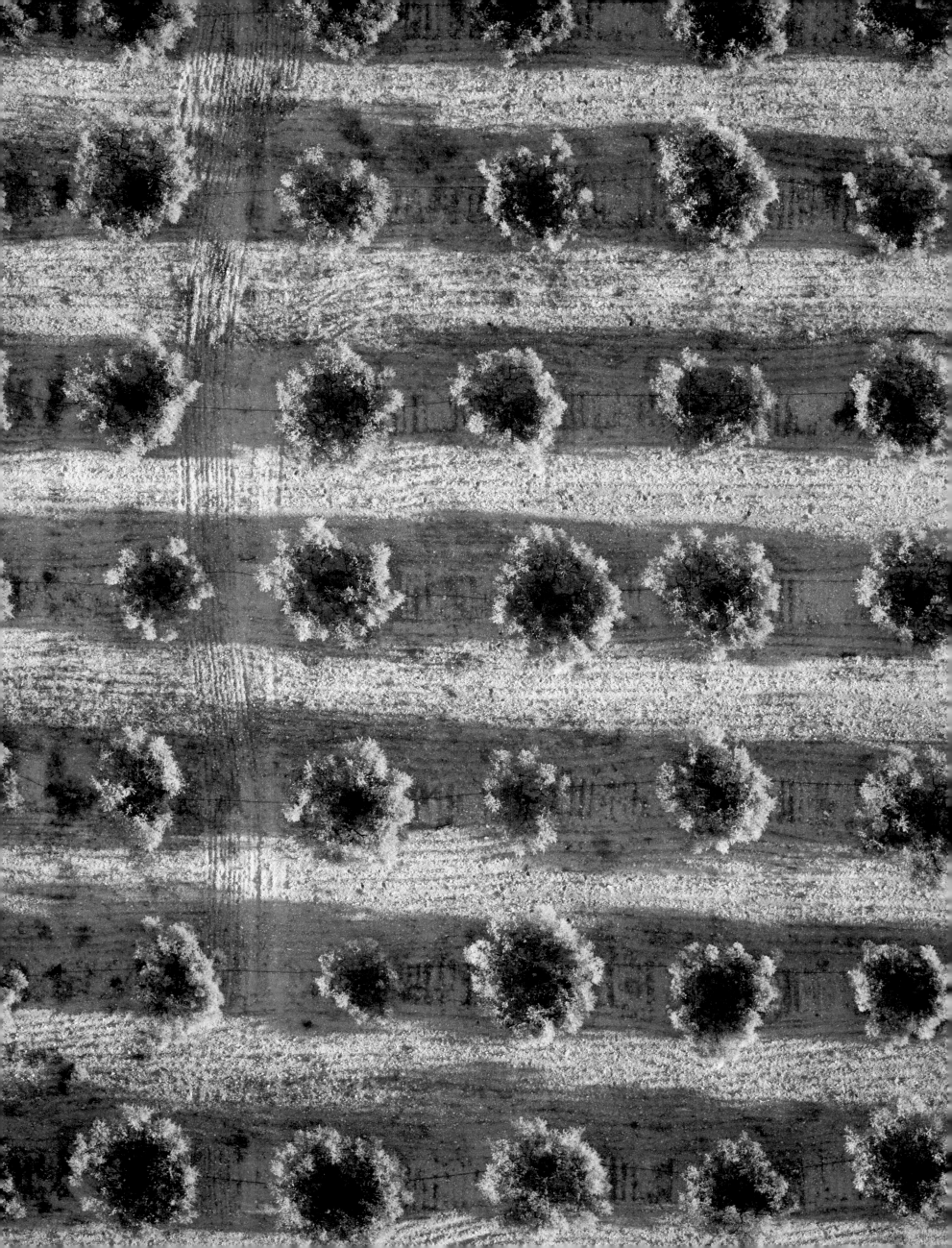

◁ BARLEY
Mature crop, grown as fodder.
Near Montélimar, Drôme, France; early June

SORGHUM ▷
Fodder cereal.
Germination less regular than maize, plant
rows stand closer together.
Beaumont-lès-Valence, Drôme, France;
early June

"The Drôme cereal cooperative has an
output of over 200,000 tonnes a year,
of which half is maize, a quarter wheat,
and the rest other cereals both
oleaginous and proteaginous. All of this
is produced in six months and used over
the whole year, primarily for livestock.
The mass capitalisation, the degree of
managed production and the length of
the yearly cycle make agriculture a
heavy industry."

Paul Vindry, agricultural advisor, Valsoleil
Cooperative, Montelier, Drôme, France

◁ GERSTE
Reife Gerste, als Viehfutter bestimmt.
Umgebung von Montélimar, Drôme,
Frankreich, Anfang Juni.

SORGHUM ▷
Als Viehfutter vorgesehenes Getreide.
Weniger regelmäßige Keimung als beim
Mais, engere Pflanzreihen.
Beaumont-lès-Valence, Drôme, Frankreich,
Anfang Juni, .

„Bei der Getreidegenossenschaft der
Drôme kommen jährlich mehr als 200
Tonnen Getreide zusammen: Die Hälfte
davon ist Mais, ein Viertel Weizen, und
der Rest besteht aus anderen ölhaltigen
oder proteinreichen Getreidesorten. Das
Ganze wird binnen eines halben Jahres
produziert und im Verlaufe eines Jahres
verbraucht, in erster Linie als Viehfutter.
Die massive Kapitalisierung, die
Massenproduktion und der ein Jahr
währende Zyklus machen die
Landwirtschaft zu einer regelrechten
Schwerindustrie."

Paul Vindry, Agrarberater, Genossenschaft
Valsoleil, Montelier, Drôme, Frankreich.

OREGANO OR MARJORAM

Crop of aromatic plants: four different
oregano clones are alternated to breed
new hybrids, irrigation pipes.
La Bâtie-Rolland, Drôme, France;
early June

"My goal is agriculture with a greater
respect for man and nature: organic
agriculture."

MURIEL SAUSSAC, agronomist, Institut technique
interprofessionnel des plantes à parfum,
médicinales et aromatiques [technical institute
of perfumed, medicinal and aromatic plants].
Vesc Experimental Station, La Bâtie-Rolland,
Drôme, France

ORIGANO ODER MAJORAN

Aromapflanzenkultur: regelmäßige
Aufeinanderfolge von vier Oreganoklonen
zur Züchtung von Hybriden,
Bewässerungsrohre.
La Bâtie-Rolland, Drôme, Frankreich,
Anfang Juni.

„Mein Einsatz gilt einer umwelt- und
menschenfreundlichen Landwirtschaft
– der biologischen Landwirtschaft."

MURIEL SAUSSAC, Agraringenieurin, Institut
technique interprofessionnel des plantes
à parfum, médicinales et aromatiques
[Interdisziplinäres technisches Institut für
Duft-, Aroma- und Arzneipflanzen].
Forschungsstation Vesc, La Bâtie-Rolland,
Drôme, Frankreich.

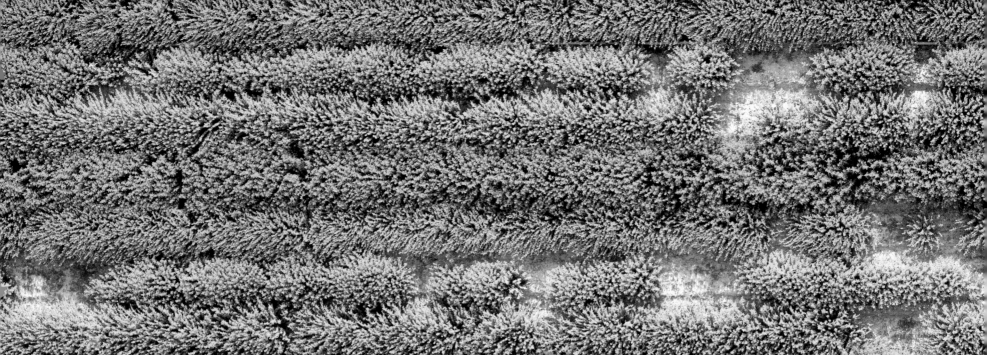

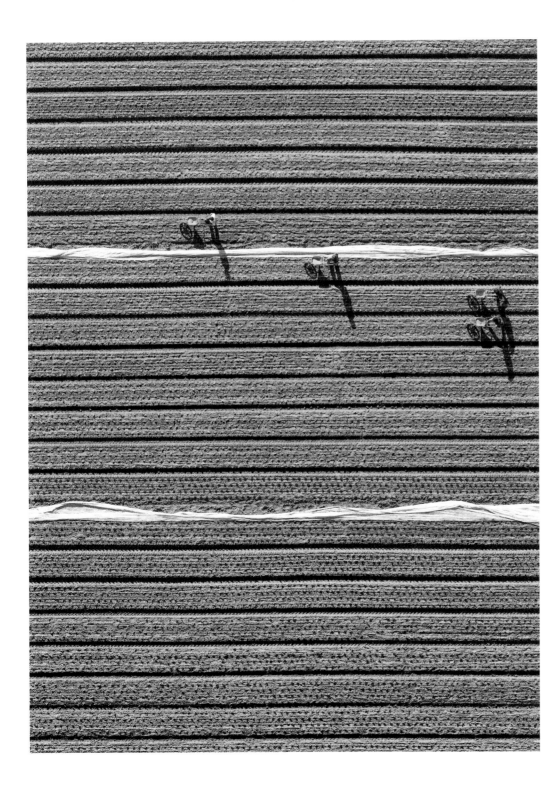

◁ YOUNG LETTUCE PLANTS
Manual spreading of pellet fertiliser.
Rennaz region, Valais canton, Switzerland;
March

"These four guys are almost as quick as
a tractor and don't compact the moist
ground: uncover, recover and it's done!
While on the subject... I think its
unfortunate that there are not more
people in your photographs!"

ROLAND STOLL, vegetable grower, Yverdon-les-
Bains, Vaud canton, Switzerland

YOUNG VEGETABLE PLANTS ▷
Plantation of lettuces and other vegetables
under sheets of polythene weighed down
by plastic sacks filled with earth.
Rennaz, Vaud canton, Switzerland; March

"In order to prepare ourselves for the
end of the last border protection,
it is essential that the fifteen to twenty
vegetable growers from the region form
an association. Yesterday evening, we
had our fist meeting. We managed to
agree on the combined purchase of fuel.
It's a start!"

FRÉDDY AND JULIEN BRÖNNIMANN, vegetable growers,
Noville, Vaud canton, Switzerland

◁ JUNGE SALATPFLANZEN
Manuelle Düngung mit Granulat.
Region Rennaz, Kanton Wallis, Schweiz,
März.

„Die vier Jungs sind beinahe genauso
schnell wie ein Traktor und stampfen
dabei nicht den feuchten Boden fest:
Folie runter, Folie drauf ... und fertig!
Übrigens ... Ich finde es schade, dass
nicht häufiger Menschen auf Ihren
Bildern sind."

ROLAND STOLL, Gemüseproduzent, Yverdon-les-
Bains, Kanton Waadt, Schweiz.

JUNGE GEMÜSEPFLANZEN ▷
Salate und andere Gemüse unter
Polypropylenfolie, beschwert mit
Erde gefüllten Plastiktüten.
Rennaz, Kanton Waadt, Schweiz, März.

„Bald fallen die letzten Zollschranken.
Darum müssen sich die 15 bis 20
Gemüseproduzenten der Region
zusammentun. Gestern Abend hatten
wir unsere erste Versammlung und
haben uns darauf geeinigt, unseren
Treibstoff gemeinsam zu kaufen.
Das ist schon mal ein Anfang!"

FRÉDDY UND JULIEN BRÖNNIMANN, Gemüsebauern,
Noville, Kanton Waadt, Schweiz.

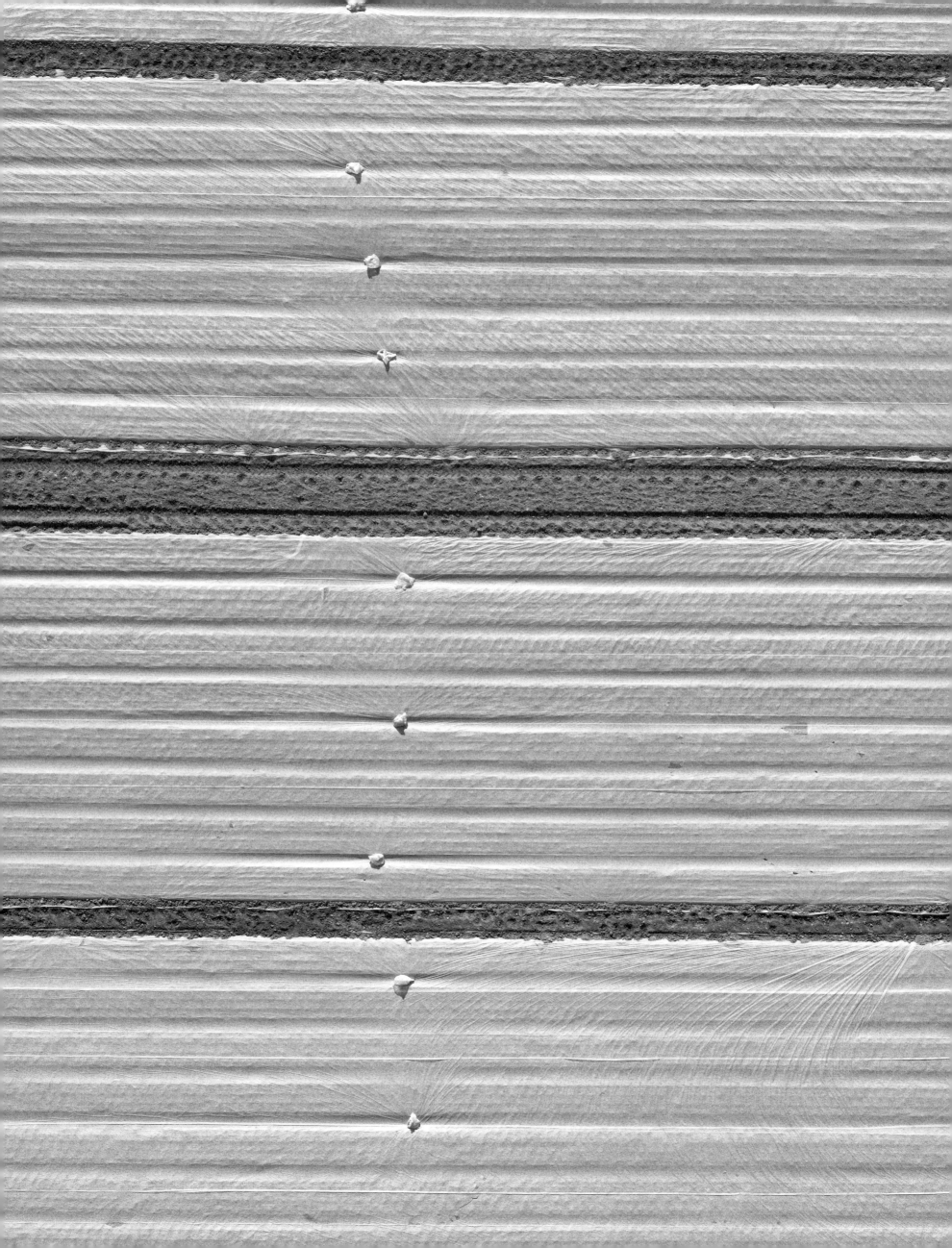

APPLE ORCHARD

The 'green' pruning of the secondary
branches has just been undertaken, to
allow more light to reach the fruit. The cut
branches are still lying on the ground.
Around Saint-Andiol, Boûches-du-Rhône,
France; late October

"We sell our fruit harvest direct to the
transporters, without the cooperative. It
means more work, but it is better paid."

ÉDOUARD AND STÉPHANE DRÔME, arboriculturists,
La Capelle-Masmolène, Gard, France

APFELPLANTAGE

Plantage direkt nach dem Grünschnitt,
bei dem die Bäume ausgelichtet werden,
damit die Früchte mehr Licht haben.
Die abgeschnittenen Zweige liegen noch
auf dem Boden.
Region Saint-Andiol, Bouches-du-Rhône,
Frankreich, Ende Oktober.

„Wir verkaufen unser Obst direkt an
die Vertreiber und nicht über eine
landwirtschaftliche Genossenschaft.
Das macht mehr Arbeit, ist aber auch
besser bezahlt."

ÉDOUARD UND STÉPHANE DROME, Obstbauern,
La Capelle-Masmolène, Gard, Frankreich.

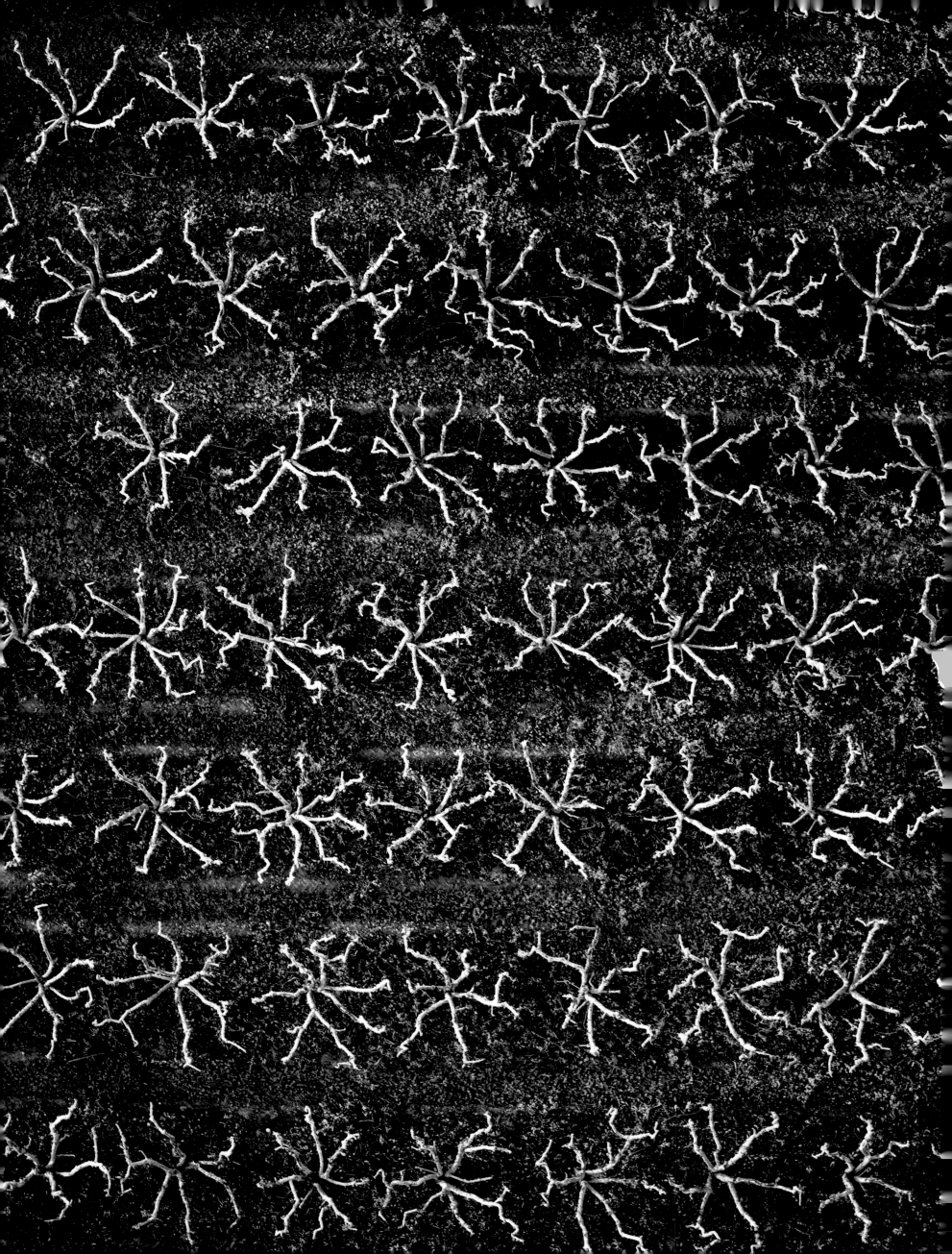

CAULIFLOWERS
Winter variety during harvest.
Châteaurenard, Vaucluse, France;
late March

"The cauliflower is sensitive to the cold,
but it is not worth growing it in
greenhouses: one single plant needs
as much space as ten lettuce plants!
My brother and I cultivate fifty hectares.
This way we can ensure a constant
supply. In December 2003, when the
Rhône dam burst, the entire harvest
was flooded, and rotted."

CLAUDE VIGNAUD, vegetable farmer, Tarascon,
Bouches-du-Rhône, France

BLUMENKOHL
Wintersorte während der Ernte.
Châteaurenard, Vaucluse, Frankreich,
Ende März.

„Blumenkohl ist kälteempfindlich,
doch es ist zu teuer, ihn im Treibhaus
anzubauen: Eine einzige Pflanze
benötigt so viel Platz wie zehn
Salatköpfe. Mit meinem Bruder baue
ich 50 ha Blumenkohl an. So viel braucht
man, um konstant liefern zu können.
Als im Dezember 2003 der Rhône-Damm
brach, stand die gesamte Ernte unter
Wasser und ist verdorben."

CLAUDE VIGNAUD, Gemüsebauer, Tarascon,
Bouches-du-Rhône, Frankreich.

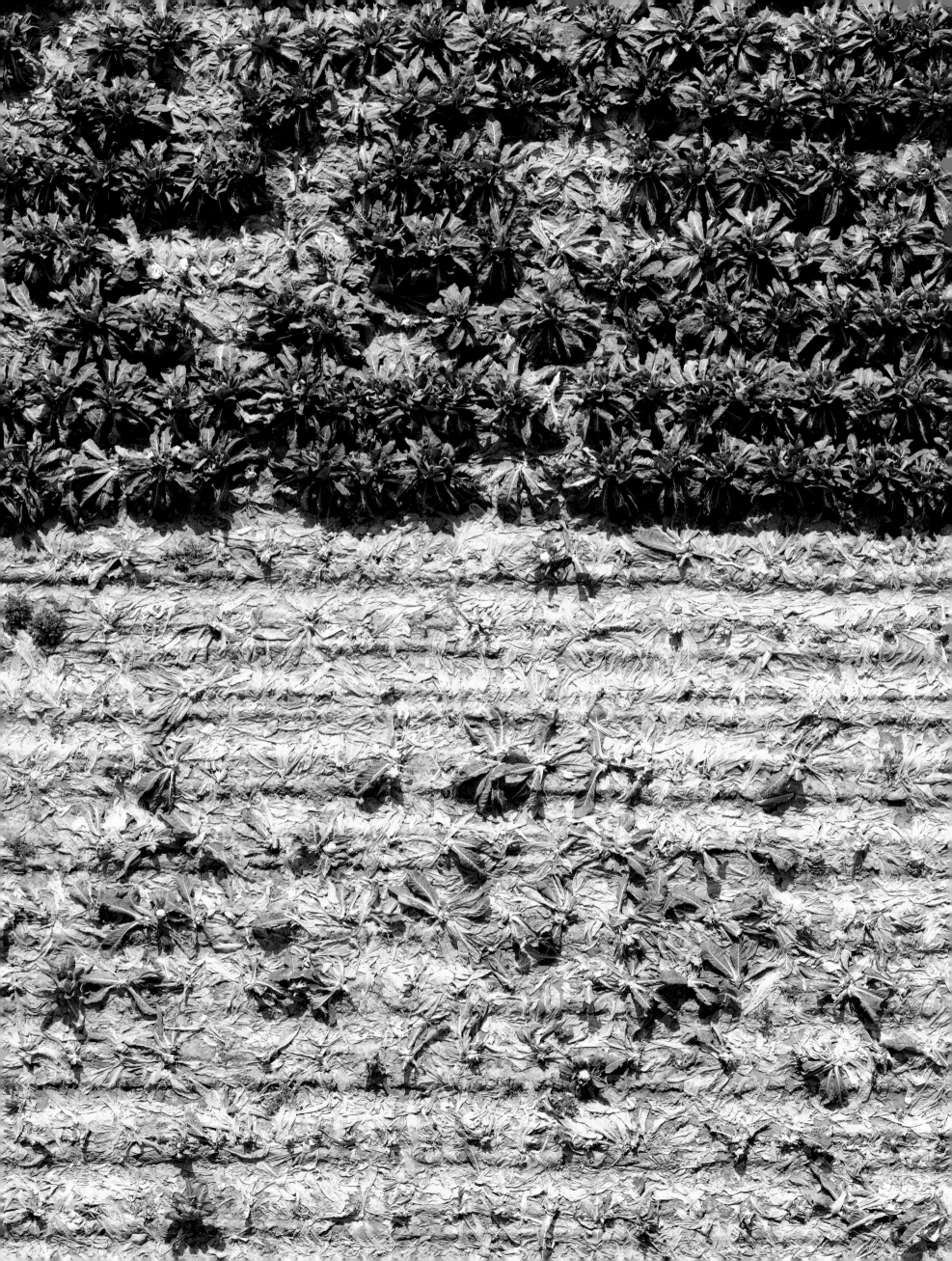

YOUNG CHERRY TREES

Plantation in 8m squares on bare soil.
Lacoste, Vaucluse, France; early June

"All the neighbouring farms have been
sold to rich people from England and
America. I am holding out here, with
my brother Joël. We will never sell, that
would be an insult to our parents, our
grandparents, and all our ancestors.
The white bigarreau cherries are sold
at Apt to the fruit jam industry. They
have to be harvested mechanically,
otherwise there would be no profit left
at all. The red cherries, which are sold at
market in Cavaillon, though, are picked
by hand."

GEORGES ADRIAN, Les Mallans, Lacoste, Vaucluse,
France

JUNGE KIRSCHBÄUME

Quadratpflanzung mit je 8 m
Baumabstand auf nacktem Boden.
Lacoste, Vaucluse, Frankreich, Anfang Juni.

„Alle Bauernhöfe in der Nachbarschaft
sind an reiche Engländer und
Amerikaner verkauft worden. Aber mein
Bruder Joël und ich halten durch. Wir
werden niemals verkaufen, das wäre
eine Beleidigung für unsere Eltern und
Großeltern, für alle unsere Vorfahren.
Die Bigarreau-Kirschen verkaufen wir in
Apt an industrielle Konfitürehersteller.
Man muss sie heute mit der Maschine
ernten, sonst ist damit kein Geld zu
verdienen. Aber die roten Kirschen für
den direkten Verzehr, die in Cavaillon auf
dem Markt verkauft werden, sind von
Hand gepflückt."

GEORGES ADRIAN, Les Mallans, Lacoste, Vaucluse,
Frankreich.

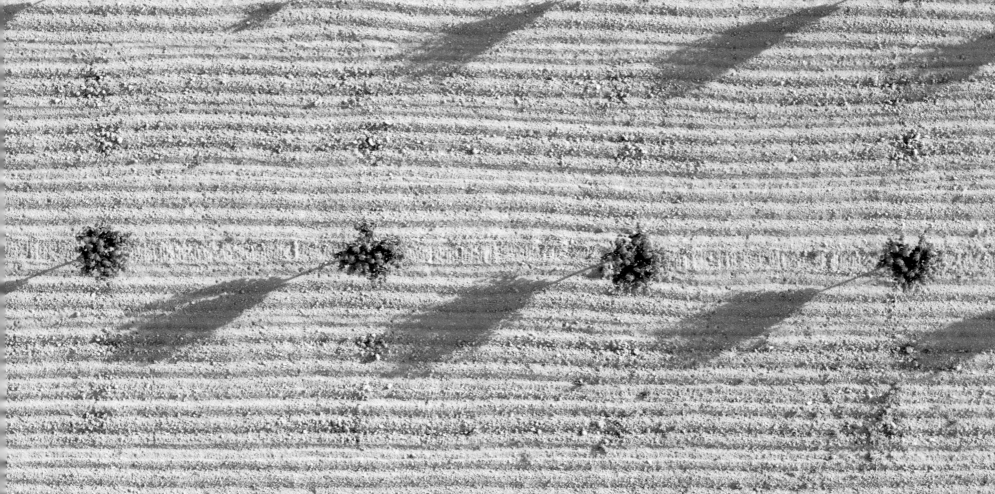
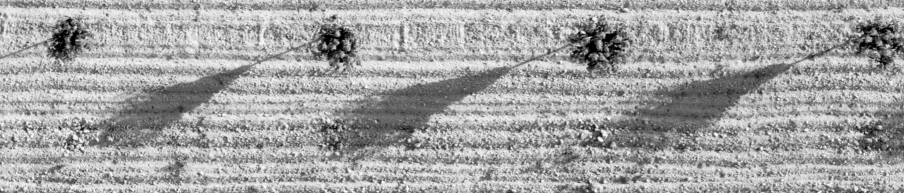
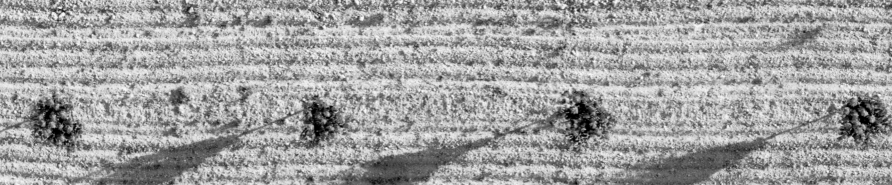

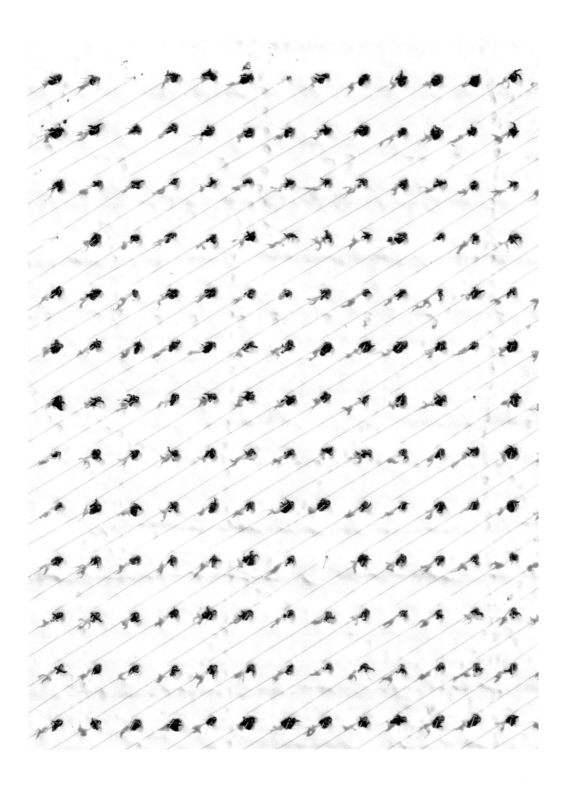

FENCE VINE ▷
Wire-supported crop, harvested.
Lower Durance Valley, France; late October

◁ GOBLET PRUNED VINES, SNOW
Old vine stock pruned into a goblet shape,
emerging from the snow.
Yvorne, Vaud canton, Switzerland;
early February

"What do I like best about the vines?
The grape harvest! It's a celebration!
In a few years time, when we uproot
these old vines (left), my employer will
replant a new wire-supported vineyard:
it lives longer and provides more space
for a machine to pass. More height
means fewer diseases and, because it is
less dense, it is of better quality too …
there are only advantages!"

JOSE PERREIRA, vineyard labourer, Yvorne,
Vaud canton, Switzerland

AUFGEBUNDENE REBSTÖCKE ▷
Drahterziehung, nach der Weinlese.
Unteres Durance-Tal, Frankreich,
Ende Oktober.

◁ WEINBERG, GOBELETERZIEHUNG,
SCHNEE
Alte Rebstöcke im Schnee,
Gobeleterziehung.
Yvorne, Kanton Waadt, Schweiz,
Anfang Februar.

„Was mir im Weinberg am besten
gefällt? Die Weinlese! Das ist ein Fest!
In einigen Jahren roden wir diesen
traditionellen Weinberg (links), dann
pflanzt mein Chef dort neue Reben in
Drahterziehung: Die haben eine längere
Lebensdauer, man hat genügend Platz,
um mit den Maschinen durch den
Weinberg zu fahren, sie sind höher, so
dass es weniger Krankheiten gibt, die
Qualität wird besser, weil sie weniger
dicht sind … Nichts als Vorteile!"

JOSE PERREIRA, Weinarbeiter, Yvorne, Kanton
Waadt, Schweiz.

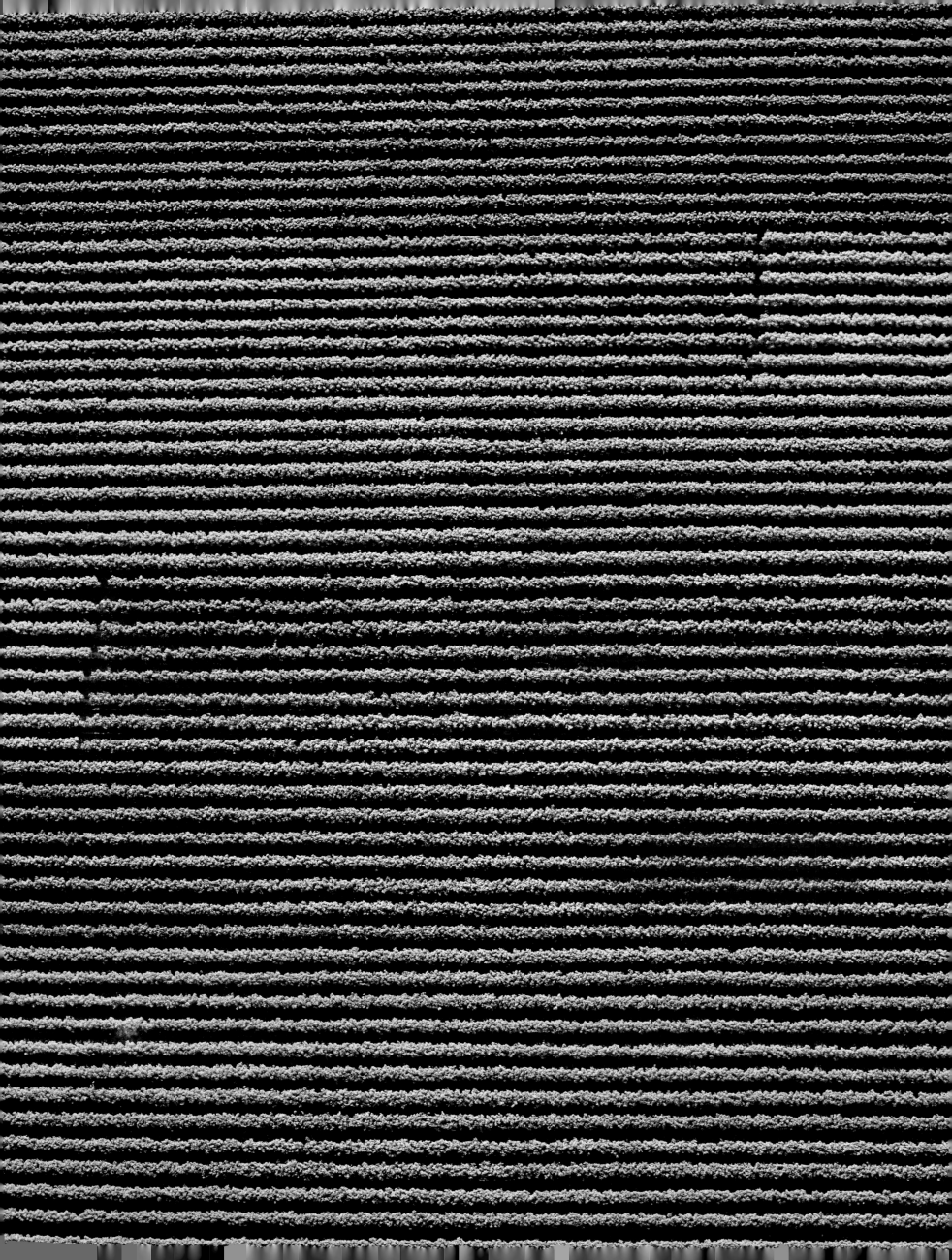

PREPARED SOIL
Finely prepared soil ready for a
vegetable crop.
Noville, Vaud canton, Switzerland;
late April

"In the long run, in order to produce and
sell our vegetables, we will have to build
a packaging plant. Otherwise, the
vegetable crops grown on this plain risk
being replaced by large-scale farming.
It may already be too late."

JEAN-MARC CHAVANNES, vegetable farmer, Roche,
Vaud canton, Switzerland

BEARBEITETES ACKERLAND
Für den Gemüseanbau bestellter Boden.
Noville, Kanton Waadt, Schweiz, Ende April.

„Langfristig benötigen wir für den
Vertrieb unseres Gemüses eine
Verpackungsfabrik, sonst werden die
Gemüsekulturen in dieser Ebene von
Großkulturen verdrängt. Vielleicht ist es
schon zu spät.“

JEAN-MARC CHAVANNES, Gemüsebauer, Roche,
Kanton Waadt, Schweiz.

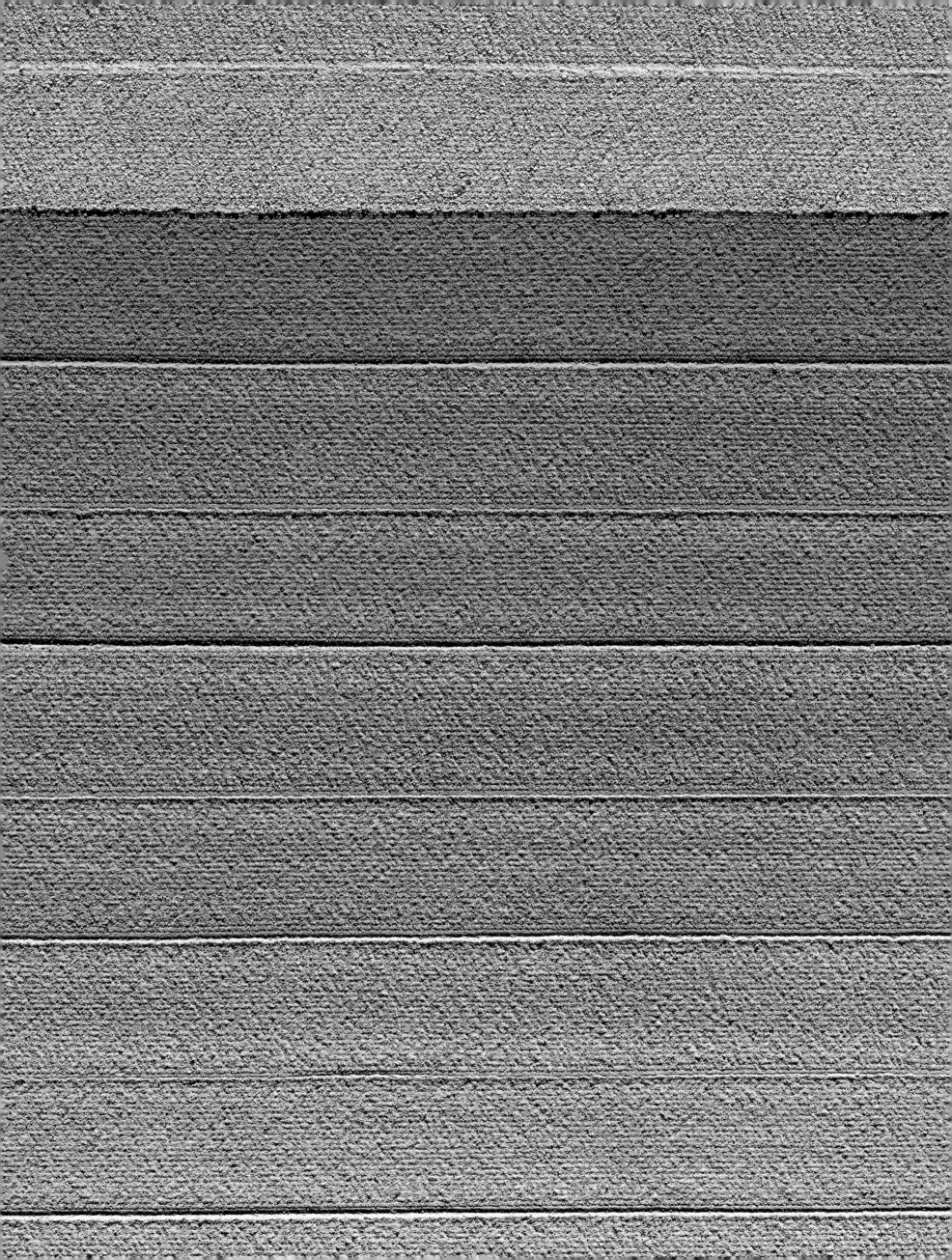

WALNUT ORCHARD

Planted in staggered rows, 10m apart,
the walnuts are harvested mechanically
from the ground, on cut grass.
Saint-Marcellin, Isère, France; early July

"We have walnuts under the skin, we
live with the odour of walnuts. All year
long, we talk about walnuts. We don't
like to go on holiday away from our
walnut trees."

MARC JANY, nut grower, Saint-Marcellin, Isère,
France

WALNUSSPLANTAGE

Bäume versetzt gepflanzt, Abstand 10 m,
das Auflesen der Nüsse vom kurzen Gras
erfolgt maschinell.
Saint-Marcellin, Isère, Frankreich,
Anfang Juli.

„Wir haben hier die Nüsse im Blut, wir
leben mit ihrem Duft. Das ganze Jahr
reden wir von Nüssen. Wir fahren nicht
gerne in Urlaub, wollen nicht von
unseren Nussbäumen weg."

MARC JANY, Nussbauer, Saint-Marcellin, Isère,
Frankreich.

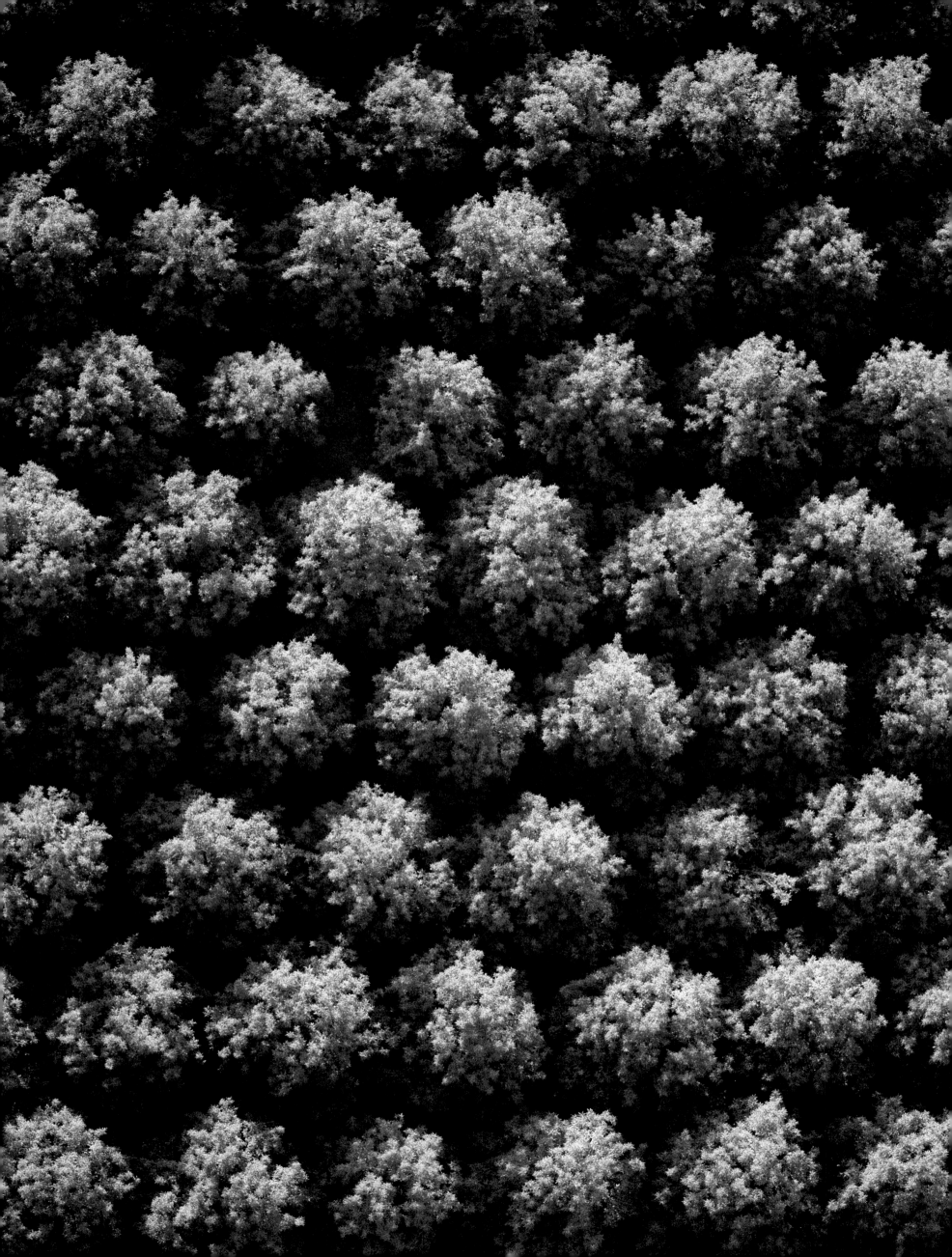

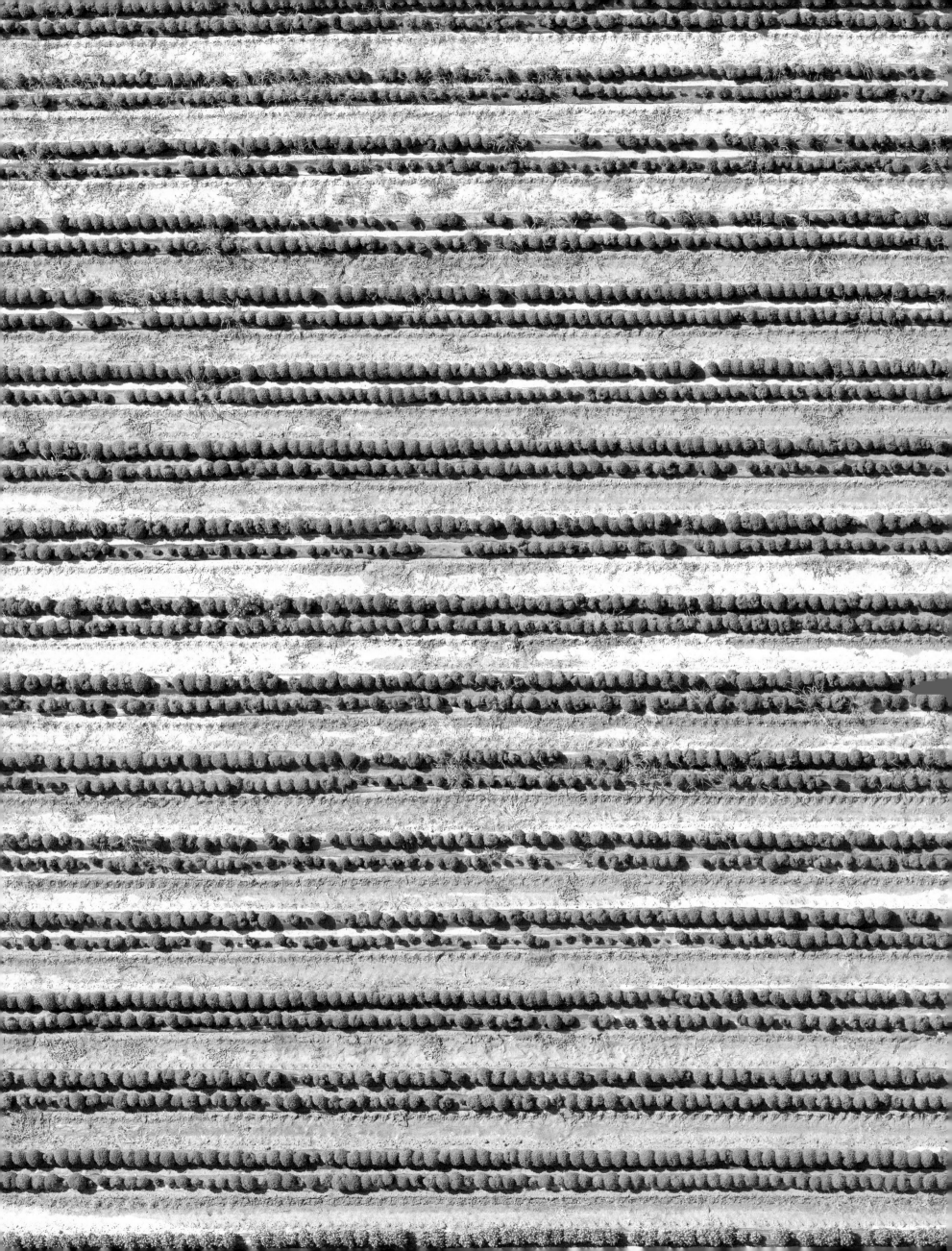

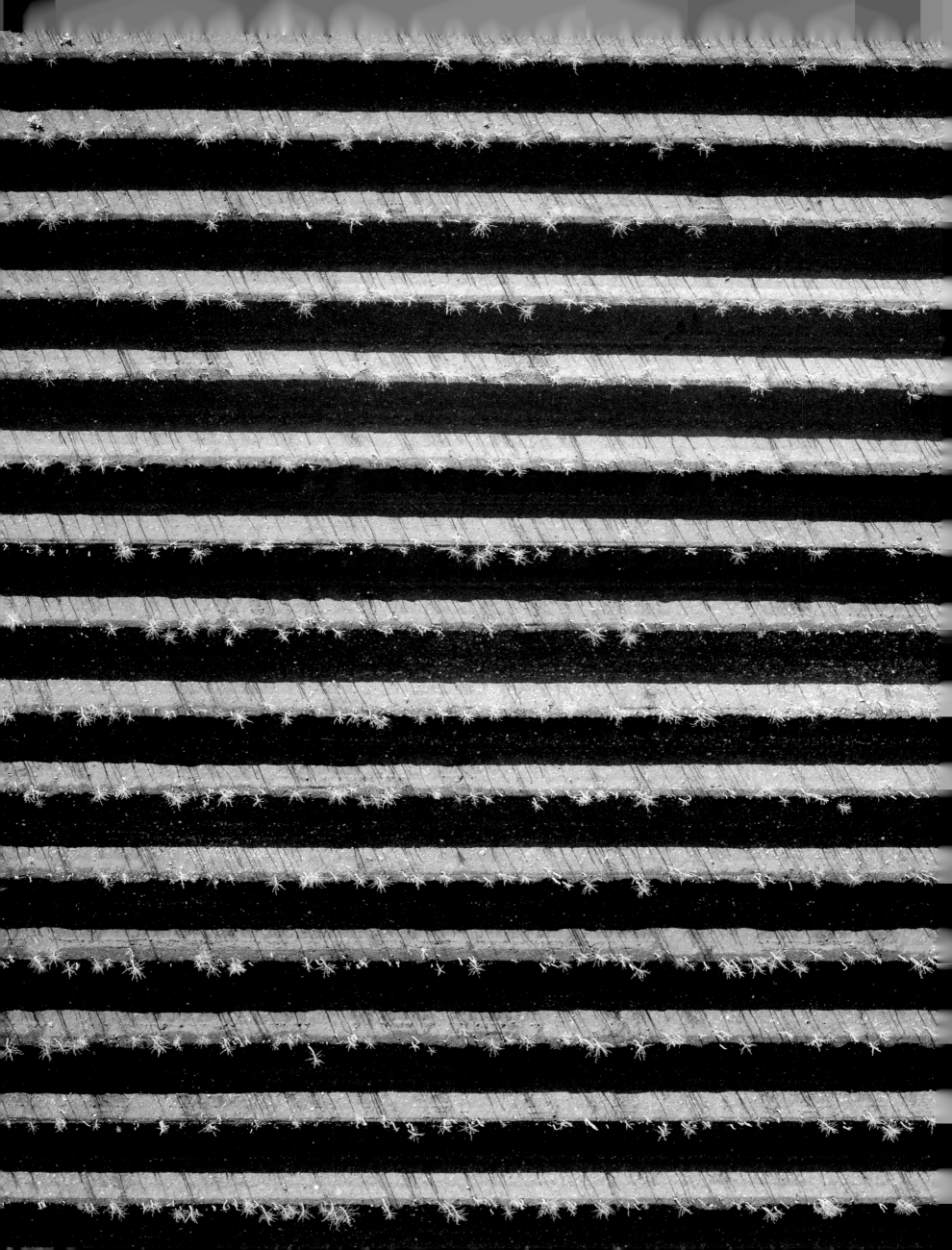

Page 124
BASIL
Crop on plastic bedding, intended for
seed production.
Saint-Rémy-de-Provence, Bouches-
du-Rhône, France; July

"Pesto is a herb paste made from basil
leaves, garlic cloves and salt, which are
ground in a mortar with olive oil, black
pepper and grated cheese. Provençale
soup is made from fresh vegetables
(haricot beans, kidney beans, French
beans, potatoes, courgettes, tomatoes).
The soup is seasoned with pesto just
before serving."

JOSEPH GAFFET, agricultural technician at
Clause Tézier, Saint-Rémy-de-Provence,
Bouches-du-Rhône, France

SEITE 124
BASILIKUM
Kultur auf Plastik zur Saatgutproduktion.
Saint-Rémy-de-Provence, Bouches-du-
Rhône, Frankreich, Juli.

„Pistou ist eine Würzpaste aus
Basilikum, Knoblauch und Salz. Das
Ganze wird im Mörser zerstoßen. Dann
kommen Olivenöl, schwarzer Pfeffer und
geriebener Käse dazu. Eine
provenzalische Gemüsesuppe besteht
aus weißen, grünen und roten Bohnen,
Kartoffeln, Zucchini, Tomaten usw. und
wird erst kurz vor dem Servieren mit
Pistou gewürzt."

JOSEPH GAFFET, Agrartechniker, Clause Tézier,
Saint-Rémy-de-Provence, Bouches-du-Rhône,
Frankreich.

PAGE 125
ASPARAGUS
Beginning of the regeneration period after
the harvest.
Sugiez, Fribourg canton, Switzerland;
late June

"Asparagus grows up to 10cm per day.
It takes seven days a week to harvest it.
Here in the prison, twenty young
prisoners work on the vegetable
production under surveillance. In spring,
they will cut the asparagus once or
twice a day. The mounds are reheaped
each week by the machine, protecting
the asparagus from the sun to keep it
white. From 21 June, we let the plants
grow in the open air so that they
regenerate. On this photograph, taken
on 29 June, the asparagus is beginning
to emerge from the mounds of earth.
Asparagus is a fascinating crop."

ROLAND GUISNARD, warder and farmer, Bellechasse
Prison, Sugiez, Fribourg canton, Switzerland

SEITE 125
SPARGEL
Beginn der Regenerationsphase nach
der Ernte.
Sugiez, Kanton Freiburg, Schweiz, Ende Juni.

„Spargel wächst bis zu 10 cm täglich.
Während der Erntezeit benötigt man
viele Leute, die sieben Tage in der Woche
arbeiten. Hier in dieser Strafanstalt
arbeiten zehn junge Häftlinge unter
Beobachtung im Gemüseanbau. Im
Frühjahr kommen sie zweimal täglich
zum Spargelstechen. Die Wälle werden
einmal in der Woche mit der Maschine
neu geformt, damit der Spargel vor Licht
geschützt ist und weiß bleibt.
Vom 21. Juni an lassen wir die Pflanzen
unter freiem Himmel wachsen, damit sie
sich regenerieren. Auf diesem Bild vom
29. Juni beginnen sie aus dem Torf zu
schießen. Der Spargelanbau ist eine
faszinierende Arbeit."

ROLAND GUIGNARD, landwirtschaftlicher Aufseher,
Strafanstalt Bellechasse, Sugiez, Kanton
Freiburg, Schweiz.

HAY MEADOW
Permanent meadow, overground irrigation.
Plaine de la Crau, Bouches-du-Rhône,
France; July

"During the course of thirty years,
irrigation systems have turned this arid
plain into agricultural land. On this poor
soil, a grass grows that is not very
nutritious but highly sought-after for
horses. We even export hay by sea for
the thoroughbreds in the United Arab
Emirates!"

ROBERT MACCARI, farmer, Arles, Bouches-du-Rhône,
France

HEUWIESE
Dauerwiese, Bewässerung überirdisch.
Crau-Ebene, Bouches-du-Rhône,
Frankreich, Juli.

„Innerhalb von 30 Jahren ist durch den
Bau von Bewässerungssystemen aus
dieser trockenen Ebene eine
landwirtschaftlich nutzbare Fläche
geworden. Die Wiesen dieses kargen
Bodens ergeben ein wenig
nährstoffhaltiges Heu, das sich
besonders als Pferdefutter gut eignet.
Wir exportieren es per Schiff sogar
in die Vereinigten Arabischen Emirate,
für die Rassepferde!"

ROBERT MACCARI, Landwirt, Arles, Bouches-
du-Rhône, Frankreich.

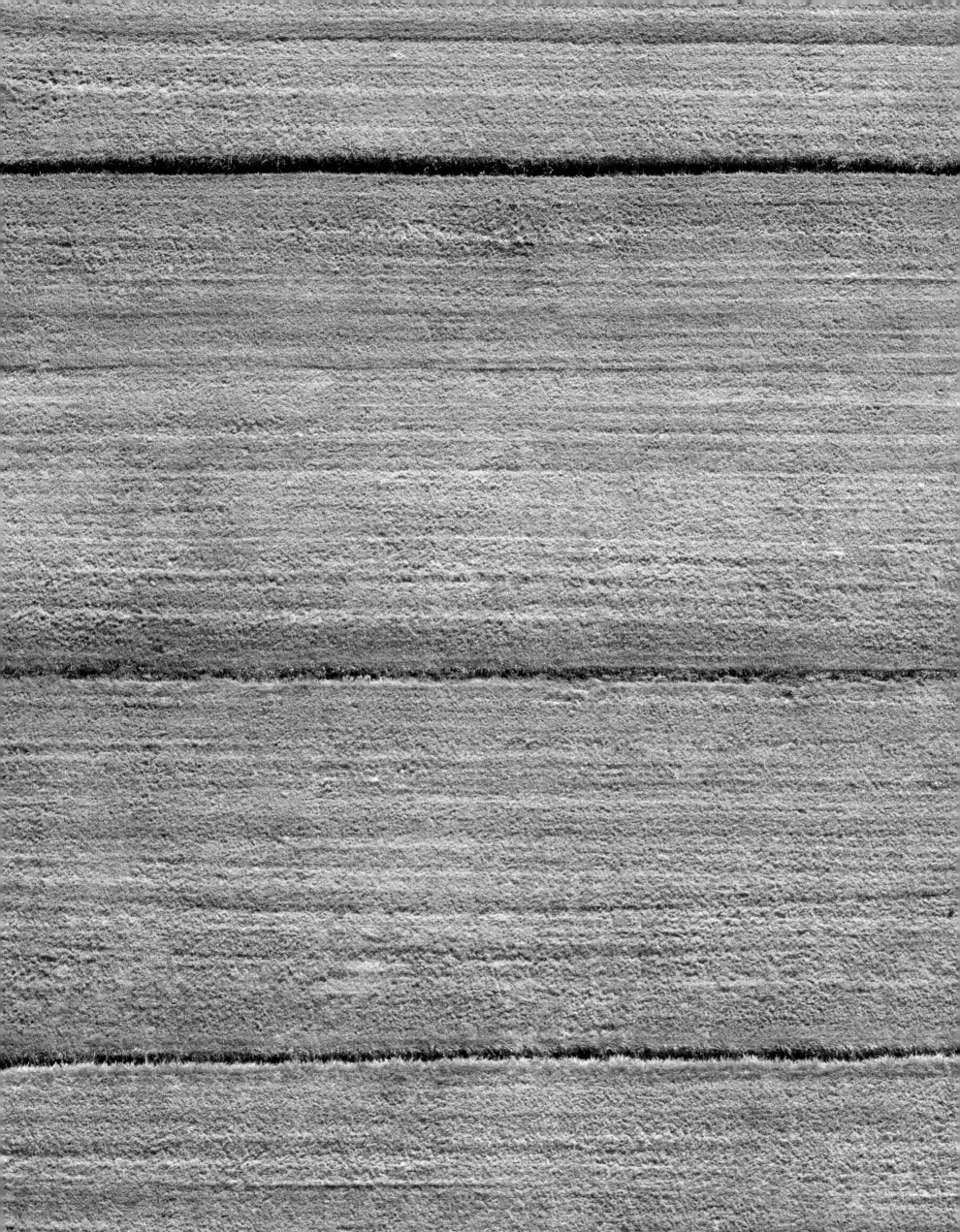

FLOWERING LAVANDIN
A young lavandin crop.
Le Poët-Laval, Drôme, France; early July

"Real lavender for pharmacies grows mostly in the mountains. Here, the soil is poor; there are no crops other than the lavandin, which is a clone. My husband and I cultivate thirty hectares. We used to distil 'dry'. Recently we started to distil 'green': the machine loads the container in the field, and we then connect it at the distillery. One hour later, we leave with our lavender essence. This means that there is less work to do."

Martine Ayme, lavender grower, Salles-sous-Bois, Drôme, France

BLÜHENDER LAVANDIN
Junge Lavandinkultur.
Le Poët-Laval, Drôme, Frankreich,
Anfang Juli.

„Der echte Lavendel, der in der Pharmazie verwendet wird, wächst eher in den Bergen. Auf dem kargen Boden hier gedeiht nur Lavandin, eine Lavendel-Kreuzung. Mein Mann und ich bewirtschaften 30 ha. Früher wurden die Pflanzen vor der Destillation getrocknet. Seit kurzem wird das blühende Kraut destilliert: Der Container wird direkt auf dem Feld maschinell beladen und zur Destillerie gebracht. Eine Stunde später können wir die Lavendelessenz schon wieder mitnehmen. So haben wir weniger Arbeit damit."

Martine Ayme, Lavendelbäuerin, Salles-sous-Bois, Drôme, Frankreich.

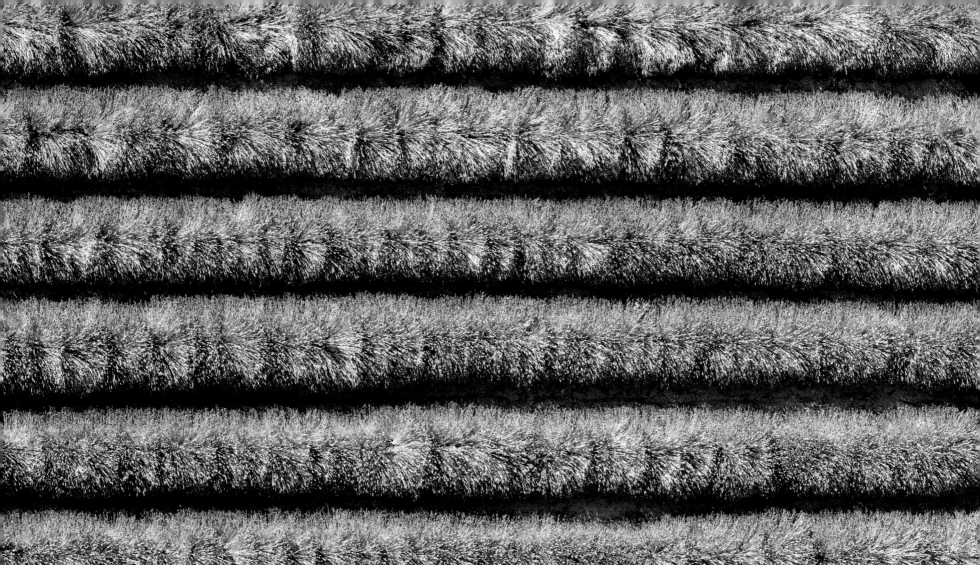

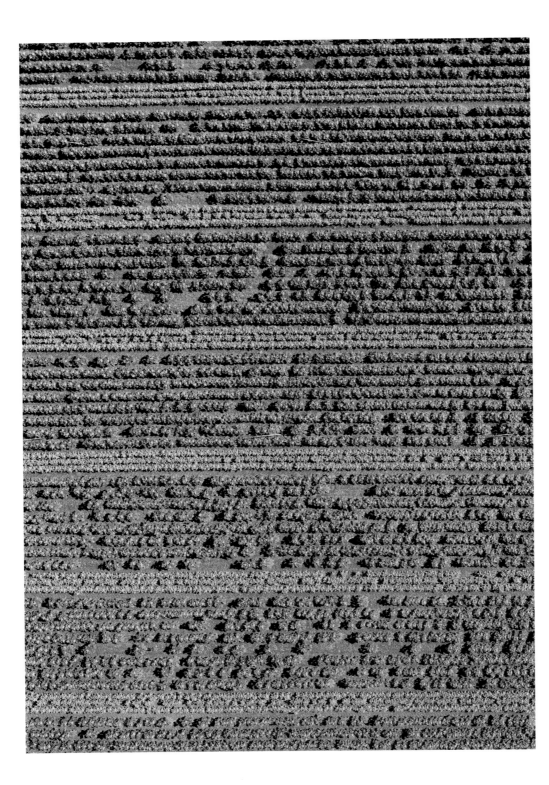

◁ SUNFLOWERS

Seed production by hybridization: yellow lines of three rows of pollinators between the tractor tracks, green lines or eight rows of plants that produce the seeds. Charols, Drôme, France; early July

"The water from the Rhône now arrives via an underground pipeline. We try to secure a return on this investment by planting crop which need to be irrigated, like seed-producing sunflowers."

SERGE COMTE, farmer, Cléon-d'Andran, Drôme, France

SUNFLOWERS ▷

Hybrids for oil production from seed. Barcelonne, Drôme, France; early July

"When you cultivate sunflowers for seed, you must maintain a distance of 700m between two fields of similar crops, in order to avoid undesired germination. We meet up among neighbouring farmers and find a mutually acceptable solution."

SERGE COMTE, farmer, Cléon-d'Andran, Drôme, France

◁ SONNENBLUMEN

Saatgutproduktion durch Kreuzung: gelbe Streifen zwischen den Traktorspuren: jeweils drei Reihen Bestäuberpflanzen; grüne Streifen: jeweils acht Reihen mit den Pflanzen zur Samenproduktion. Charols, Drôme, Frankreich, Anfang Juli.

„Inzwischen haben wir einen unterirdischen Zulauf, der uns mit Rhône-Wasser versorgt. Damit sich diese Investition lohnt, bauen wir jetzt Pflanzen an, die bewässert werden müssen, wie die Sonnenblumen zur Saatgutproduktion."

SERGE COMTE, Landwirt, Cléon-d'Andran, Drôme, Frankreich.

SONNENBLUMEN ▷

Hybriden für die Produktion von Samen zur Ölgewinnung. Barcelonne, Drôme, Frankreich, Anfang Juli.

„Wenn man Sonnenblumen für die Samenproduktion anbaut, muss man darauf achten, dass zwischen zwei Feldern mit denselben Kulturen 700 m Abstand bleiben, um jede unerwünschte Befruchtung auszuschließen. Unter benachbarten Landwirten spricht man sich ab und arrangiert sich."

SERGE COMTE, Landwirt, Cléon-d'Andran, Drôme, Frankreich.

POLYTUNNELS
Almost certainly tomato crops in tunnels
made of steel covered with whitewashed
polythene film, aeration holes.
Crau Plain, Bouches-du-Rhône,
France; July

FOLIENTUNNEL
Vermutlich Tomatenkultur unter mit Kalk
geweißter Polyethylenfolie, Gerüst aus
Stahl. Belüftungslöcher.
Crau-Ebene, Bouches-du-Rhône,
Frankreich, Juli.

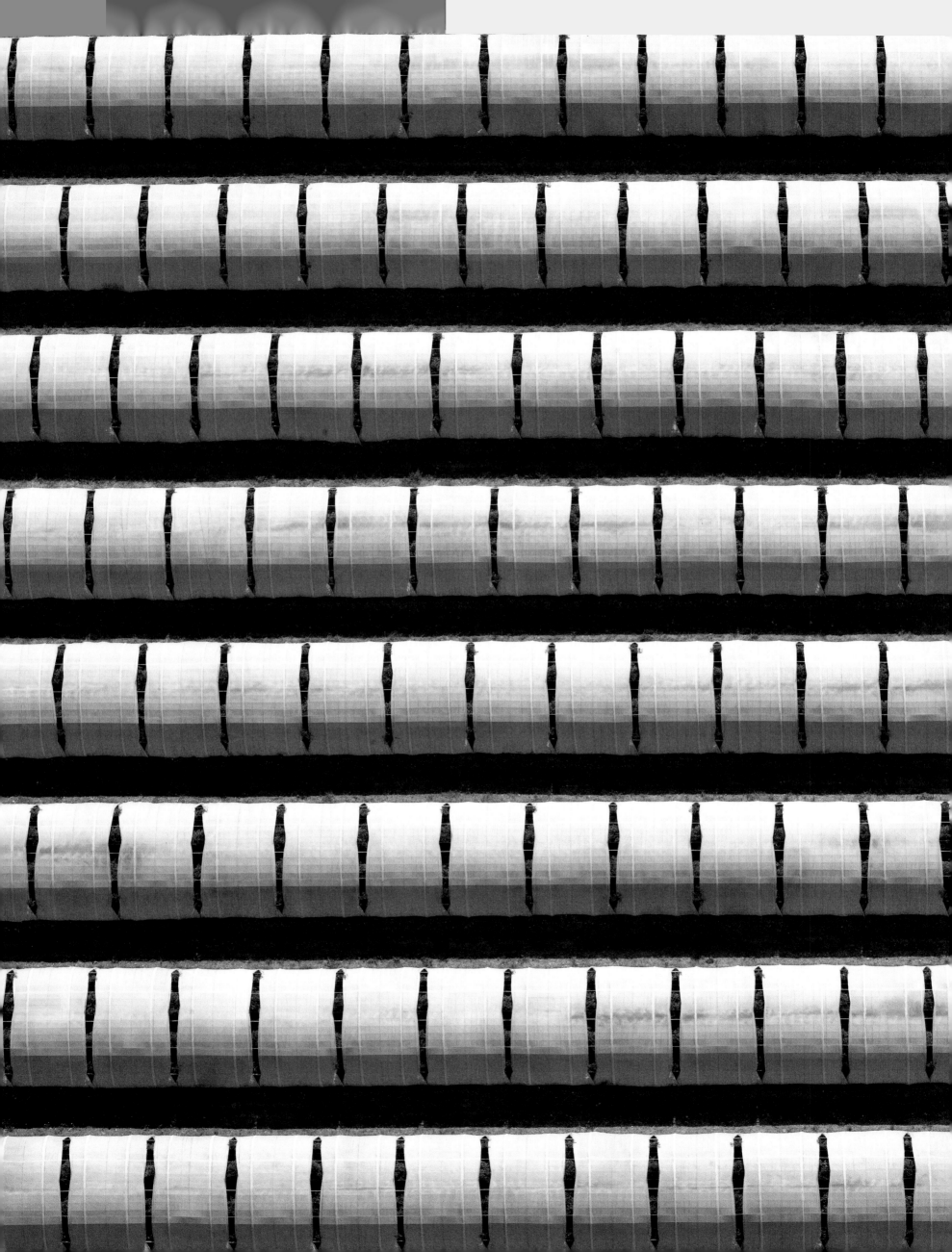

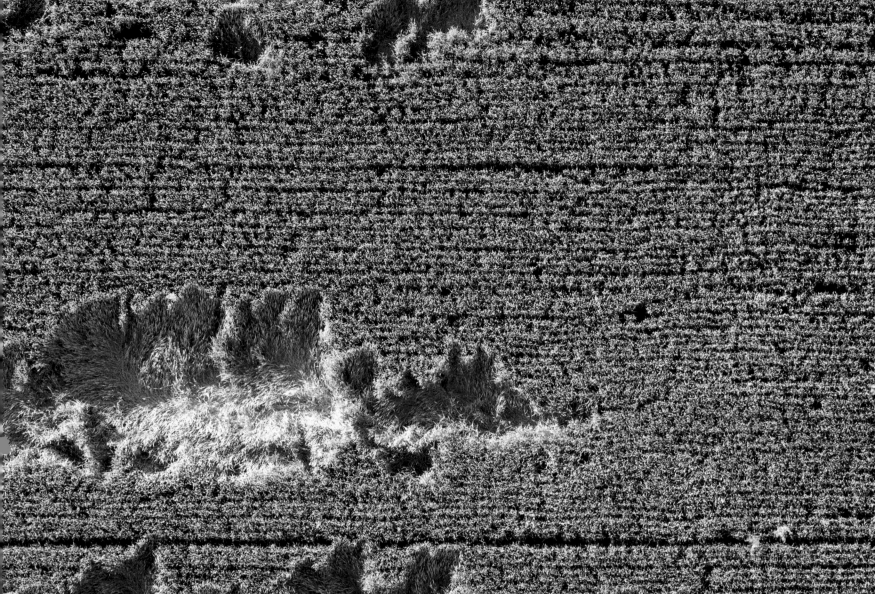
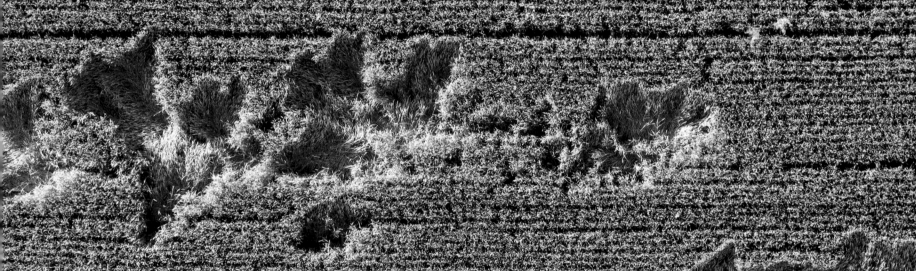
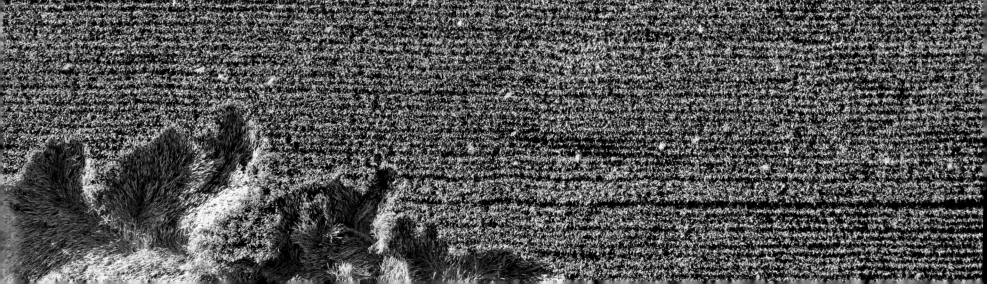

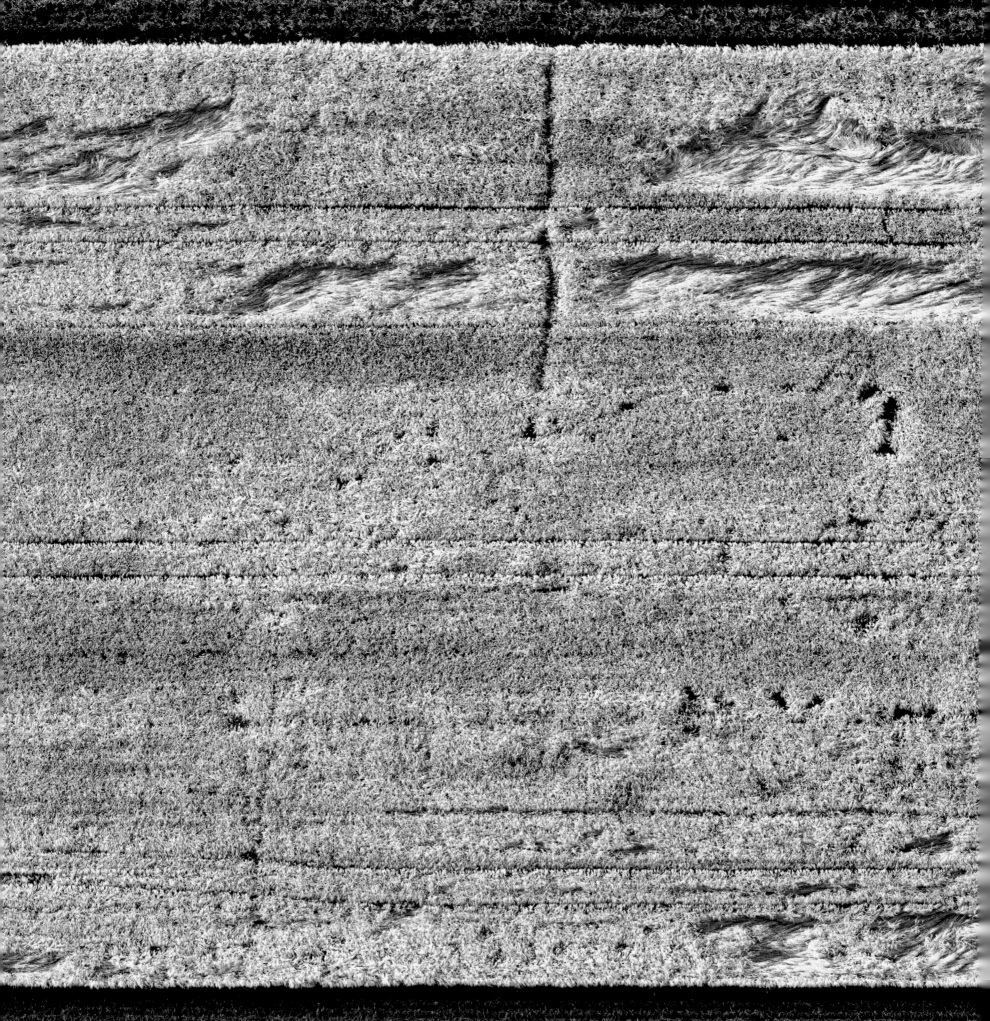

FALLEN WHEAT
Wind has flattened a part of the crop,
weakened by the excess of nitrates
in the peat.
Chiètres, Fribourg canton, Switzerland;
late June

"Due to its nutritional richness, peat is
not ideal for growing wheat and barley.
Sometimes the rotation of crops
requires a crop anyway."

ERNST MAEDER, director, Bio-Gemüse, Galmitz,
Fribourg canton, Switzerland

SEITE 134
GEKNICKTER WEIZEN
Der Wind hat einen Teil der Pflanzen
geknickt, die durch den hohen
Stickstoffgehalt im Torf geschwächt sind.
Chiètres, Kanton Freiburg, Schweiz,
Ende Juni.

„Wegen seines Nährstoffreichtums
eignet sich Torf schlecht für den Anbau
von Weizen und Gerste. Doch der
Feldfruchtwechsel macht diesen
gelegentlich erforderlich."

ERNST MAEDER, Geschäftsführer von Bio-Gemüse,
Galmiz, Kanton Freiburg, Schweiz.

PAGE 135
LEEKS, BARLEY, ONIONS
At the top, a leek crop; in the centre,
a barley crop, flattened in part;
at the bottom, onions.
Ried, Fribourg canton, Switzerland;
late June

"Towards the end of the 1990s, I thought
about converting to organic farming, as
the demand grew faster than the supply.
Today, in 2005, fifteen percent of
producers have become organic, but the
demand has stagnated around the ten
percent mark. I was right not to change
too early."

PASCAL GUTKNECHT, farmer and vegetable producer,
Ried, Fribourg canton, Switzerland

SEITE 135
LAUCH, GERSTE, ZWIEBELN
Oben: Lauch; in der Mitte: teilweise
geknickte Gerste; unten: Zwiebeln.
Ried, Kanton Freiburg, Schweiz, Ende Juni.

„Ende der 1990er-Jahre habe ich kurz
daran gedacht, auf biologische
Landwirtschaft umzusteigen, denn
die Nachfrage wuchs schneller als das
Angebot. Nun, im Jahr 2005, sind 15%
der Landwirte Biobauern, doch die
Nachfrage stagniert bei unter 10%.
Ich habe gut daran getan, meinen
Betrieb nicht zu schnell umzustellen."

PASCAL GUTKNECHT, Gemüsebauer, Ried, Kanton
Freiburg, Schweiz.

CUTTING LETTUCE
Different varieties of 'cutting lettuces':
the young shoots are cut for mixed lettuce
leaves sold in bags.
Saint-Rémy-de-Provence, Bouches-du-
Rhône, France; July

"The sale of mixed lettuce leaves in bags
started around twenty years ago with
hardy varieties such as the escarole,
the radicchio or the sugar loaf. The
technology has developed to such an
extent, from the harvest up to the
punnet in the supermarket, that today
one can use far more delicate varieties,
such as this coloured assortment of
young shoots. The trend is towards the
diversification of ready-to-eat products:
mixed salads, juliennes of cabbage,
carrots, celery, turnips, radishes..."

JEAN-JACQUES AGASSIS, vegetable composer, Essert-
sous-Champvent, Vaud canton, Switzerland

PFLÜCKSALAT
Verschiedene Sorten Pflücksalat: Die
jungen Triebe werden für in Plastikbeutel
abgepackte Salatmischungen geschnitten.
Saint-Rémy-de-Provence,
Bouches-du-Rhône, Frankreich, Juli.

„Der Verkauf von Salat in Plastikbeuteln
hat vor 20 Jahren mit robusten Sorten
wie Winterendivie, Radicchio und
Zuckerhutsalat begonnen. Inzwischen
hat sich die Technologie von der Ernte
bis zur Umverpackung im Supermarkt
so weit entwickelt, dass man auch
wesentlich sensiblere Sorten wie in
dieser Mischung aus jungen Trieben
verwenden kann. Der Trend geht zu
einer großen Vielfalt im Bereich der
verzehrfertigen Produkte: gemischte
Salate, feine Streifen von Kohl, Möhren,
Sellerie, Rüben, Radieschen ..."

JEAN-JACQUES AGASSIS, stellt Gemüse zusammen,
Essert-sous-Champvent, Kanton Waadt, Schweiz.

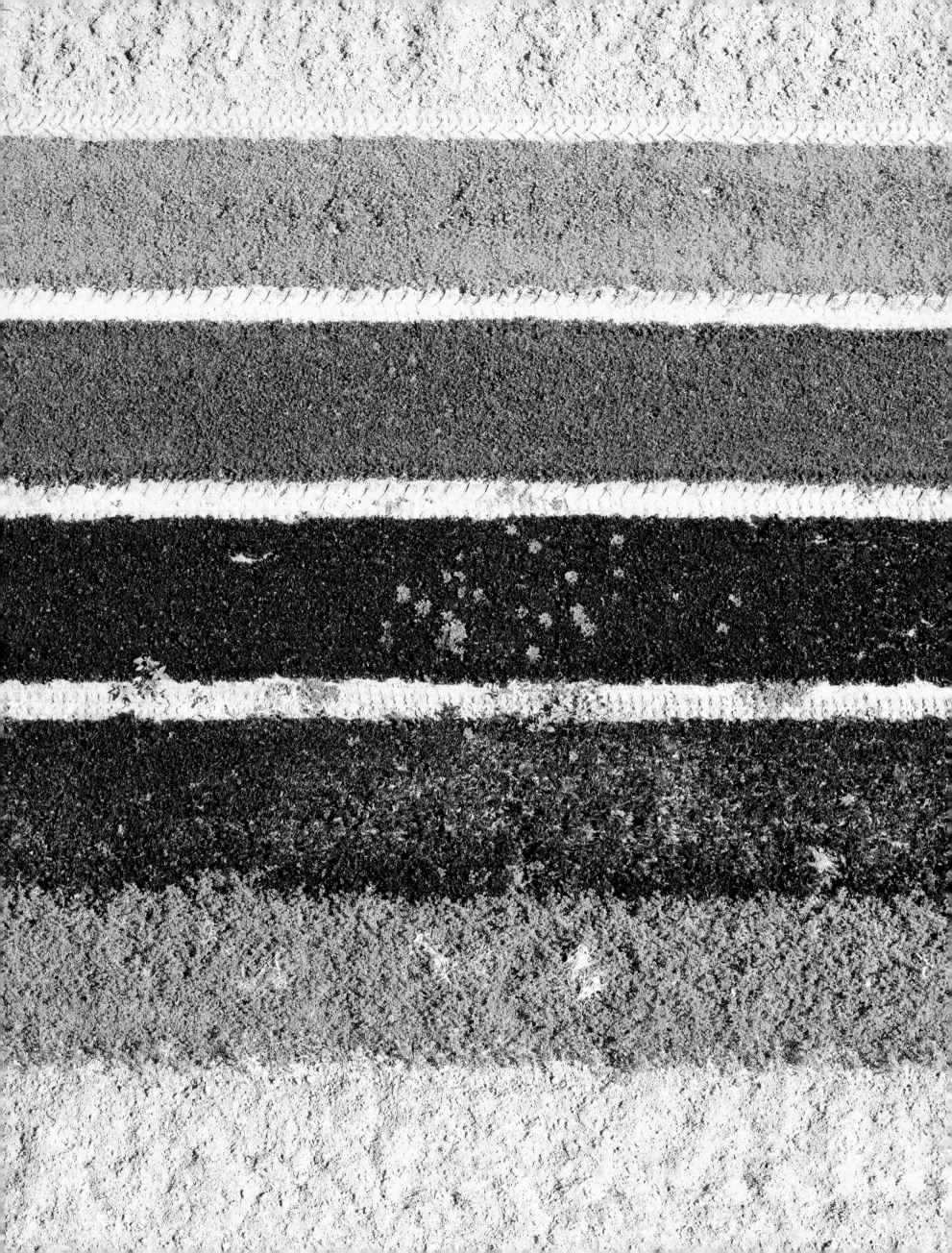

APRICOT PLANTATION

Experimental hybrid plantation, not grafted
for selection; blue plastic devices protect
plants against rabbits.
Saint-Marcel-lès-Valence, Drôme, France;
late March

"The apricot is a difficult crop: it reacts
badly to changes in soil and climate.
We are therefore obliged to find varieties
that are suited to different regions."

GUY CLAUZEL, assistant engineer at Experimental
Unit Gotheron INRA, Saint-Marcel-lès-Valence,
Drôme, France

APRIKOSENPLANTAGE

Versuchsplantage mit unveredelten
Hybriden für die Selektionszüchtung.
Blaue Plastikfolie zum Schutz vor
Kaninchen.
Saint-Marcel-lès-Valence, Drôme,
Frankreich, Ende März.

„Aprikosen sind ein schwieriges Obst:
Boden- oder Klimawechsel verkraften
sie nur schlecht. Darum sind wir auf der
Suche nach Sorten, die auch auf
unterschiedlichen Böden gedeihen."

GUY CLAUZEL, Ingenieursassistent,
Versuchsabteilung des INRA [Nationales Institut
für landwirtschaftliche Forschung] in Gotheron,
Saint-Marcel-lès-Valence, Drôme, Frankreich.

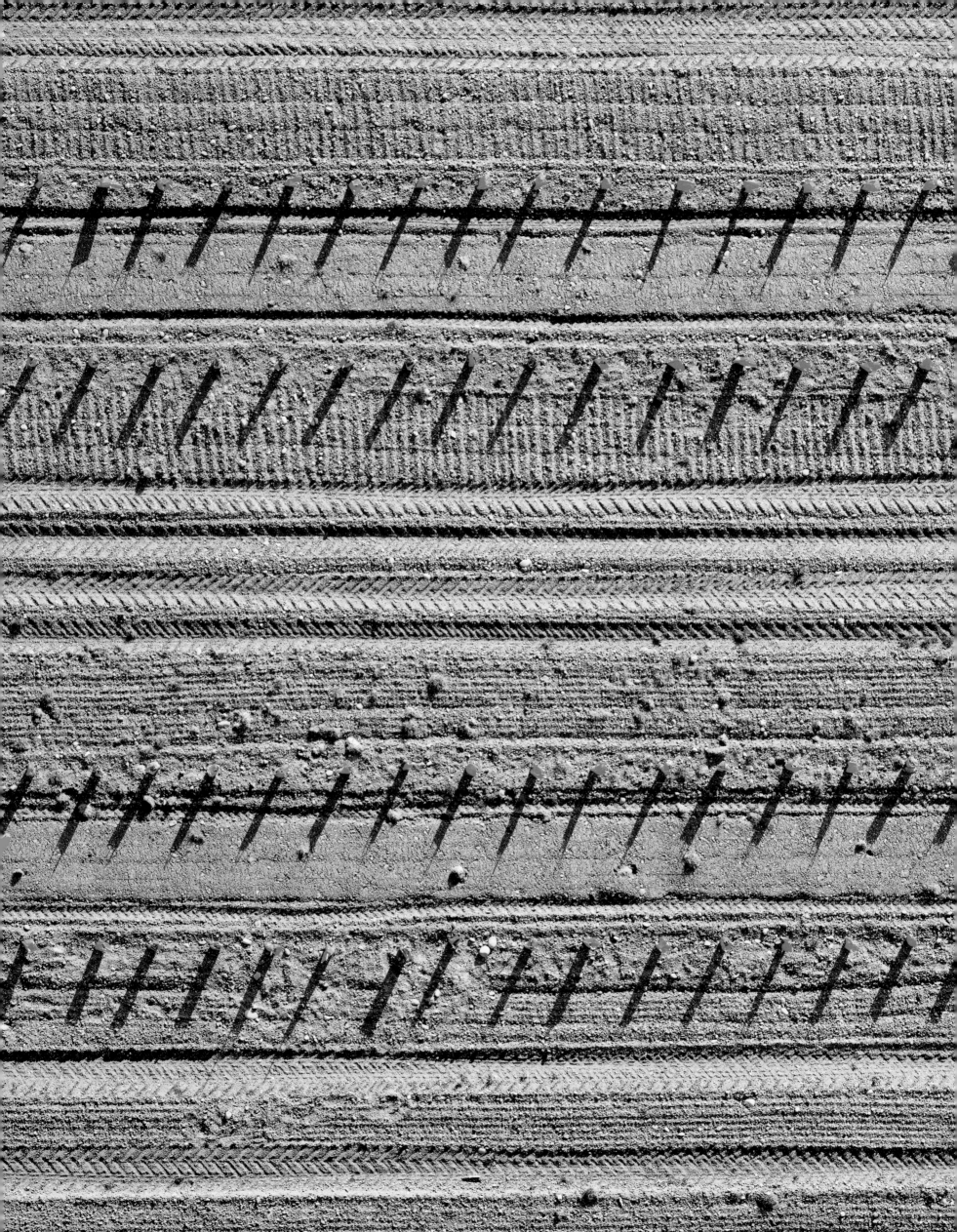

MAIZE

Fodder crop, watered by a main pipe
(slanting line) and ramps of spaced jets.
Montvedre, Drôme, France; late July

"Animal protection has achieved great
things this last decade. Livestock
conditions have been radically
improved; the animals live far more
comfortably. This costs more, but
nobody complains. That is fine, but
sometimes I ask myself if we are not
more preoccupied with the wellbeing of
our cows, pigs and chickens, than that
of our own kind…"

EVELYNE MARENDAZ, agronomist, Service romand
de Vulgarisation agricole, Lausanne, Vaud canton,
Switzerland

MAIS

Als Viehfutter vorgesehener Mais.
Beregnung über ein Hauptrohr (diagonale
Linie) und auf dem Feld verteilte Sprenger.
Montvendre, Drôme, Frankreich, Ende Juli.

„Im Bereich des Tierschutzes hat sich in
den letzten Jahrzehnten viel getan. Die
Tiere wachsen unter grundlegend
verbesserten Bedingungen auf, ihr
Leben ist wesentlich angenehmer
geworden. Obwohl das alles viel Geld
kostet, wird es nicht infrage gestellt.
Und das ist auch gut so, doch manchmal
frage ich mich, ob uns das Wohlergehen
unserer Kühe, Schweine und Hühner
nicht mehr am Herzen liegt als das
unserer eigenen Artgenossen …"

ÉVELYNE MARENDAZ, Agraringenieurin, Service
romand de Vulgarisation agricole, Lausanne,
Kanton Waadt, Schweiz.

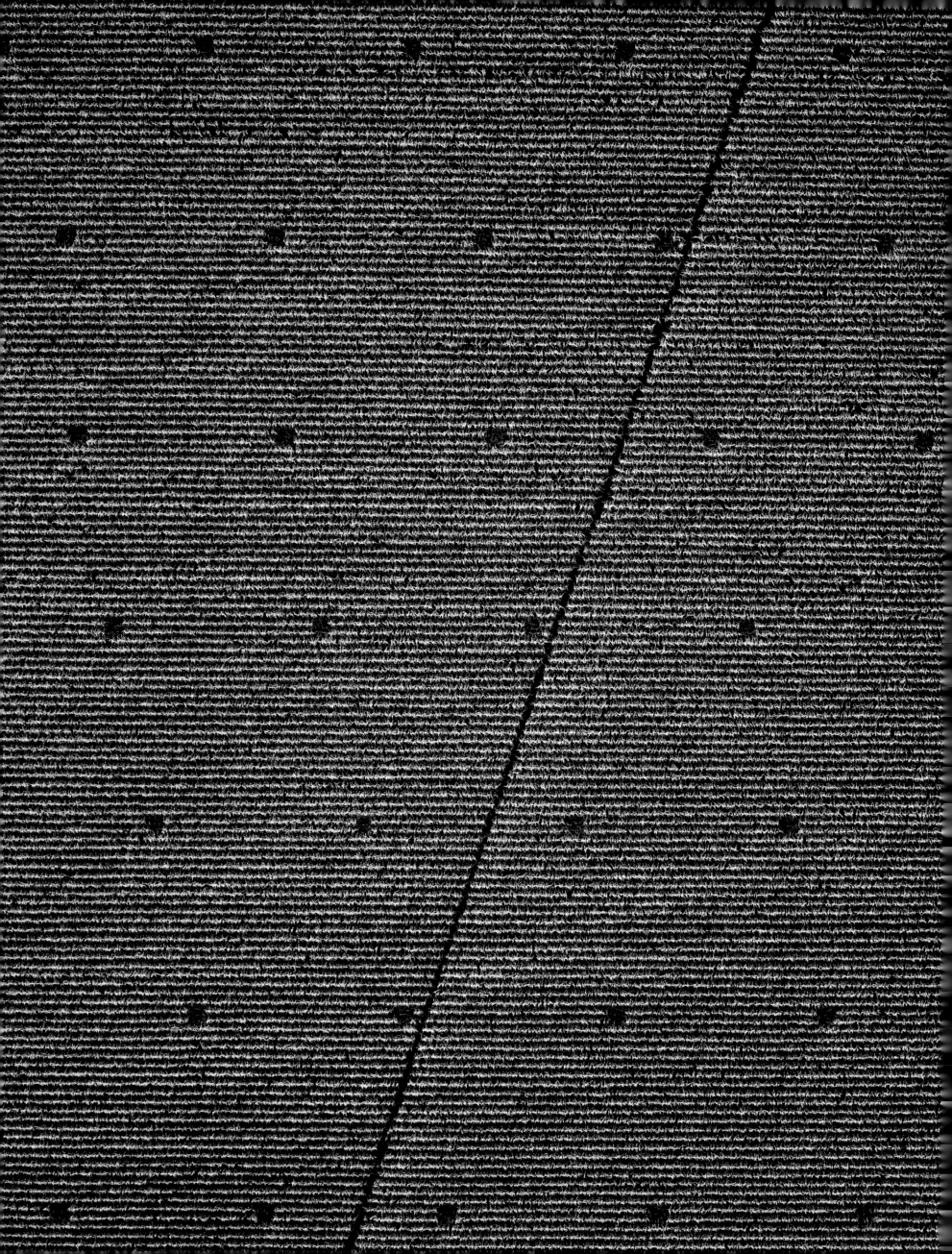

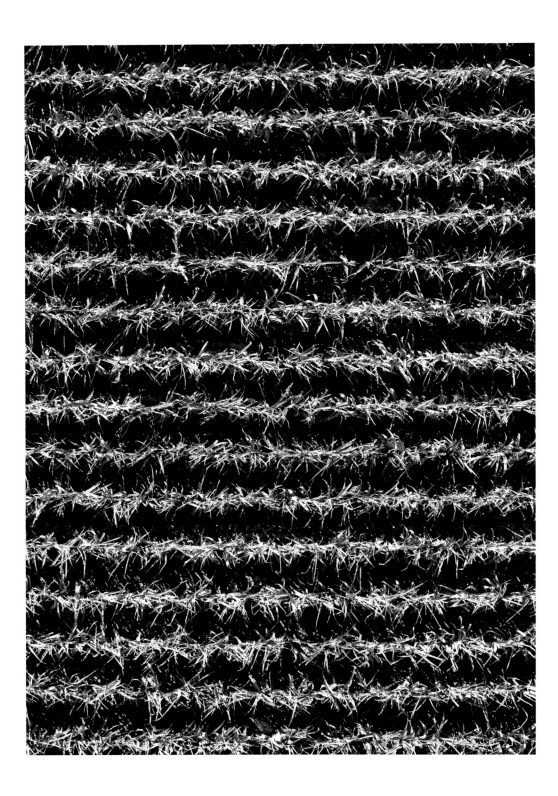

◁ LEEKS
Lower Durance Valley, Bouches-du-Rhône,
France; September

"It is said that the leek is the poor man's
asparagus. In fact it is a very delicate
vegetable which can be used in a variety
of manners: with vinaigrette, as stewed
leeks with sausages, leek quiche – it can
even be used to make sushi!"

CHRISTOPHE ZIEGERT, chef at Auberge de Bugnaux-
sur-Rolle, Vaud canton, Switzerland

LEEKS ▷
Seed-bearing crop for seed production.
Vaunaveys La Rochette, Drôme, France;
July

"Onions, leeks, cabbages, beetroots,
artichokes, radishes... seed-bearing
crops are my primary activity.
It's fascinating. Seed merchants sign
contracts with those who love their work!"

FRÉDERIC RAILLON, farmer, Vaunaveys La Rochette,
Drôme, France

◁ LAUCH
Unteres Durance-Tal, Bouches-du-Rhône,
Frankreich, September.

„Lauch gilt als Spargel der armen Leute.
In der Tat ist er in sehr schmackhaftes
Gemüse, das sich auf tausenderlei Weise
zubereiten lässt: in Vinaigrette, als
Waadtländer Lauchgemüse mit
Würstchen, als Quiche ... Man kann
sogar Sushi damit machen!"

CHRISTOPHE ZIEGERT, Koch, Auberge de Bugnaux-
sur-Rolle, Kanton Waadt, Schweiz.

LAUCH ▷
Samenträgerkultur zur Saatgutproduktion.
Vaunaveys La Rochette, Drôme,
Frankreich, Juli.

„Zwiebeln, Lauch, Kohl, Rüben,
Artischocken, Radieschen ... Ich baue
hauptsächlich Samenträger an – eine
faszinierende Tätigkeit. Die
Samenhändler schließen ihre Verträge
mit denen ab, die Spaß an ihrer Arbeit
haben!"

FRÉDERIC RAILLON, Landwirt, Vaunaveys
La Rochette, Drôme, Frankreich.

POLYTUNNELS
Polytunnels being built, with hoops being mounted.
Near Arles, Bouches-du-Rhône, France; late July

"This site of a polytunnel being built illustrates the principal stages of work: ground levelling, implantation, laying the elements out, progressive assembly and finally the erection of the arches."

Pierre Villin, Richel Serres de France, Eygalières, Bouches-du-Rhône, France

FOLIENTUNNEL
Aufbau von Folientunneln, Montage des Gestells.
Umgebung von Arles, Bouches-du-Rhône, Frankreich, Ende Juli.

„Bei der Montage dieser Folientunnel kann man die wichtigsten Arbeitsschritte beobachten: Boden vorbereiten, pflanzen, Bauelemente auf dem Boden verteilen und schrittweise zusammenbauen und schließlich die Bogengestelle aufrichten."

Pierre Villin, Richel Serres de France, Eygalières, Bouches-du-Rhône, Frankreich.

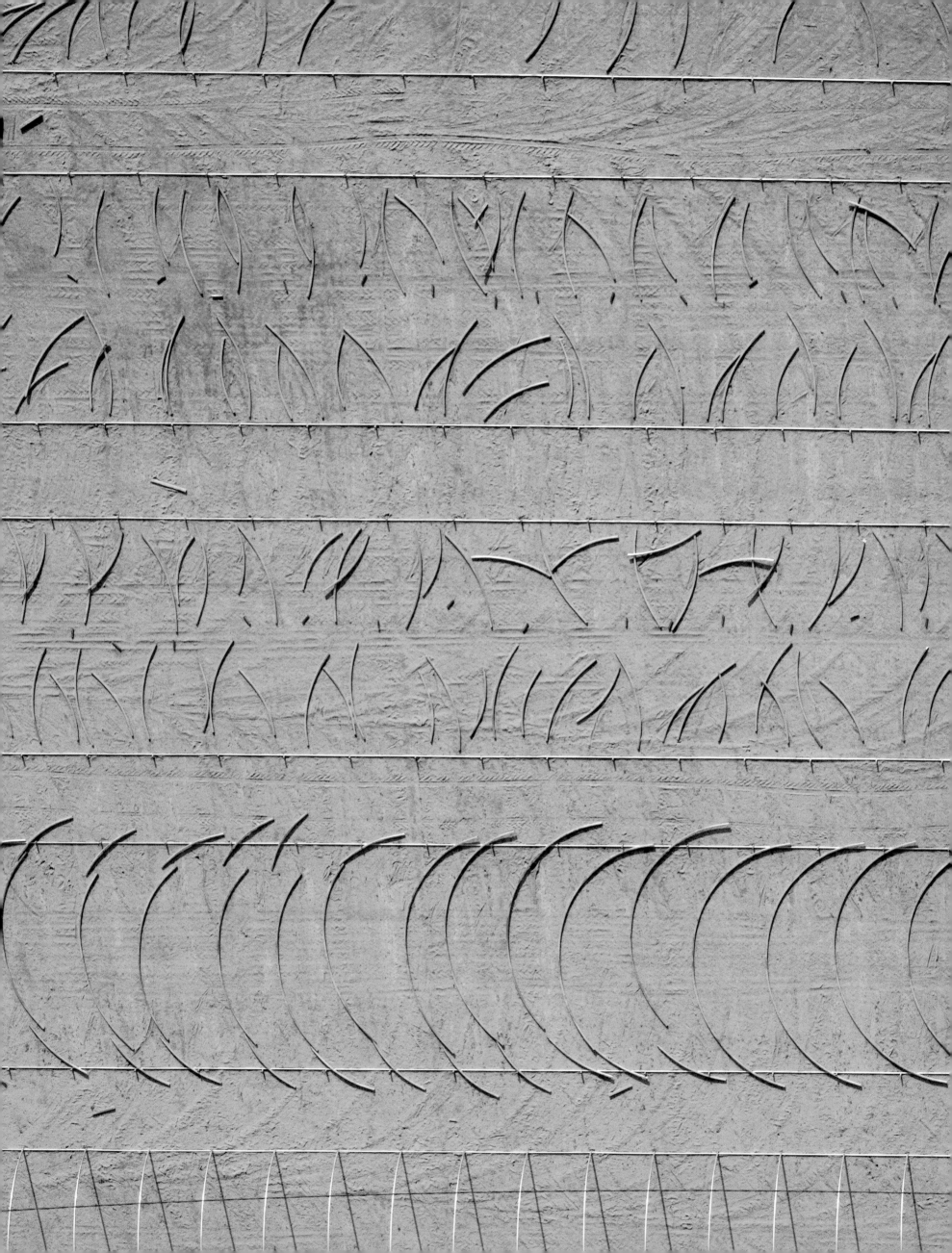

APRICOT ORCHARD
Square plantation on grassy land.
Verquières Region, Bouches-du-Rhône,
France; late October

"The family domain was a vineyard.
Today, the apricot has become our major
product, alongside the cherry and the
plum. The change took place around
1970 when the sales of table wine
started dropping.
We aim for quality, without artificial
irrigation, only moderate use of
chemicals and harvesting at ripeness.
We have no problems selling our
produce."

EDOUARD AND STÉPHANE DRÔME, arboriculturists,
La Capelle-Masmolène, Gard, France

APRIKOSENPLANTAGE
Quadratpflanzung, Untergrund: Gras.
Region Verquières, Bouches-du-Rhône,
Frankreich, Ende Oktober.

„Ursprünglich waren wir eine
Winzerfamilie. Heute bauen wir
hauptsächlich Aprikosen an, außerdem
Kirschen und Pflaumen. Der Wandel hat
sich um das Jahr 1970 vollzogen, als
sich einfache Weine immer schlechter
verkauften.
Keine künstliche Bewässerung,
sparsamer Umgang mit
Chemieprodukten und Ernte von reifen
Früchte: Wir setzen auf Qualität.
Absatzprobleme haben wir nicht."

ÉDOUARD UND STÉPHANE DROME, Obstgärtner,
La Capelle-Masmolène, Gard, Frankreich.

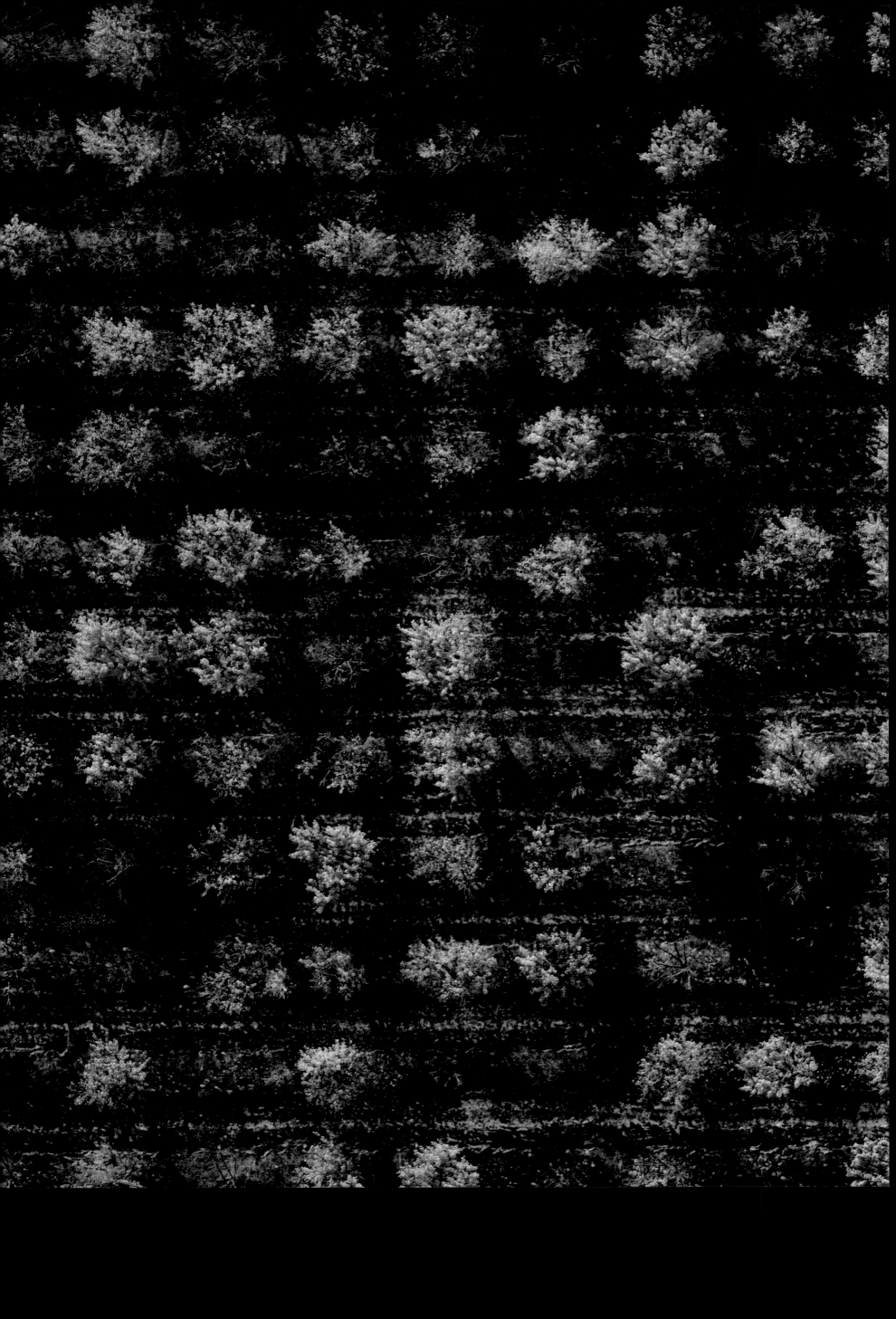

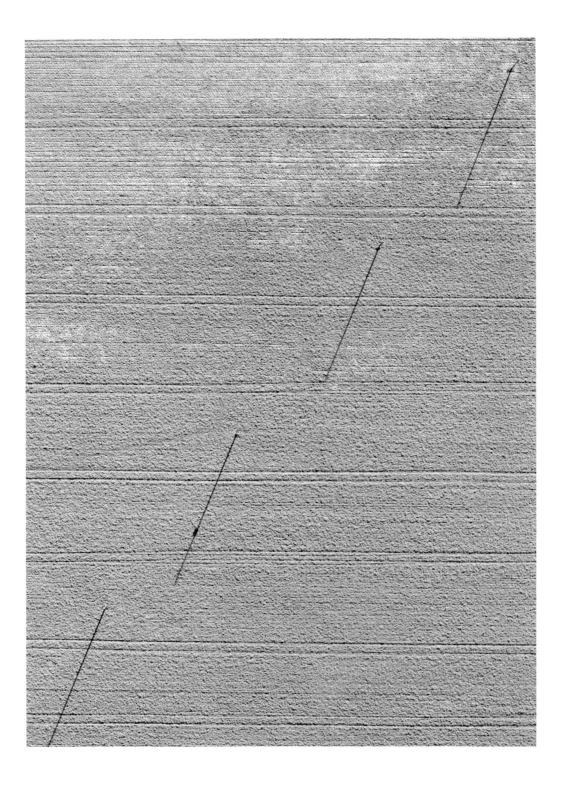

◁ RÜBENSAAT
Direktsaat von Rüben auf gefrorener
Herbstkultur. Kahle Stellen bedingt durch
zu viel Feuchtigkeit.
Elektroleitung.
Vouvry, Kanton Wallis, Schweiz, Ende April.

„Die Herbstkultur – auch 'grüner Dünger'
genannt – schützt den Boden und
verhindert das Wuchern von Unkraut.
Wenn sie im Winter gefriert, wie das hier
der Fall ist, kann man direkt wieder
säen. Wenn nicht, wird vor dem Säen
gepflügt."

GÉRALD BERGER, Essert-Pittet, Kanton Waadt,
Schweiz.

RÜBEN- UND MAISSAAT ▷
Vorbereitung des Bodens mit Rotoregge
und Ackerwalze für die Rüben (oben) und
den Mais (unten). Auf dem noch
unbearbeiteten Ackerstück in der Mitte
wurde der Dünger mit der Walze verteilt.
Vouvry, Kanton Wallis, Schweiz, Ende April.

„In ganz Europa gibt es immer weniger,
aber dafür immer größere
landwirtschaftliche Betriebe."

OLIVIER POTTERAT, Vorstandsmitglied von Migros
Waadt, Ecublens, Kanton Waadt, Schweiz.

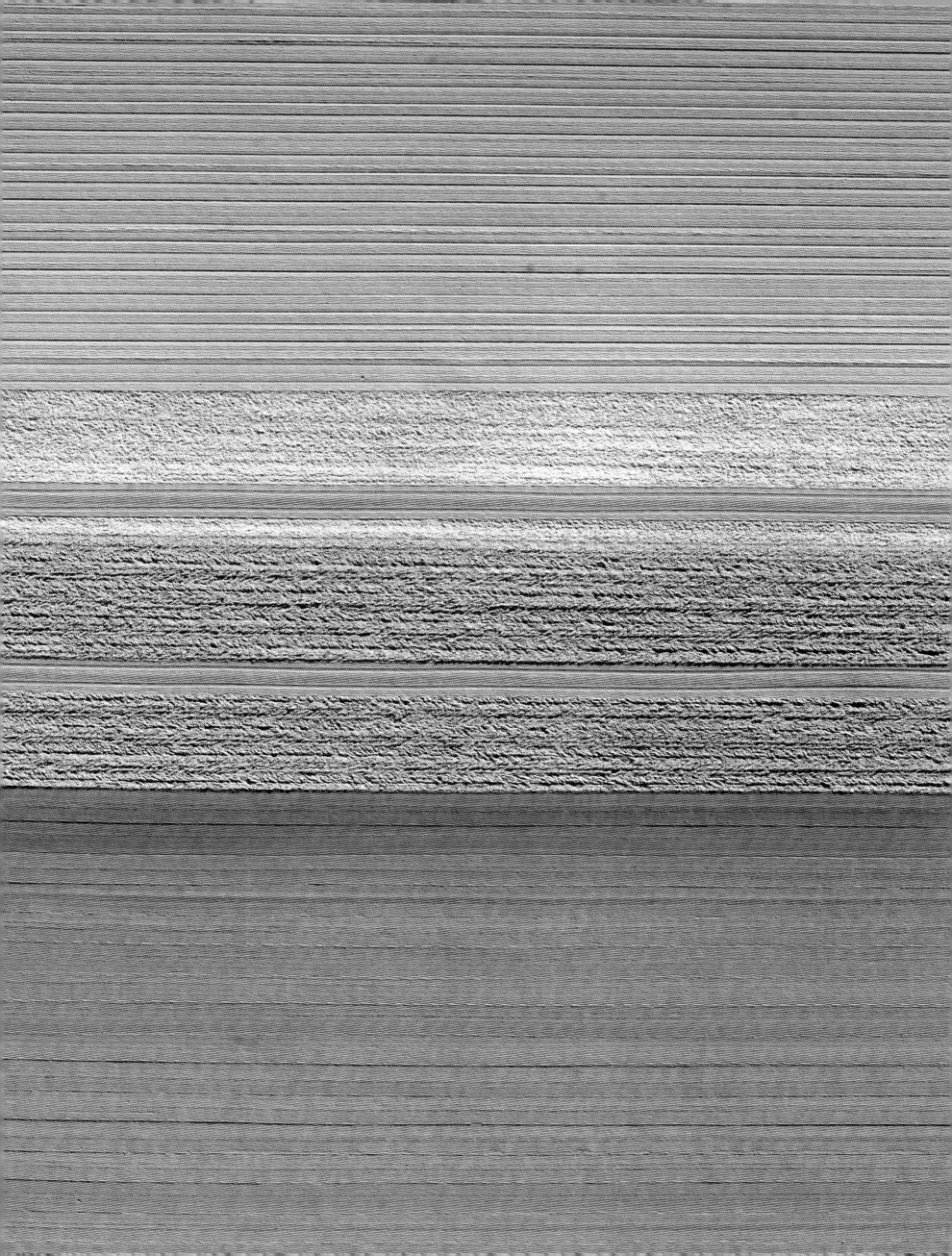

SALADS, MAIZE

Beds of four rows of salads at different stages of development, maize at the bottom.
Chiètres, Fribourg canton, Switzerland; late June

"People want produce from small traditional farms, but most also want to pay less. They believe that vegetables are of higher quality if they are produced in small quantities, yet the opposite is true: a professional grower uses far fewer chemicals than an amateur in an allotment. People also believe that what is sold at market is produced in small quantities, traditionally – this is often not the case."

JEAN-LUC RUEGSEGGER, vegetable seller, Sugiez, Fribourg canton, Switzerland

SALAT, MAIS

Streifen zu je vier Reihen in unterschiedlichen Wachstumsphasen. Unten Mais.
Chiètres, Kanton Freiburg, Schweiz, Ende Juni.

„Die Leute wollen Produkte aus kleinen Betrieben, doch gleichzeitig sollen die Sachen auch billig sein. Die Leute denken, dass Gemüse gesünder ist, wenn es in kleinen Mengen produziert wird, doch das Gegenteil ist der Fall: Ein professioneller Erzeuger verwendet weniger Chemie als ein Hobbygärtner. Und außerdem glauben die Leute, dass die Sachen, die auf dem Markt verkauft werden, in kleinen Mengen, so wie früher, produziert werden. Das stimmt häufig nicht."

JEAN-LUC RUEGSEGGER, Gemüsehändler, Sugiez, Kanton Freiburg, Schweiz.

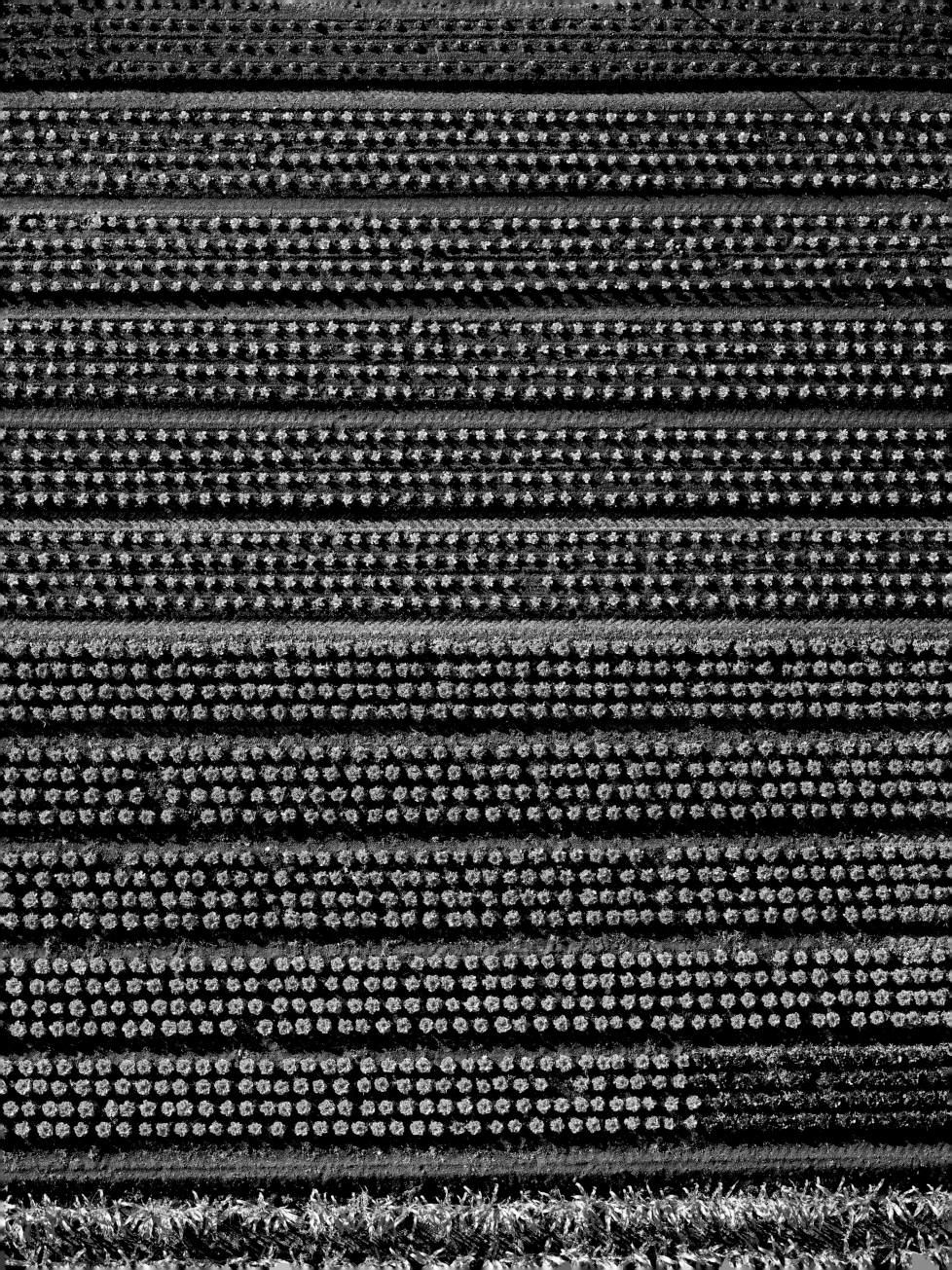

MOWN MEADOW

Swathes of second crop ready for
collection on a permanently irrigated
meadow.
Crau Plain, Bouches-du-Rhône, France;
late July

"The association Accueil Paysan (rural
welcome) guarantees holidaymakers
that they will be accommodated on a
working farm, usually on small farms
with varied crops and livestock, goats,
making cheese, growing aromatic
plants, preparing traditional cooked
meats... Such holidays represent an
economic diversification which
contributes to local development and
continued farming activity."

MARC ROSSETTI, donkey breeder, member
of Accueil Paysan, Vaunaveys La Rochette,
Drôme, France

HEUWIESE

Zum Aufladen bereites Heu aus dem
zweiten Schnitt auf einer
dauerbewässerten Wiese.
Crau-Ebene, Bouches-du-Rhône,
Frankreich, Ende Juli.

„Die Organisation ‚Accueil Paysan'
[Ferien auf dem Bauernhof] garantiert
dem Urlauber die Unterbringung auf
einem bewirtschafteten Bauernhof.
Häufig handelt es sich um kleine
Betriebe mit extensiven Mischkulturen
und Viehhaltung, mit Ziegen, Käse,
Aromapflanzen, Wurstwaren aus eigener
Herstellung usw. Damit werden neue
Wirtschaftszweige erschlossen, die der
lokalen Entwicklung zuträglich sind und
Arbeitsplätze in ländlichen Gebieten
erhalten."

MARC ROSSETTI, Eselzüchter, Anbieter von
„Accueil Paysan", Vaunaveys La Rochette,
Drôme, Frankreich.

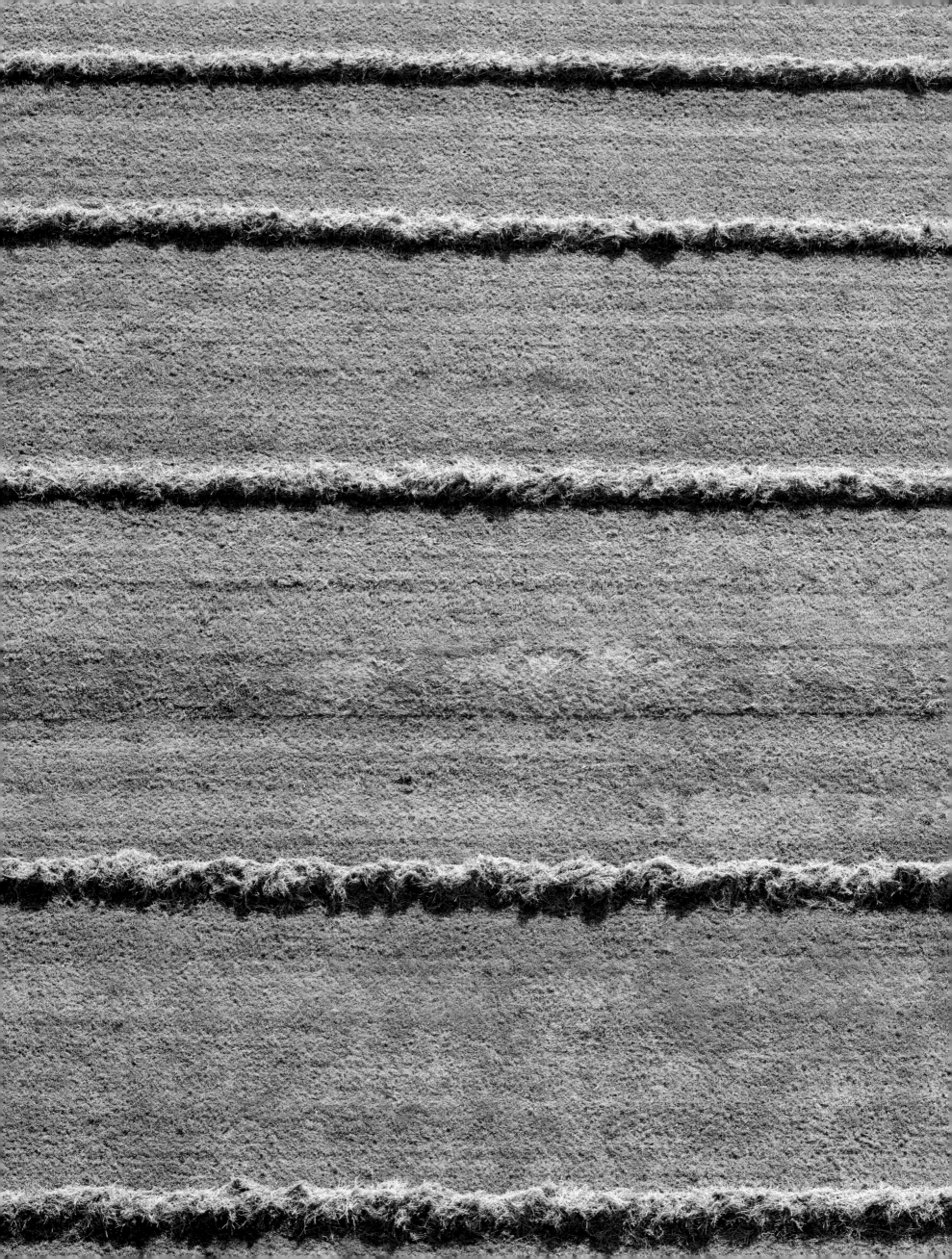

Page 154
HARVESTED WHEAT
Stubble after the harvest.
Chabeuil Region, Drôme, France; late July

"Today's agriculture is capable of feeding
everyone, this is a victory! Technical
progress will continue to allow greater
precision in agricultural techniques.
Reducing the burden on the
environment while maintaining high
production output has become an
achievable goal."

Évelyne Marendaz, agronomist, Service Romand
de Vulgarisation agricole, Lausanne, Vaud
canton, Switzerland

Seite 154
ABGEERNTETER WEIZEN
Stoppelfeld nach der Ernte.
Region Chabeuil, Drôme, Frankreich,
Ende Juli.

„Heute ist die Landwirtschaft in der
Lage, die ganze Welt zu ernähren. Das
ist ein Riesenerfolg! Der technologische
Fortschritt erlaubt immer größere
Präzision auf dem Gebiet der
landwirtschaftlichen Produktions-
methoden. So ist es ein realisierbares
Ziel geworden, Umweltbelastungen
zu reduzieren und gleichzeitig gute
Produktionsergebnisse zu erzielen."

Évelyne Marendaz, Agraringenieurin, Service
Romand de Vulgarisation agricole, Lausanne,
Kanton Waadt, Schweiz.

Page 155
HARROWED LAND
Harrowing after the harvest.
Arles region, Bouches-du-Rhône, France;
late July

"In Europe, food is easily available and
abundant. The consumer is no longer
willing to pay high prices in order to eat,
yet perhaps he is more inclined to pay
for the upkeep of the landscapes and
ways of life. We consume cultural
landscapes during our holidays, we
consume pastoral landscapes in our
olive oil. Our cheese or our wine, our
consumption is responsible for the
presence of the farmer at market... We
are thus willing to contribute to the
upkeep of our agriculture, to slow down
delocalisation. But for how long?"

Évelyne Marendaz, agronomist, Service Romand
de Vulgarisation agricole, Lausanne, Vaud
canton, Switzerland

Seite 155
GEEGGTES FELD
Bearbeitung nach der Ernte.
Region Arles, Bouches-du-Rhône,
Frankreich, Ende Juli.

„In Europa gibt es überall Nahrung im
Überfluss. Der Verbraucher ist nicht
mehr bereit, viel Geld für seine
Ernährung auszugeben, doch vielleicht
fällt es ihm leichter, für die Erhaltung
von Landschaften und Lebensräumen
zu bezahlen. In den Ferien konsumieren
wir Kulturlandschaften, entdecken in
Olivenöl, Käse oder Wein den ländlichen
Zauber einer Region, genießen auf dem
Markt die Anwesenheit der Bauern ...
Man ist also bereit, zum Erhalt unserer
Landwirtschaft beizutragen, ihre
Verlagerung zu bremsen. Wie lange noch?"

Évelyne Marendaz, Agraringenieurin, Service
Romand de Vulgarisation Agricole, Lausanne,
Kanton Waadt, Schweiz.

WALNUTS AND MAIZE
Maize crop between young walnut trees
before they start producing.
Saint-Marcellin, Isère, France; early July

"These young half-standard walnut trees
are seven years old. At ten or twelve,
they will produce walnuts, if all goes
well, for around fifty years. In the olden
days, standard trees did not really
produce any walnuts until they were
twenty years old. They did then,
however, produce for over one hundred
years, and at the end of their life
delivered a trunk of precious wood for
furniture making."

Maurice Boisset, walnut grower, Chatte, Isère,
France

WALNUSSBÄUME UND MAIS
Maiskultur zwischen jungen, noch nicht
tragenden Walnussbäumen.
Saint-Marcellin, Isère, Frankreich,
Anfang Juli.

„Diese jungen Walnussbäume mit
halbhohen Stämmen sind sieben Jahre
alt. Mit zehn oder zwölf Jahren werden
sie Nüsse tragen – wenn alles gut geht,
50 Jahre lang. Früher waren die hohen
Walnussbäume erst nach 20 Jahren
wirklich ertragreich. Doch sie haben
mehr als 100 Jahre lang getragen, und
schließlich lieferten sie noch wertvolles
Holz für die Möbelherstellung."

Maurice Boisset, Nussbauer, Chatte, Isère,
Frankreich.

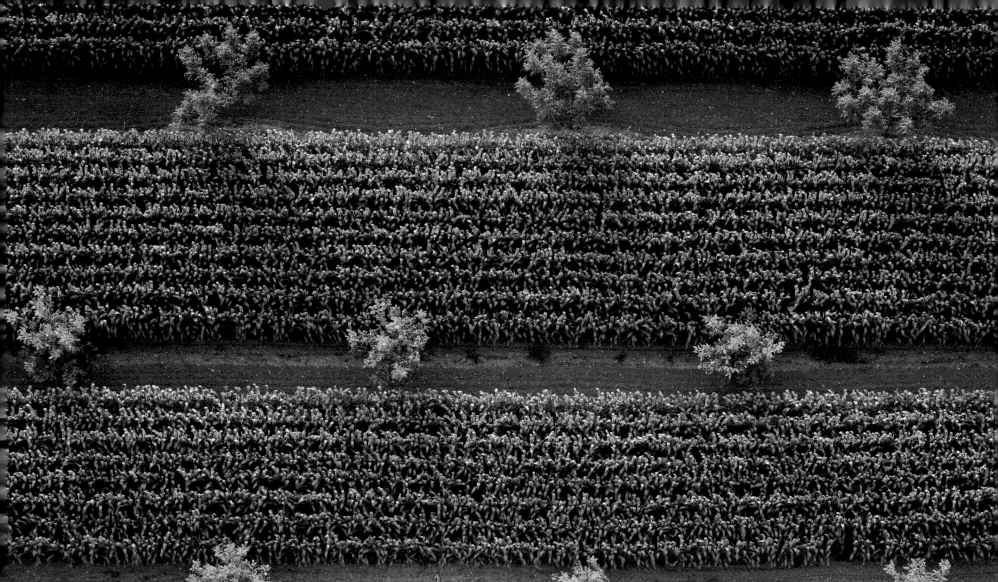

VINES

Old plantation, pruned into goblet shape,
on mineral soil (grey) with ground shoots
(yellow marks).
Saillon, Valais canton, Switzerland;
late April

"Our family distillery transforms by-
products of viticulture: grape marc after
pressing, wine dregs after fermentation,
and, more and more, wine surpluses.
For four generations, thanks to a
constant effort of research and
development, we have improved the
different extractions: eau de vie and
strong spirits, tartrate used in bread
making and plaster, seeds for the oil
press, pulp for animal fodder and finally
compost for re-use on the vines."

THIERRY DEBARGE, Bois des Dames Distillery,
Violes, Vaucluse, France

WEINBERG

Alte Pflanzung, Gobeleterziehung,
mineralischer Boden (grau) mit
Rebenspänen (gelbe Flecken).
Saillon, Wallis, Schweiz, Ende April.

„Unsere Familienbrennerei produziert
alle Nebenprodukte des Weinbaus:
Traubentrester nach dem Pressen,
Weinhefe nach der Gärung, und
zunehmend verwertet sie auch den
Weinüberschuss. Dank einer
konsequenten Forschung und
Entwicklung können wir die Qualität
unserer Produkte seit vier Generationen
konsequent verbessern: Dazu gehören
Schnäpse und hochprozentige Alkohole,
Tartrate – Weinstein – für die Brot- und
Gipsherstellung, Traubenkerne zur
Ölherstellung, Fruchtfleisch als
Viehfutter und schließlich Kompost für
die Weinberge."

THIERRY DEBARGE, Brennerei Bois des Dames,
Violes, Vaucluse, Frankreich.

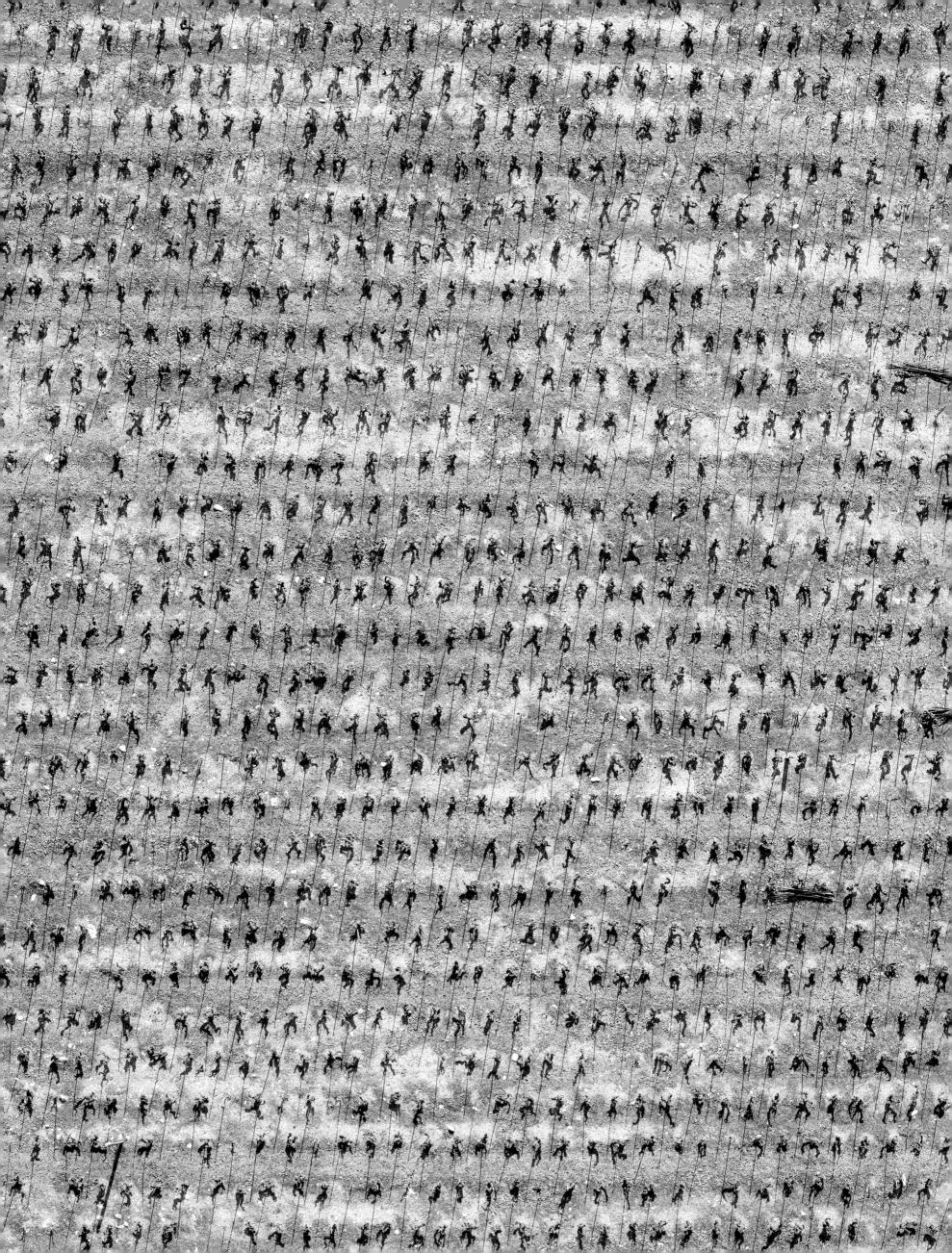

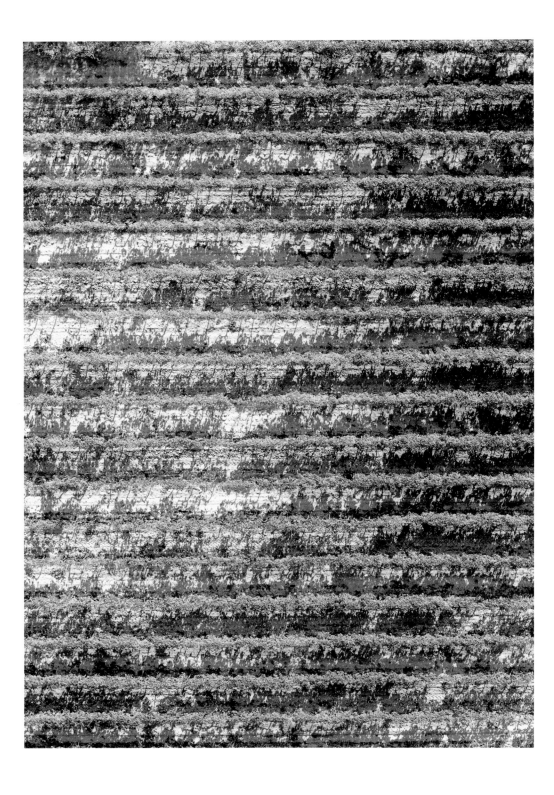

◁ VINEYARD
Fence crop on supporting wire.
Senas, Bouches-du-Rhône, France;
September

"Wine crops are in danger due to the
decline in wine consumption and the
competition from Australia, Chile, Spain...
Even some 'grand cru' vineyards
(Bordeaux, Beaujolais...) have sales
problems. Mass uprootings are taking
place. The possibilities for change are
limited on this poor soil: lavender, olives,
truffles, sometimes arboriculture...
In many cases, urbanisation takes over:
activities, infrastructure, holiday
homes... For the rest, whole sections of
the landscape will become wasteland,
and will slowly turn into forests."

JEAN-LUC FOURNIÉ AND SOPHIE STÉVENIN, arboriculture
advisors, the farmers' association of the Drôme,
Valence, Drôme, France

VINEYARD ▷
Wire-supported crop. Production of vat
grapes.
Between Aix and Salon-de-Provence,
Bouches-du-Rhône, France; late October

"The young drink less wine than before
because of the police."

MOHAMED MOUNCHO, vineyard worker, Sainte-
Cécile-les-Vignes, Vaucluse, France

◁ WEINBERG
Drahterziehung.
Senas, Bouches-du-Rhône, Frankreich,
September.

„Der Weinbau ist bedroht durch den
sinkenden Weinkonsum und die
Konkurrenz aus Australien, Chile,
Spanien usw. Einige Weinregionen
haben sogar Schwierigkeiten mit dem
Absatz ihrer Grands Crus (Bordeaux,
Beaujolais usw.). Es gibt auch groß-
flächige Rodungsprojekte, doch zur
weiteren landwirtschaftlichen Nutzung
eigenen sich die kargen Böden nur
bedingt – etwas für Lavendel, Oliven,
Trüffeln oder manchmal auch für den
Obstanbau. Häufig verstädtern diese
Gebiete: Dort siedeln sich Unternehmen
an, es entwickelt sich eine Infrastruktur,
es entstehen Ferienhäuser. Was den
Rest angeht, so liegen ganze
Landschaften brach und werden nach
und nach zu Waldgebieten."

JEAN-LUC FOURNIÉ UND SOPHIE STÉVENIN,
Obstbauberater, Landwirtschaftskammer
Drôme, Valence, Drôme, Frankreich.

WEINBERG ▷
Drahterziehung. Produktion von Trauben
zur Weinherstellung.
Zwischen Aix und Salon-de-Provence,
Bouches-du-Rhône, Frankreich,
Ende Oktober.

„Wegen der Polizei trinken die jungen
Leute heute weniger Wein als früher."

MOHAMED MOUNCHO, Weinarbeiter, Sainte-Cécile-
les-Vignes, Vaucluse, Frankreich.

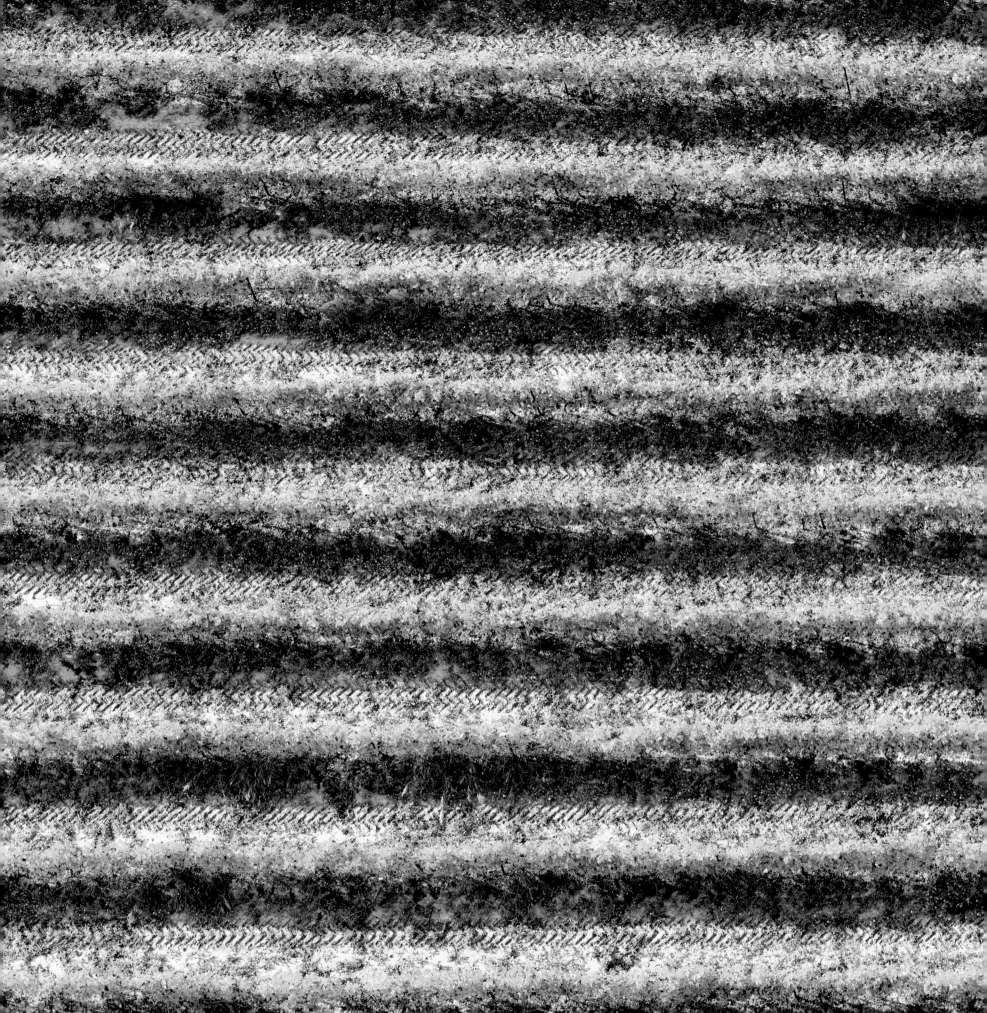

HARROWED AND ROLLED LAND
Prepared soil, the teeth on the rollers leave
marks that show the alternating direction
of passage.
Noville, Vaud canton, Switzerland;
early September

"It looks like a carpet..."

PHILIPPE TSCHANZ, farm machinery mechanic,
Essert-sous-Champvent, Vaud canton,
Switzerland

GEEGGTER UND GEWALZTER ACKER
Bearbeitetes Feld. Die Spuren, die das
Profil der Ackerwalze hinterlässt, zeigen
die wechselnden Fahrtrichtungen an.
Noville, Kanton Waadt, Schweiz,
Anfang September.

„Das sieht beinahe aus wie ein
Teppich ..."

PHILIPPE TSCHANZ, Landmaschinenmechaniker,
Essert-sous-Champvent, Kanton Waadt,
Schweiz.

OLIVE GROVE
Plantation on bare soil, pruned into goblet
form.
Near Arles, Bouches-du-Rhône, France;
September

"By mixing many different varieties of
'idle' olives (over-ripened for a few days
between the harvest and the press),
we are aiming for a 'black-fruited' oil:
with subtle aromas of undergrowth,
cut hay, mushroom and hazelnut."

ANNE PONIATOWSKI, olive grower, Le Mas de la Dame,
Les Baux-de-Provence, Bouches-du-Rhône,
France

OLIVENPLANTAGE
Anbau auf nacktem Boden, Gobeletschnitt.
Umgebung von Arles, Bouches-du-Rhône,
Frankreich, September.

„Durch die Zusammenstellung
verschiedener Olivensorten, die
zwischen Ernte und Pressung einige
Tage nachgereift sind, erhält man
ein Öl mit zarten Aromen von Unterholz,
geschnittenem Heu, Pilzen und
Haselnüssen."

ANNE PONIATOWSKI, Olivenbäuerin, Le Mas
de la Dame, Les Baux-de-Provence, Bouches-
du-Rhône, Frankreich.

PAGE 166
PADDYFIELD
Mature rice, the perpendicular lines
correspond to the irrigation and drainage
trenches, the little holes are coypu dens.
Near Arles, Bouches-du-Rhône, France;
September

SEITE 166
REISFELD
Erntereifer Reis. Die rechtwinkligen Linien
sind Bewässerungs- und Abflussrohre,
die kleinen Löcher Futternischen von
Biberratten.
Umgebung von Arles, Bouches-du-Rhône,
Frankreich, September.

PAGE 167
PADDYFIELD
Mature crop.
Near Arles, Bouches-du-Rhône, France;
September

"Rice crops are necessary in the
Camargue, in order to reduce the salinity
of the soil. The fresh water brought into
the paddyfields, draws the salt down,
which allows us to alternate our crops."

PATRICK MADAR, Tourelles domain and collection
centre, Aigues-Mortes, Gard, France

SEITE 167
REISFELD
Erntereife Pflanzen.
Umgebung von Arles, Bouches-du-Rhône,
Frankreich, September.

„Der Reisanbau hat in der Camargue eine
wichtige Funktion, denn er verringert
den Salzgehalt des Bodens. Das
Süßwasser, mit dem die Felder
gewässert werden, lässt die Salze weiter
absickern, sodass wir dort auch andere
Pflanzen anbauen können."

PATRICK MADAR, Domaine des Tourelles, Aigues-
Mortes, Gard, Frankreich.

SANDY SOIL
The remains of an unidentified crop after
harvest.
Near Arles, Bouches-du-Rhône, France;
September

SANDBODEN
Überreste einer nicht identifizierten Kultur
nach der Ernte.
Umgebung von Arles, Bouches-du-Rhône,
Frankreich, September.

ARTICHOKES

A species of artichoke called the 'Violet de Provence', harvested from October onwards.
Lower Durance Valley, Bouches-du-Rhône, France; September

"I grow more and more flowers, and I work extensively with the Dutch. When I went to Amsterdam with my daughter to visit the large flower market near the airport, they had decorated the entire entrance with my artichoke flowers. I was very happy."

DENIS PELOUZET, farmer, Saint-Etienne-du-Grès, Bouches-du-Rhône, France

ARTISCHOCKEN

Gemüseartischocken, Sorte „Violet de Provence", Erntezeit ab Oktober.
Unteres Durance-Tal, Bouches-du-Rhône, Frankreich, September.

„Ich baue immer mehr Blumen an und arbeite häufig mit den Holländern zusammen. Als ich mit meiner Tochter in Amsterdam auf dem großen Blumenmarkt direkt neben dem Flughafen war, hatten sie den ganzen Eingang mit meinen Zierartischocken dekoriert. Das hat mich gefreut."

DENIS PELOUZET, Landwirt, Saint-Etienne-du-Grès, Bouches-du-Rhône, Frankreich.

PLANTING OF VINES ▷
Marking and staking out before the
planting of a new vine; mineral soil from
the alluvial fan of a tributary of the Rhône.
Saint-Pierre-de-Clages, Valais canton,
Switzerland; late April

◁ VINE
Red grapes grown along wires.
Fallen leaves on stony ground.
Chamoson, Valais canton, Switzerland;
November

"This large fan of gravel accumulated, bit
by bit, brought by the river each time it
flooded. It was covered by a pine forest.
It was only around 1880, when the river
was dammed, that we were able to plant
vines."

M. Roduit, wine grower, Leytron, Valais canton,
Switzerland

ANPFLANZUNG EINES WEINBERGS ▷
Begehung und Vermessung des Geländes
vor der Anpflanzung eines neuen
Weinbergs. Mineralischer Boden vom
Schwemmkegel eines in die Rhône
fließenden Gebirgsbaches.
Saint-Pierre-de-Clages, Kanton Wallis,
Schweiz, Ende April.

◁ WEINBERG
Rote Rebsorte, Drahterziehung.
Herabgefallenes Weinlaub auf steinigem
Boden.
Chamoson, Wallis, Schweiz, November.

„Dieser große Kieskegel hat sich bei
jedem Hochwasser des Flusses weiter
vergrößert. Hier standen früher Kiefern.
Wein konnte man erst nach 1880
anbauen, nachdem die Flussdämme
gebaut wurden."

M. Roduit, Winzer, Leytron, Kanton Wallis, Schweiz.

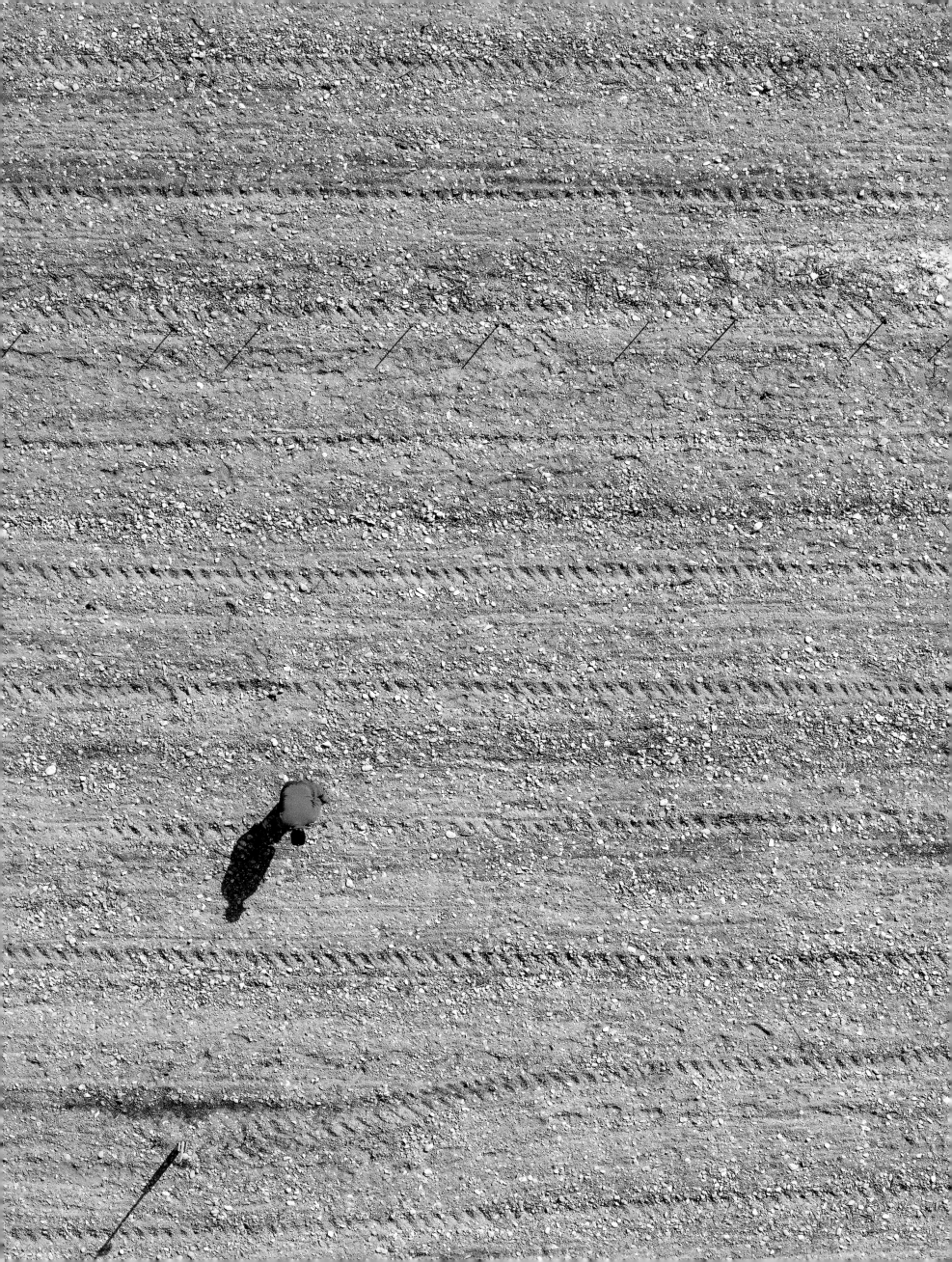

VEGETABLE CROPS

Top, courgette plants under sheeting
placed on crates; below, onions in open air,
celery seeds under sheeting, five coloured
strips planted with red and green lettuces.
Roche, Vaud canton, Switzerland; late April

"Here the well-draining soil is perfect
for growing vegetables. And the
climate allows us to cultivate without
polytunnels. A simple protective sheet
in spring suffices. We will know how to
adapt to an increasingly competitive
market!"

FREDDY AND JULIEN BRÖNNIMANN, Noville, Vaud
canton, Switzerland

GEMÜSEKULTUREN

Oben: Zucchinipflanzen; Abdeckung: über
Schalen gespannte Folie; darunter:
Freilandzwiebeln; Selleriesaat unter Folie;
grüner und roter Salat unter fünf farbigen
Folienstreifen.
Roche, Kanton Waadt, Schweiz, Ende April.

„Die durchlässigen Böden hier eignen
sich besonders gut für den Anbau von
Gemüse. Und wegen des günstigen
Klimas müssen wir nicht unter
Folientunneln anbauen. Eine einfache
Schutzplane im Frühjahr reicht
vollkommen aus. Wir sind bereit, uns
dem zunehmend härteren Wettbewerb
anzupassen."

FREDDY UND JULIEN BRÖNNIMANN, Noville, Kanton
Waadt, Schweiz.

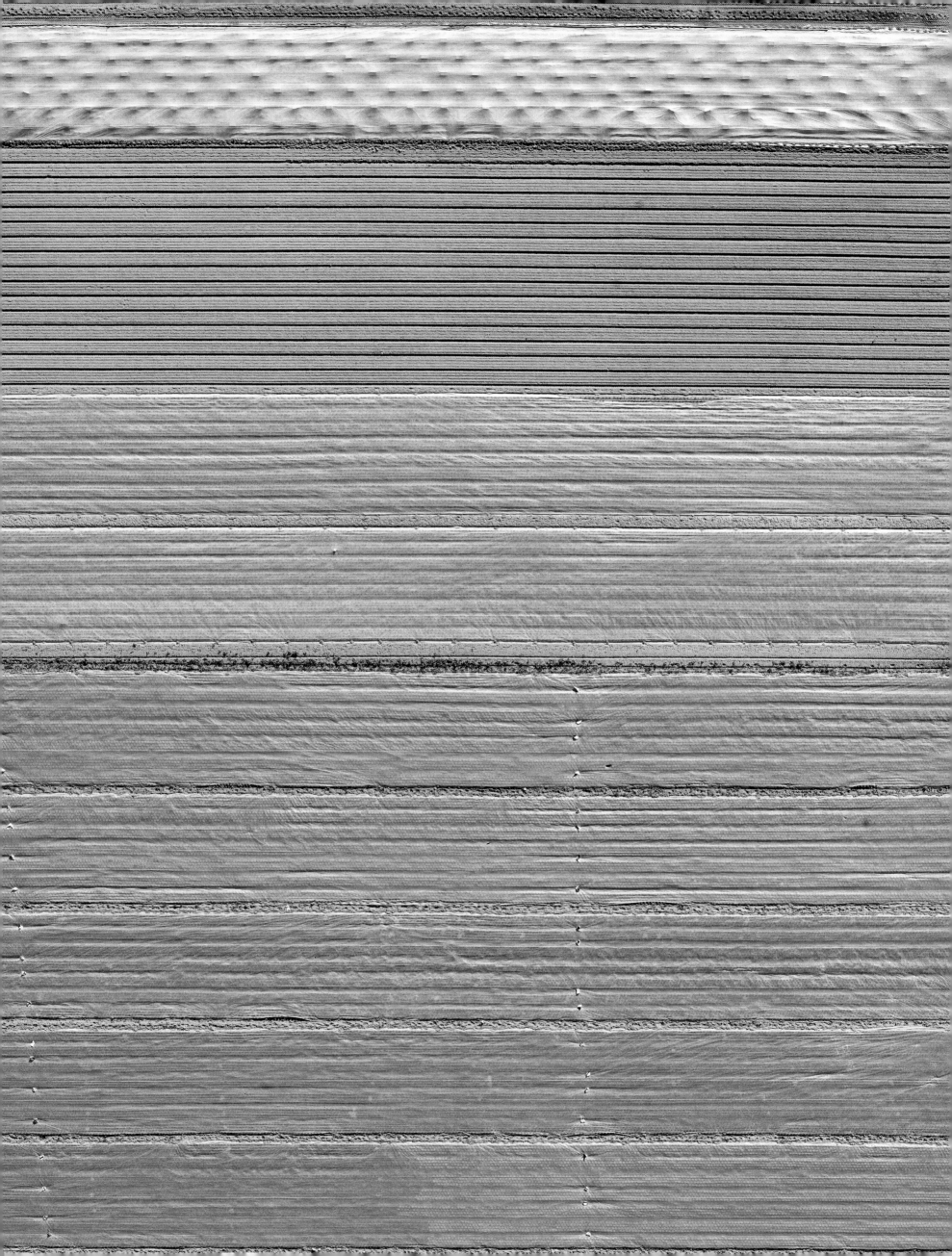

CHRYSANTHEMUMS
Potted plants on plastic bedding,
drip watering.
Near Mérindol, Vaucluse, France;
late October

"The chrysanthemum is the flower of the
dead. This remains a taboo: one does
not plant them in gardens."

CORINNE GRAS, The greenhouses of Grenouillet,
Cavaillon, Vaucluse, France

CHRYSANTHEMEN
Topfkultur auf Plastikfolie. Pflanzen
einzeln bewässert.
Umgebung von Mérindol, Vaucluse,
Frankreich, Ende Oktober.

„Die Chrysantheme ist eine
Friedhofsblume. Die pflanzt man nicht
im Garten, das ist noch immer ein Tabu."

CORINNE GRAS, Serres du Grenouillet, Cavaillon,
Vaucluse, Frankreich.

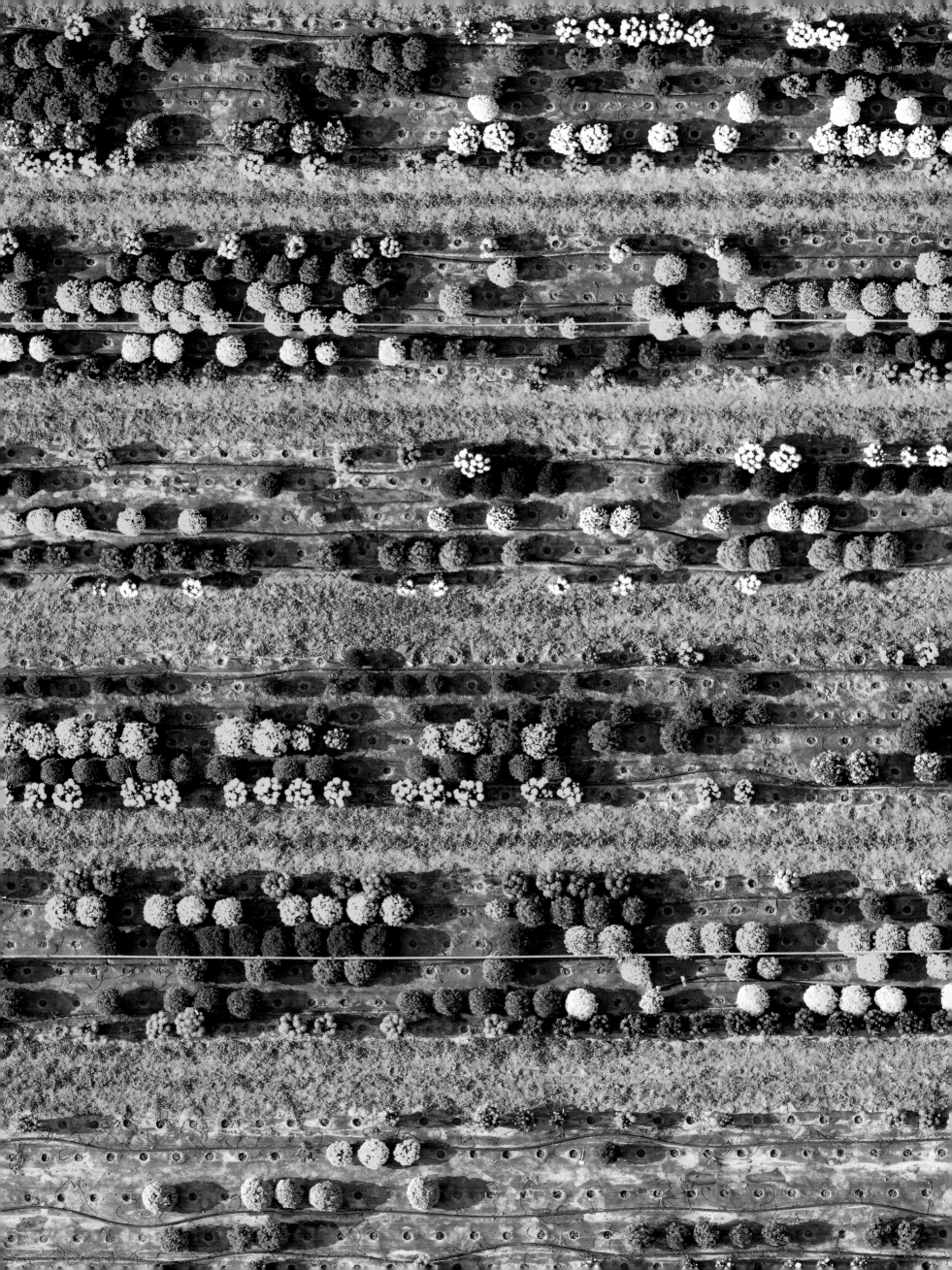

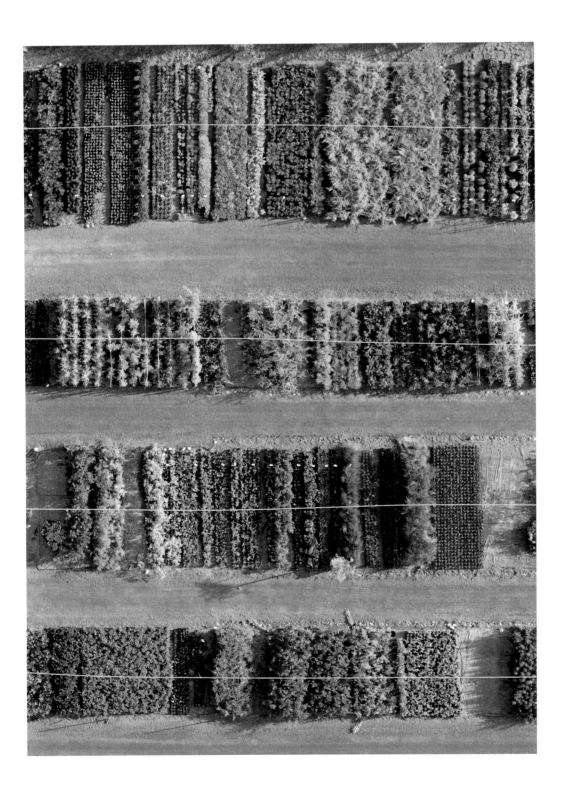

◁ NURSERY
Crops of garden plants in pots on display for sale.
L'Isle-sur-la-Sorgue, Vaucluse, France; late October

"My father was a vegetable grower, and gave me the passion for growing plants. I have specialised in aromatic plants. I supply garden centres. To have fresh tarragon on hand when cooking, is something else..."

ERIC BISCARAT, horticulturist and nurseryman, Cavaillon, Vaucluse, France

GREENHOUSE TOMATOES ▷
Crop without soil in glass greenhouses with opening windows in staggered rows; the yellow marks are flytraps.
Châteaurenard, Vaucluse, France; late March

"We are often compared to manufacturers, but we are simply large-scale farmers. The advantages of large-scale production are the rationalisation and lowering of costs. And also the energy saved: a greenhouse is a fantastic solar cell! The Dutch have just invented another type of closed greenhouse, which accumulates heat and cold in underground water reservoirs. This system economises energy, water and pesticides! You'll see: the vegetable growers of the future will be energy suppliers!"

ROLAND STOLL, vegetable grower, Yverdon-les-Bains, Vaud canton, Switzerland

◁ BAUMSCHULE
In Töpfen kultivierte Gartenpflanzen, zum Verkauf ausgestellt.
L'Isle-sur-la-Sorgue, Vaucluse, Frankreich, Ende Oktober.

„Mein Vater war Gemüsebauer. Von ihm habe ich die Leidenschaft für die Pflanzenzucht geerbt. Ich habe mich auf Aromapflanzen spezialisiert und beliefere Gartencenter. Beim Kochen frisches Estragon zur Hand zu haben, das ist einfach etwas ganz anderes ...“

ERIC BISCARAT, Gärtner und Pflanzenzüchter, Cavaillon, Vaucluse, Frankreich.

TREIBHAUSTOMATEN ▷
Anbau ohne Erde, Glastreibhaus mit Fensterluken. Die gelben Flecken sind Fliegenfallen.
Châteaurenard, Vaucluse, Frankreich, Ende März.

„Man vergleicht uns oft mit einem Industrieunternehmen, doch wir sind einfach ein landwirtschaftlicher Betrieb, der in großem Maßstab produziert. Der Vorteil besteht darin, dass wir so rationeller und günstiger arbeiten können. Aber wir sparen auch Energie: Treibhäuser sind fantastische Sonnenkollektoren! Die Holländer sind gerade wieder mit einem innovativen Konzept auf den Markt gekommen, nämlich mit geschlossenen Treibhäusern, die in unterirdischen Wassertanks Wärme und Kälte speichern. Mit diesem System spart man gleichzeitig Energie, Wasser und Pflanzenschutzmittel!
Sie werden sehen: Die Gemüsezüchter der Zukunft werden Energielieferanten sein!“

ROLAND STOLL, Gemüseproduzent, Yverdon-les-Bains, Kanton Waadt, Schweiz.

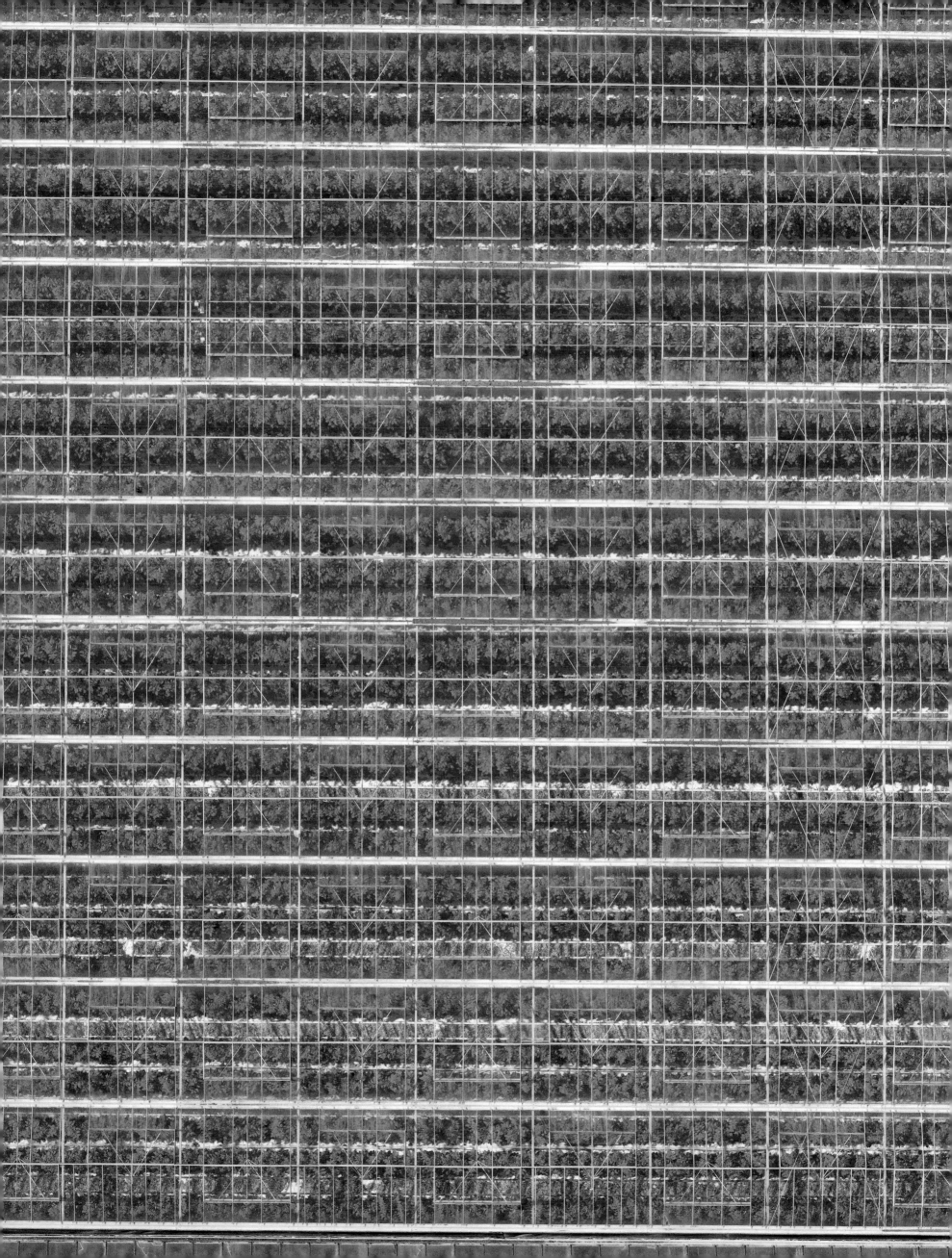

STRAWBERRIES
Crop on white plastic bedding; tunnel
hoops for winter coverage..
Lower Durance Valley, Bouches-du-Rhône,
France; late October

"These photographs of farmed land look
like the genes of the earth."

José Bové, farmer, former farming union activist,
Causse du Larzac, Aveyron, France

ERDBEEREN
Anbau auf weißem Plastik. Gestell für die
Abdeckung im Winter.
Unteres Durance-Tal, Bouches-du-Rhône,
Frankreich, Ende Oktober.

„Diese Fotografien von
landwirtschaftlichen Kulturen sehen
aus, als wären sie die Gene der Erde."

José Bové, Landwirt, ehemaliger
Bauerngewerkschafter, Causse du Larzac,
Aveyron, Frankreich.

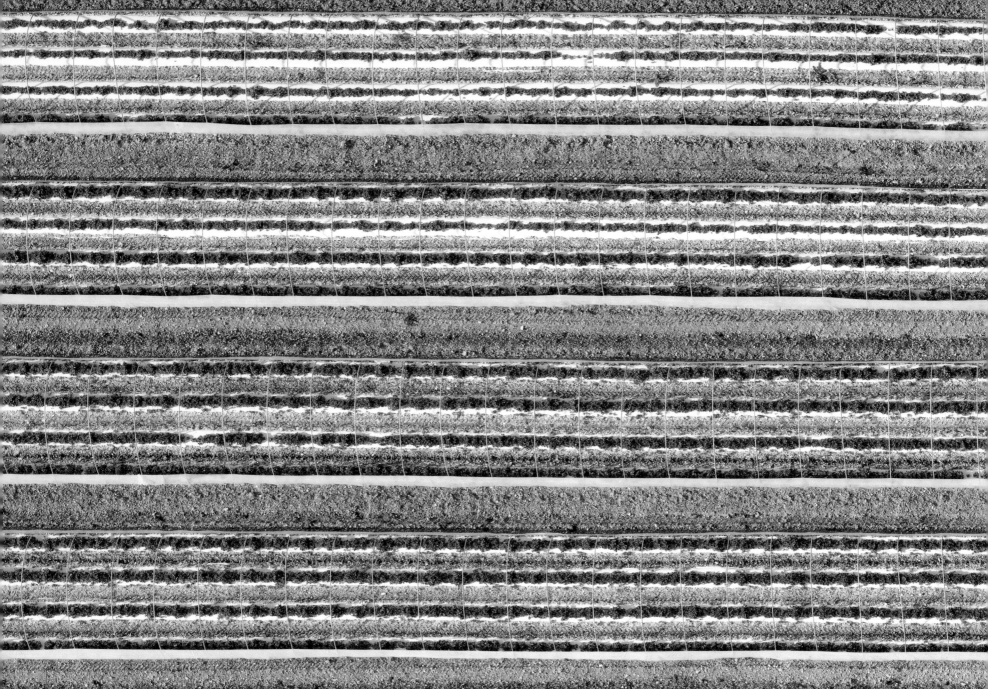

APPLE ORCHARD

The pollinating trees, with yellow leaves, un-pruned, dominate the rows of fruiting trees that are pruned; orange harvest crates.
Cavaillon, Vaucluse, France; late October

"The 'valentine apple' or Pink Lady is a late variety, created in 1973 in Australia by crossing a Lady William's and a Golden Delicious. It has produced a giant collaborative network between nurseries, producers and sellers. In this orchard, the green trees are the producers, and the yellow trees, which bear small un-saleable red apples, are the pollinators. The third and last harvest has just taken place. The few orange crates were not needed."

DENIS RAVANAS, arboriculturist, Cavaillon, Vaucluse, France

APFELPLANTAGE

Die unbeschnittenen Bestäuber mit dem gelben Blattwerk überragen die Reihen der zu bestäubenden Bäume. Orangefarbene Erntekisten.
Cavaillon, Vaucluse, Frankreich, Ende Oktober.

„Die 'Pink Lady' ist eine späte Sorte, die 1973 in Australien aus einer Kreuzung zwischen Lady William's und Golden Delicious gezüchtet wurde. Sie ist das Produkt einer engen Zusammenarbeit zwischen Baumzüchtern, Produzenten und Vertreibern. Die grünen Bäume hier sind die fruchttragenden Pflanzen, die gelben, deren kleine, rote Äpfel nicht verwertbar sind, Bestäuber. Wir sind gerade mit der dritten und letzten Ernte fertig. Die orangenen Kisten da haben wir nicht gebraucht."

DENIS RAVANAS, Obstbauer, Cavaillon, Vaucluse, Frankreich.

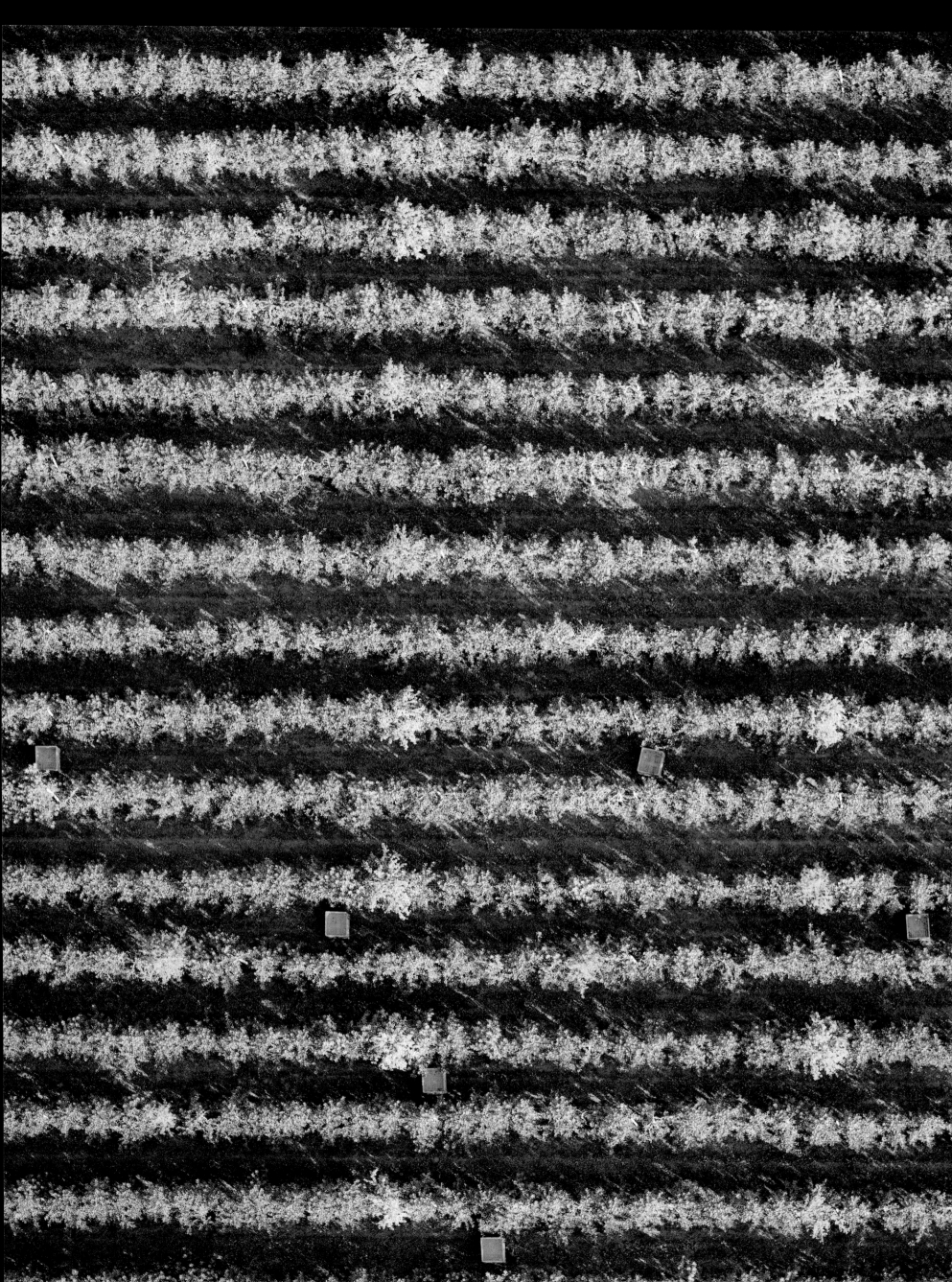

MAIZE

Crop devastated by the drought.
Near Arles, Bouches-du-Rhône, France;
September

"There is nothing left to harvest on this
maize. It has to be shredded and
ploughed back in."

EDOUARD AND STÉPHANE DRÔME, arboriculturists,
La Capelle-Masmolène, Gard, France

MAIS

Durch große Trockenheit zerstörte Kultur.
Umgebung von Arles, Bouches-du-Rhône,
Frankreich, September.

„Bei diesem Mais gibt's nichts mehr zu
ernten. Der muss gehäckselt und
untergepflügt werden."

Édouard und Stéphane Drome, Obstbauern,
La Capelle-Masmolène, Gard, Frankreich.

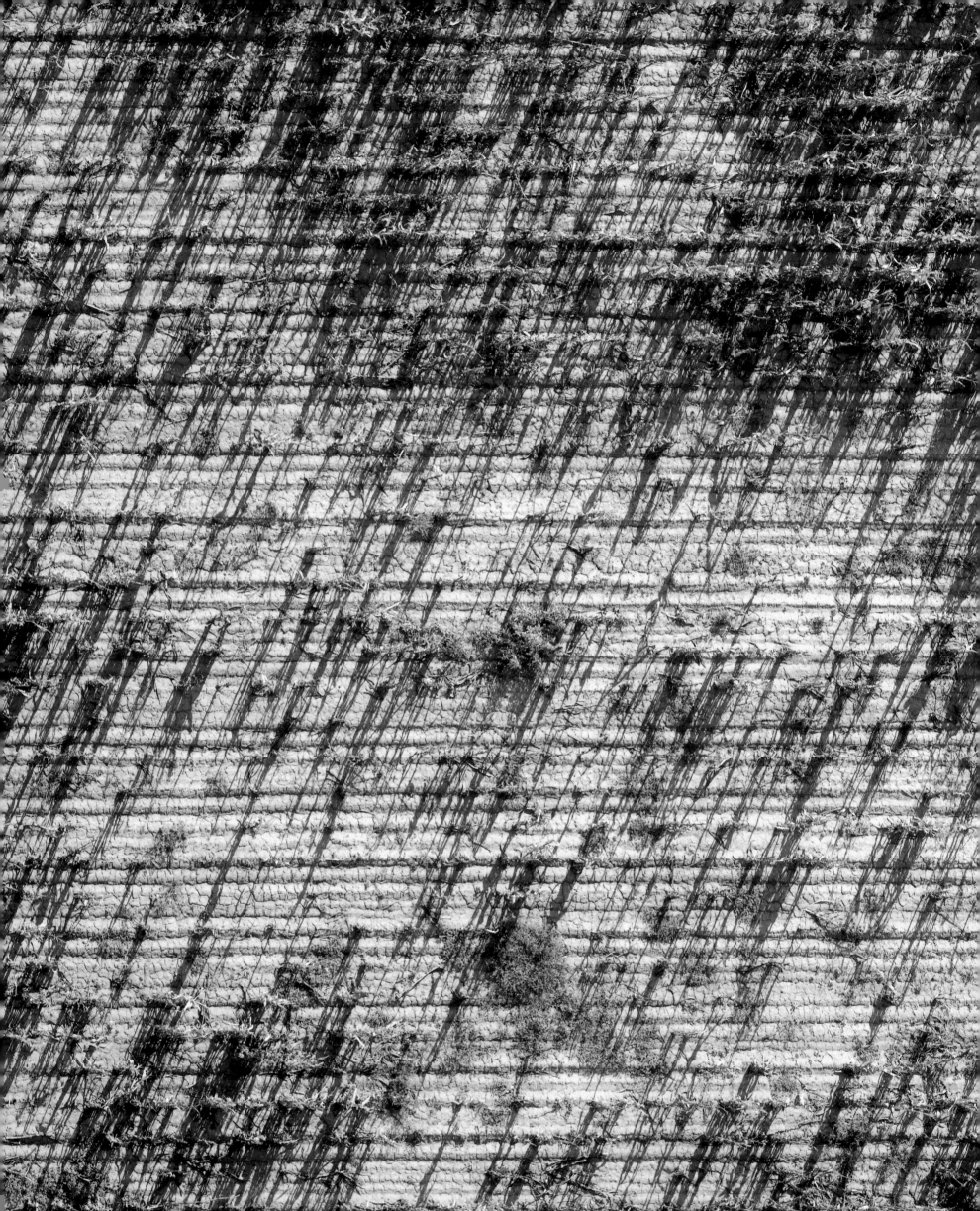

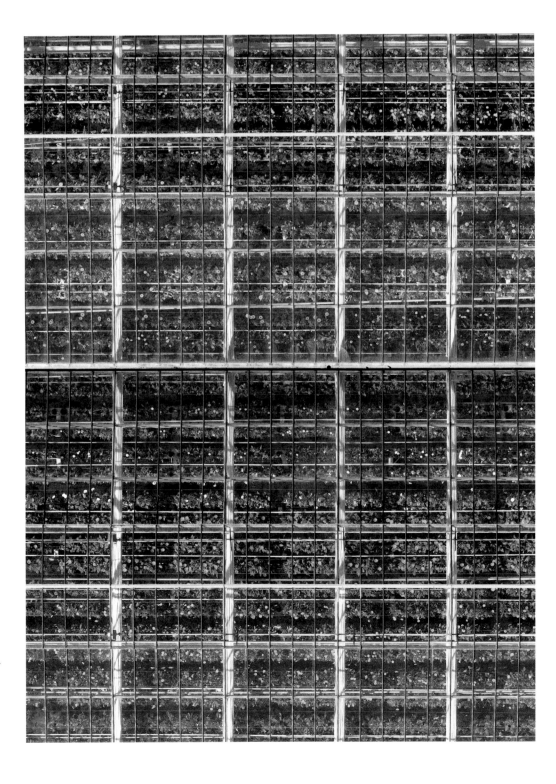

◁ **FLORAL CROP IN GREENHOUSE**
Soil-less gerbera crop in glass greenhouse.
Rennaz, Vaud canton, Switzerland; March

"The gerbera is a noble flower. Due to its
sun shape and its variable, yet always
warm, colourways, this large flower
seems to smile at you!"

ERICA DE KLEERMAEKER, florist, Vaudois University
Hospital, Lausanne, Vaud canton, Switzerland

VEGETABLE GREENHOUSE ▷
White-washed greenhouse with small
opening windows in staggered rows and
heating chimneys.
Saint-Rémy de Provence, Bouches-du-
Rhône, France; July

"The greenhouses are whitewashed in
March by helicopter."

CARMEN, Saint-Rémy de Provence, Bouches-du-
Rhône, France

◁ **TREIBHAUSBLUMEN**
Gerberakultur unter Glas, Anbau ohne Erde.
Rennaz, Kanton Waadt, Schweiz, März.

„Die Gerbera ist eine edle Blume.
Mit ihrer Sonnenform, ihren
unterschiedlichen, jedoch immer
warmen Farben lächelt diese großartige
Blume einen an."

ERICA DE KLEERMAEKER, Floristin im
Universitätskrankenhaus Waadt, Lausanne,
Kanton Waadt, Schweiz.

GEMÜSETREIBHAUS ▷
Treibhaus mit gekälkten Scheiben,
Fensterluken und Heizschächten.
Saint-Rémy-de-Provence, Bouches-
du-Rhône, Frankreich, Juli.

„Die Glastreibhäuser werden im März
vom Hubschrauber aus geweißt."

CARMEN, Saint-Rémy de Provence, Bouches-
du-Rhône, Frankreich.

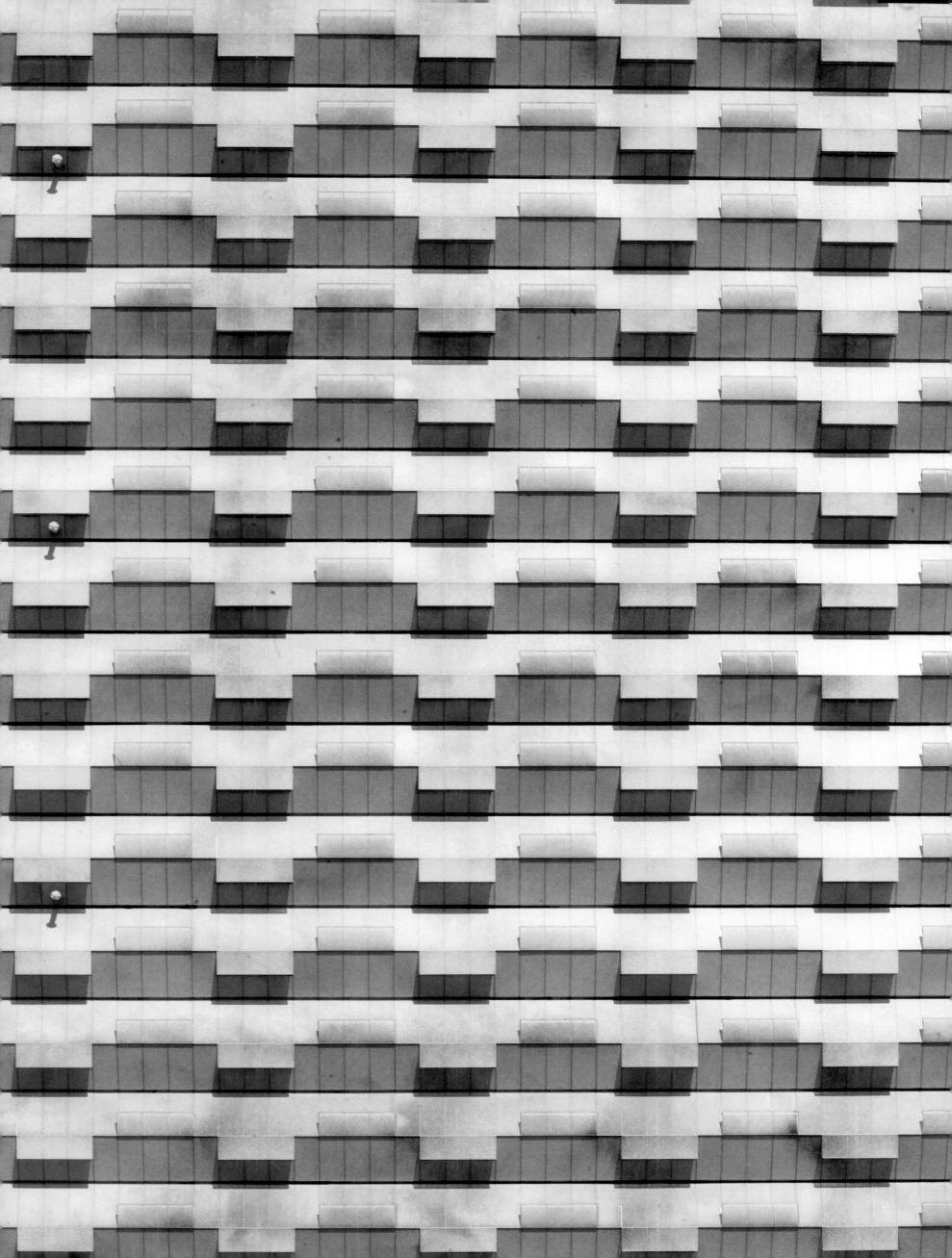

CHICORY HARVEST

Near Arles, Bouches-du-Rhône, France;
September

"A greenhouse lettuce has less flavour
than a lettuce grown outside."

GÉRALD BEZERT, farmer and vegetable grower,
Velleron, Vaucluse, France

ENDIVIENERNTE

Umgebung von Arles, Bouches-du-Rhône,
Frankreich, September.

„Ein Treibhaussalat hat weniger
Geschmack als ein Freilandsalat."

Gérald Bezert, Landwirt und Gemüsebauer,
Velleron, Vaucluse, Frankreich.

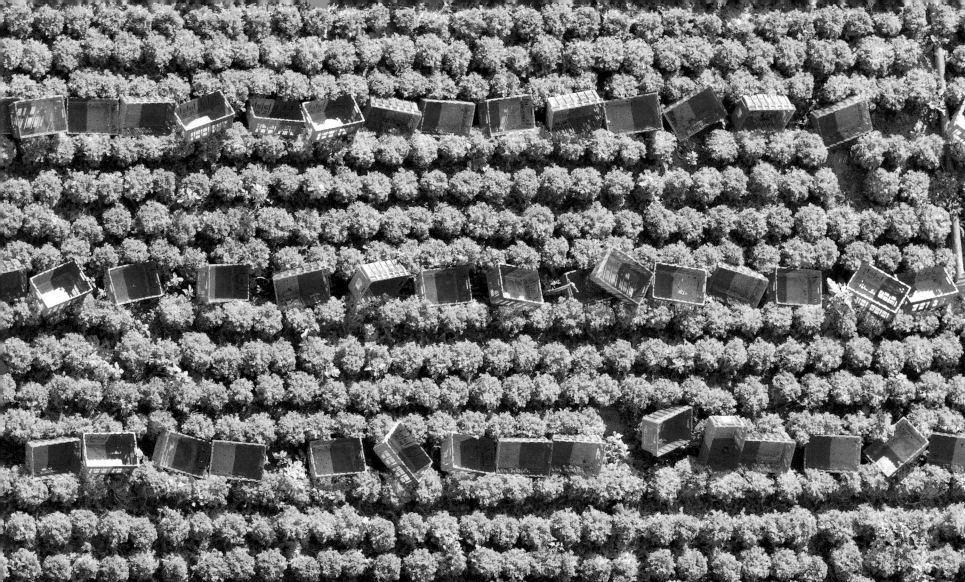
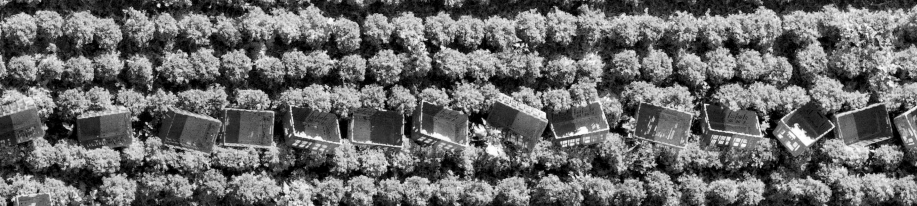
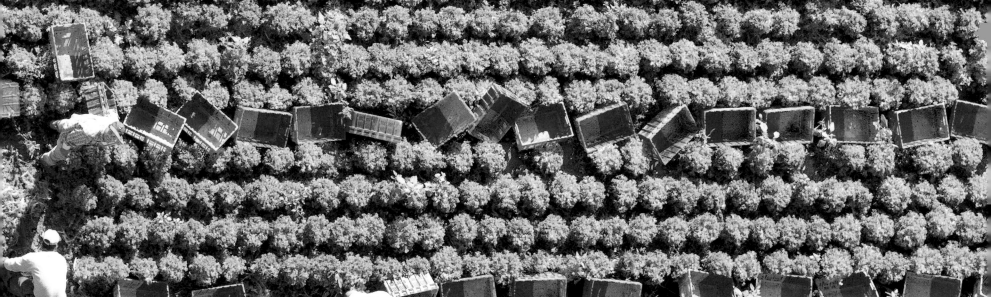
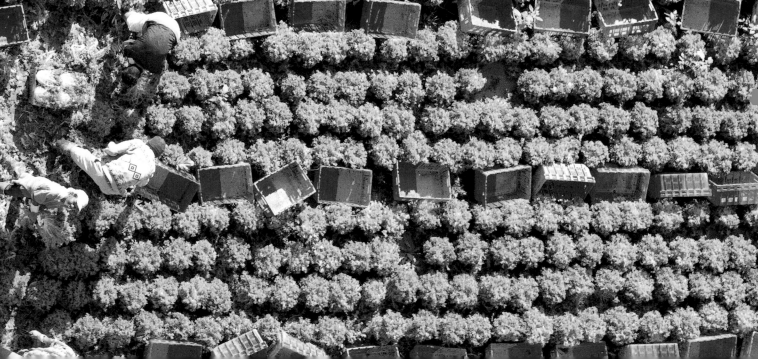

PREPARED SOIL

The soil shows marks of havng been tilled,
firsy in one direction, then the other.
Lower Durance Valley, Bouches-du-Rhône,
France; September

"No, I can't read a map.
My map is the land: its colour, the shape
of the rocks, their size and their
position. The fineness of the sand, the
orientation of the dunes and the waves
of sand, all this creates a map in my
head. This is how I get my bearings."

MOHAMED AGHALER, desert guide, Agadès, Niger

BEARBEITETES ACKERLAND

An den Spuren am Boden erkennt man,
dass der Acker erst in die eine und dann
in die andere Richtung bearbeitet wurde.
Unteres Durance-Tal, Bouches-du-Rhône,
Frankreich, September.

„Nein, ich kann keine Karten lesen.
Der Boden ist meine Karte: seine Farbe,
die Form der Steine, ihre Größe, ihre
Anordnung. Die Körnung des Sandes,
die Ausrichtung der Dünen und der
Sandverwehungen, all das zusammen
ergibt eine Karte in meinem Kopf.
Danach orientiere ich mich."

MOHAMED AGHALER, Wüstenführer, Agadès, Niger.

Acknowledgements

First of all, I would like to thank all those workers of the land who interrupted their activities in order to help me understand and describe my photographs, who explained their work and its changing nature to me; some will not find their comments in this book, as some images were eliminated during the final selection, others will discover their remarks next to a photograph taken elsewhere, and some will find their remarks changed, if I was unable to submit it to them before printing, as I tried to do whenever possible. I hope they will accept my apologies:

Georges & Joël Adrian, Jean-Jacques Agassis (PRODAGUE), Urban Anderau (SYNGENTA LES BARGES), Thierry Anet, Martine Ayme, Max Baladou (OFFICE CENTRAL VAUDOIS DE LA CULTURE MARAÎCHÈRE), Géo Balme, (LA TRUFFE DU LUBÉRON), Jacques Balossier (COMPAGNIE DES SALINS DU MIDI), M'Hamed Bennina, Gérald Berger, Nadine Bertrand (INRA), Gérald Bézert, Bernard Chauvin (SERVICE ROMAND DE VULGARISATION AGRICOLE), Éric Biscarat, Maurice Boisset, José Bové, Charly Bressoud (SYNGENTA LES BARGES), Fréddy & Julien Brönnimann, Jean-Paul Bruchez, (ŒNOTHÈQUE DE LEYTRON), José Maria Calva, Michel & Annie Camelin, Frédéric Campin (ŒNOTHÈQUE DE SION), Carmen, Éric Chareyre, Jean-Marc Chavannes, Guy Clauzel (INRA), Serge Comte, Flavien Cornut, Fernand Cuche, Thierry Debarge (DISTILLERIE DU BOIS DES DAMES), Erica de Kleermaecker (CENTRE HOSPITALIER UNIVERSITAIRE VAUDOIS), Bruno Doche, Édouard & Stéphane Drome, (EARL DROME), Patrick Ferdier (COMPAGNIE DES SALINS DU MIDI), Jean-Luc Fournié (CHAMBRE D'AGRICULTURE DE LA DRÔME), Fabien Fournier (VALPLANTES), Daniele Fuog (SYNGENTA LES BARGES), Joseph Gaffet (CLAUSE TÉZIER), Chantal Gautier, (TOP SEMENCE), Pascal Gilloz, François Gonfond, Corinne Gras (LES SERRES DU GRENOUILLET), Jean-Claude Grenier (TOP SEMENCE), Roland Guignard (PÉNITENCIER DE BELLECHASSE), Jürg Gutknecht-Gysi, Pascal Gutknecht, Haxhi Hajdari (PIERRE TROLLUX MARAÎCHER), Jean-François Hanocq (INRA), Bruno Hucbourg (GROUPEMENT RÉGIONAL DES CENTRES D'ÉTUDES TECHNIQUES AGRICOLES DE BASSE DURANCE), Bruno Isenegger (DOMAINE DES BARGES), Marc Jany, Raymond Jouve, Daniel Keller-Gfeller (LA BERNOISE), Hervé Krubsky (LES FLEURS DE LA GARE), Stéphanie Laffont, Yves Le Dù (SEMENCES GAUTIER), Robert Maccari, Mohamed Aghaler, Patrick Madar (DOMAINE ET CENTRE COLLECTEUR DES TOURELLES), Ernst Maeder (BIO-GEMÜSE), Daniel Marchand (PRIMPLANT, BIOPLANTS, PRIMSERRE & RICHEL), Évelyne Marendaz (SERVICE ROMAND DE VULGARISATION AGRICOLE), François-Arnaud (CHAMBRE D'AGRICULTURE DE LA DRÔME), Philippe Monney (STATION FÉDÉRALE DE RECHERCHES EN PRODUCTION VÉGÉTALE, RAC), Bernard Monnier (SYNGENTA LES BARGES), Mohamed Mouncho, Denis Pelouzet, José Perreira, Armel Perrion, Anne Poniatowski (LE MAS DE LA DAME), Olivier Potterat (MIGROS PAYS DE VAUD), Jean-Marie Prosperi (INRA), Gilles Pujante, Jean-Baptiste Quenin (MOULIN DES BARRES), Fréderic Raillon (COOPÉRATIVE VALSOLEIL), Denis Ravanas (AZ MÉDITERRANÉE), Jean-Charles Reihle (DOMAINE DE LA GRANDE-ÎLE), Alix Rey (CLAUSE TÉZIER), Elio Riboli (CENTRE INTERNATIONAL DE RECHERCHE SUR LE CANCER), M. Roduit, Marc Rossetti, Jean-Luc Ruegsegger, Muriel Saussac (ITEIPMAI), Hervé Serieys (INRA), René Steiner (INFORAMA SEELAND), Sophie Stévenin (CHAMBRE D'AGRICULTURE DE LA DRÔME), Roland Stoll (STOLL FRÈRES), Didier Strolin (SOTRAFA), Véronique Terol, Amandine Têtu (AZ MÉDITERRANÉE), Rémy Theinz, Pierre Trollux, Philippe Tschanz (PRODAGUE), Bruno & Françoise Urbain, Gérard Vignard, Claude Vignaud, Marie-Thérèse Viguier, Pierre Villin (RICHEL SERRES DE FRANCE), Paul Vindry (COOPÉRATIVE AGRICOLE VALSOLEIL).

I would also like to thank Christoph Blaser, assistant curator, MUSÉE DE L'ÉLYSÉE, CANTONAL PHOTOGRAPHY MUSEUM in Lausanne, and André Rouvinez, curator of exhibitions, for their valuable help, in particular in getting this project started.

Thank you to Chantal Vieuille, editor, whose idea it was to publish this book and who put me in touch with my publisher.

Thank you to my associate, Laurent Salin, for his indispensable help, and to everyone at PAYSAGESTION, landscape architects in Lausanne, especially Nabinka Zaech, Claudine Deschênes, Jocelyne Baudin, Anthony Lecoultre, Olivier Donzé, Marek Pasche...

Thank you to René Hämmerli, professional advisor, LEICA CAMERA SA, Nidau Bern, for his many tips and the loan of a 22-megapixel HASSELBLAD back for 2004, with which all the images in this book were taken.

Thank you to Guido Noth, cameraman for TÉLÉVISION SUISSE, for his many tips, and the loan and installation of a gyroscopic stabiliser.

Thank you to Julien Ganivet, computer expert, for the masterful way in which he helped me deal with vast digital files and print preparation.

Thank you of course to the helicopter pilots for their patience and their performance, in sometimes difficult situations, especially at low altitudes:
Stefan Bachmann, André Belaieff, Jean-Daniel Berthod, Gabriel Besson, Rémy Burri, Maxime Castelain, Raphaël Leservot, Robert Maccari, Dominique Morel, Jacques Maurel, Georges Moulin, Jacques Rippert, Christian Rosat, Adrian von Siebenthal and Dany Vionnet.

Thank you to Evelyne Marendaz, agronomist, member of the board of the SERVICE ROMAND DE VULGARISATION AGRICOLE, for her detailed and critical reading of the text.

Thank you to Maximilien Bruggmann, Marco Cennini, Anna Favre, Werner Jeker, Jean-Luc Kaiser, Genette and Wendula Lasserre, Charles and Marianne Meynard, Sonia Othenin-Girard, Alice Pauli, Michel Rey, Jacques Straessle, Jean-François Tiercy, Léopold Veuve, Caroline de Watteville and Christophe Ziegert who, in many different ways, helped me to produce this book.

Finally, thank you to my wife Anita and our two daughters, Aurélie and Valentine, for having put up with the inconveniences brought about by the excess of work — and for accompanying, helping and encouraging me throughout the time of the book's creation.

Danksagung

Ich möchte mich zunächst bei all den Menschen aus der Landwirtschaft bedanken, die mir etwas von ihrer Zeit geopfert haben, um mir meine Fotos zu erläutern und mir einen Einblick in ihre Arbeit und die Veränderungen, denen sie unterworfen ist, zu gewähren. Einige werden ihre Äußerungen nicht entdecken können, weil wir bei der definitiven Auswahl der Fotos auf das entsprechende Bild verzichten mussten, andere werden merken, dass ihr Kommentar nicht zu dem nebenstehenden Bild gehört oder dass ihre Worte verfälscht wiedergegeben sind, weil es mir nicht möglich war, ihnen den fertigen Text noch einmal zu zeigen, was ich so oft wie möglich getan habe. Bei all jenen möchte ich mich entschuldigen. Dank an:

Georges & Joël Adrian, Jean-Jacques Agassis (PRODAGUE), Urban Anderau (SYNGENTA LES BARGES), Thierry Anet, Martine Ayme, Max Baladou (OFFICE CENTRAL VAUDOIS DE LA CULTURE MARAÎCHÈRE), Géo Balme, (LA TRUFFE DU LUBÉRON), Jacques Balossier (COMPAGNIE DES SALINS DU MIDI), M'Hamed Bennina, Gérald Berger, Nadine Bertrand (INRA), Gérald Bézert, Bernard Chauvin (SERVICE ROMAND DE VULGARISATION AGRICOLE), Éric Biscarat, Maurice Boisset, José Bové, Charly Bressoud (SYNGENTA LES BARGES), Fréddy & Julien Brönnimann, Jean-Paul Bruchez, (ŒNOTHÈQUE DE LEYTRON), José Maria Calva, Michel & Annie Camelin, Frédéric Campin (ŒNOTHÈQUE DE SION), Carmen, Éric Chareyre, Jean-Marc Chavannes, Guy Clauzel (INRA), Serge Comte, Flavien Cornut, Fernand Cuche, Thierry Debarge (DISTILLERIE DU BOIS DES DAMES), Erica de Kleermaecker (UNIVERSITÄTSKLINIK WAADT), Bruno Doche, Édouard & Stéphane Drome, (EARL DROME), Patrick Ferdier (COMPAGNIE DES SALINS DU MIDI), Jean-Luc Fournié (LANDWIRTSCHAFTSKAMMER DRÔME), Fabien Fournier (VALPLANTES), Daniele Fuog (SYNGENTA LES BARGES), Joseph Gaffet (CLAUSE TÉZIER), Chantal Gautier, (TOP SEMENCE), Pascal Gilloz, François Gonfond, Corinne Gras (LES SERRES DU GRENOUILLET), Jean-Claude Grenier (TOP SEMENCE), Roland Guignard (PÉNITENCIER DE BELLECHASSE), Jürg Gutknecht-Gysi, Pascal Gutknecht, Haxhi Hajdari (PIERRE TROLLUX MARAÎCHER), Jean-François Hanocq (INRA), Bruno Hucbourg (REGIONALGRUPPE DER CENTRES D'ÉTUDES TECHNIQUES AGRICOLES DE BASSE DURANCE), Bruno Isenegger (DOMAINE DES BARGES), Marc Jany, Raymond Jouve, Daniel Keller-Gfeller (LA BERNOISE), Hervé Krubsky (LES FLEURS DE LA GARE), Stéphanie Laffont, Yves Le Dù (SEMENCES GAUTIER), Robert Maccari, Mohamed Aghaler, Patrick Madar (DOMAINE ET CENTRE COLLECTEUR DES TOURELLES), Ernst Maeder (BIO-GEMÜSE), Daniel Marchand (PRIMPLANT, BIOPLANTS, PRIMSERRE & RICHEL), Évelyne Marendaz (SERVICE ROMAND DE VULGARISATION AGRICOLE), François-Arnaud (LANDWIRTSCHAFTSKAMMER DRÔME), Philippe Monney (STATION FÉDÉRALE DE RECHERCHES EN PRODUCTION VÉGÉTALE, RAC), Bernard Monnier (SYNGENTA LES BARGES), Mohamed Mouncho, Denis Pelouzet, José Perreira, Armel Perrion, Anne Poniatowski (LE MAS DE LA DAME), Olivier Potterat (MIGROS PAYS DE VAUD), Jean-Marie Prosperi (INRA), Gilles Pujante, Jean-Baptiste Quenin (MOULIN DES BARRES), Fréderic Raillon (COOPÉRATIVE VALSOLEIL), Denis Ravanas (AZ MÉDITERRANÉE), Jean-Charles Reihle (DOMAINE DE LA GRANDE-ÎLE), Alix Rey (CLAUSE TÉZIER), Elio Riboli (INTERNATIONALES KREBSFORSCHUNGSZENTRUM), M. Roduit, Marc Rossetti, Jean-Luc Ruegsegger, Muriel Saussac (ITEIPMAI), Hervé Serieys (INRA), René Steiner (INFORAMA SEELAND), Sophie Stévenin (LANDWIRTSCHAFTSKAMMER DRÔME), Roland Stoll (STOLL FRÈRES), Didier Strolin (SOTRAFA), Véronique Terol, Amandine Têtu (AZ MÉDITERRANÉE), Rémy Theinz, Pierre Trollux, Philippe Tschanz (PRODAGUE), Bruno & Françoise Urbain, Gérard Vignard, Claude Vignaud, Marie-Thérèse Viguier, Pierre Villin (RICHEL SERRES DE FRANCE), Paul Vindry (COOPÉRATIVE AGRICOLE VALSOLEIL).

Ich danke auch Christoph Blaser, dem stellvertretenden Konservator des Museums für Fotografie MUSÉE DE L'ÉLYSÉE in Lausanne, außerdem André Rouvinez, dem Ausstellungsbeauftragten, für ihre wertvolle Hilfe besonders zu Beginn meiner Arbeit.

Dank auch an Chantal Vieuille, die die Idee zu diesem Buch gehabt hat und den Kontakt zu meinem Verleger hergestellt hat.

Mein Dank gilt auch meinem Teilhaber Laurent Salin für seine unentbehrliche Hilfe und der gesamten Mannschaft von Paysagestion, der Agentur für Landschaftsarchitektur in Lausanne, und ganz besonders Nabinka Zaech, Claudine Deschênes, Jocelyne Baudin, Anthony Lecoultre, Olivier Donzé, Marek Pasche u.v.a.

Ich danke René Hämmerli, Fachberater der Firma Leica Camera SA in Nidau, Bern, für seine zahlreichen Ratschläge. Unentbehrlich für meine Arbeit war das Hasselblad Digitalrückteil mit 22 Millionen Pixeln, das er mir im Jahr 2004 zur Verfügung gestellt hat und mit dem die gesamten Aufnahmen dieses Buches entstanden sind.

Dank an Guido Noth, Kameramann des Schweizer Fernsehens, für seine zahlreichen Ratschläge und den Kreiselstabilisator, den er mir geliehen und auch installiert hat.

Dank an Julien Ganivet, Informatiker, dessen sachkundige Unterstützung mir bei der Verwaltung der riesigen Datenfiles und bei der Vorbereitung der Arbeitsabzüge eine große Hilfe war.

Mein großer Dank gilt natürlich auch den Hubschrauberpiloten. Sie haben große Geduld bewiesen und mit ihrem Einsatz auch schwierige Flüge auf geringer Höhe möglich gemacht: Stefan Bachmann, André Belaieff, Jean-Daniel Berthod, Gabriel Besson, Rémy Burri, Maxime Castelain, Raphaël Leservot, Robert Maccari, Dominique Morel, Jacques Maurel, Georges Moulin, Jacques Rippert, Christian Rosat, Adrian von Siebenthal und Dany Vionnet.

Ich danke der Agraringenieurin Évelyne Marendaz, Vorstandsmitglied der Landwirtschaftlichen Beratungszentrale der französischsprachigen Schweiz (SRVA), für ihr aufmerksames und kritisches Lektorat.

Dank an Maximilien Bruggmann, Marco Cennini, Anna Favre, Werner Jeker, Jean-Luc Kaiser, Genette und Wendula Lasserre, Charles und Marianne Meynard, Sonia Othenin-Girard, Alice Pauli, Michel Rey, Jacques Straessle, Jean-François Tiercy, Léopold Veuve, Caroline de Watteville und Christophe Ziegert, die mich in vielerlei Hinsicht bei der Entstehung dieses Buches unterstützt haben.

Nicht zuletzt bedanke ich mich bei meiner Frau Anita und unseren beiden Töchtern Aurélie und Valentine. Sie haben die Unannehmlichkeiten, die durch das Übermaß an Arbeit bedingt waren, mit Nachsicht ertragen und mich in meiner Arbeit stets unterstützt und ermutigt.